Lewis Carroll's Photographs of Children and Young Adults

Other books by the author
- *Memories of a Narrow Place*
- *Life in the City of Burning Dirt*
- *Jewish Calendar Mathematics*
- *Mikasa: An Illustrated History of the Last Pre-Dreadnaught Battleship*
- *Lucky Uncle George: An Illustrated History of the Greek Armored Cruiser Averof*
- *Aurora: An Illustrated History of the Russian Cruiser*
- *Exploring the Military History of Fort MacArthur and Palos Verdes*
- *Tsesarevich: The Biography of a Battleship*
- *The Naval Battle Off Cape Sarych*

Lewis Carroll's Photographs of Children and Young Adults

James A. Shneer

Palos Verdes Historical Press

Copyright 2023

James A. Shneer

All rights reserved. No part of this book may be reproduced or transmitted in any form, or by any means electronic or mechanical, including photocopying, recording or by any information storage and retrieval system without the written consent of the copyright owner.

ISBN: 978-1-312-17161-9

To Lisa Budd who reignited my interest in Lewis Carroll and his work

Contents

Preface ..1

Charles Lutwidge Dodgson (Lewis Carroll) ...2
Family ...2
Health ...5
Social connections ..6
Politics, religion, and philosophy ..6
Artistic activities ...7
Inventions ...12
Mathematical work ..12
Correspondence ...13
Sexuality ...13
Ordination ..14
Missing diaries ..14
Later years ..15
Death ..16
Memorials ..16
Legacy ..17

Carroll's Photographic Sitters ...19
Liddell siblings (Alice, Lorina, Edith and Harry) ..19
Agnes Weld ..33
Agnes Florence Price ..34
Alice Constance Westmacott ...35
Alice Murdoch ..35
Amy Raikes and Annie Parkes ..36
Angus Douglas ..36
Annie Coates ..37
Arnold sisters (Julia and Ethel) ...37
Beatrice Mary Henley and Beatrix du Maurier ..38
Bessie Slatter ..39
Barry family (Louisa, Johnnie and Emily Barry) ..39
Bickersteth siblings (Cyril and Florence) ..40
Brodie sisters (Ethel, Lillian and Margaret Anne) ...41
Brooke Sisters (Olive, Honor and Evelyn) and Miss Cole ...41
Denham children (Charlotte Edith, Arthur and Grace) ..42
Dodgson families ...42
Donkin cousins (Alice Emily Donkin and Alice Jane Donkin) ...44
Dykes sisters (Gertrude, Mary and Caroline) ...45
Edith Hulme and Eliza D. Hobson ..46
Eleanor Winifred Howes ..47
Ellison sisters (Constance and Mary) ...47
Elizabeth Ley Hussey ..48
Ella Chlora Faithful Monier-Williams ...49
Ellis sisters (Bertha, Dymphna and Mary) ..50
Evelyn Dubourg with Kathleen O'Reilly ...51
Frederica Harriette Morrell and Frederick, Crown Prince of Denmark52
Flora Rankin and Florence Hilda Bainbridge ..53

Georgina "Gina" Mary Balfour ... 53
Gertrude Chataway ... 54
Harington sisters (Alice and Beatrice) and Harry Ashworth Taylor .. 55
Hatch Siblings (Wilfred, Beatrice, Ethel and Evelyn) ... 56
Henderson sisters (Annie and Frances) ... 59
Hughes family (Tryphena and her children Arthur, Amy, and Agnes) .. 60
Hughes, Arthur and Isabella (Ella) Maude Drury .. 61
Ivo Bligh and Joa Pollock .. 61
John (Johnnie) Henry Joshua Ellison, John Wycliffe Taylor .. 62
Kathleen Tidy and Katie Brine ... 63
Kitchin (Alexandra [Xie] Kitchin, Brock Taylor Kitchin, Hugh Bridges Kitchin, George Herbert Kitchin) 63
Langton Clarke sisters (Margaret Francis and Diane Elizabeth) ... 72
Leila Campbell Taylor and Lisa Wood ... 73
Longley sisters (Caroline and Rosamund) and Lucy Tate .. 73
MacDonald Family ... 74
Maria White ... 76
Mary L. Jackson and Mary Elizabeth Lott ... 77
Marcus Keane and the Millais Family (Effie Gray, John Everett, Effie and Mary) .. 77
Nelly MacDonald ... 78
Owen Siblings (Lucy, Henrietta, Sidney, Isobel, Margaret and Edward) .. 79
Parnell Siblings (Victor and Madeleine) ... 82
Quintin Twiss ... 83
Rogers Family (Annie and Henry) ... 83
Rose Lawrie and Rose Wood (Eliza Rose Fawcett [née Wood]) ... 84
Smith sisters (Anne, Maria, Joanna and Fanny) ... 84
Tennyson (Lionel and Hallam) and Julia Marsh .. 87
Terry Family (Kate, Ellen, Marion, Flo and Charles) ... 87
Twyford School .. 90
Unidentified girl holding a basket .. 92
Wilson-Todd Sisters (Aileen and Evelyn) .. 92
Webster sisters (Margaret and Charlotte) and Margaret Gatey ... 93
Winifred Holiday with Daisy Whiteside and Zoe Strong .. 93

Index of Surnames of Sitters and of other Significant Individuals .. 94

Important Places in Lewis Carroll's Life

Preface

Charles Dodgson (Lewis Carroll) took approximately 3000 photographs in his life time of which approximately 1580 prints and 71 glass negatives exist. When one looks at the books which focus on Carroll's photography three things become apparent. Most of these books are either out of print or expensive. Few of them focus exclusively on photographs of young people and, especially, his sometimes controversial and occasionally haunting photographs of girls in their mid-20s and younger – by far his favorite and most photographed subjects accounting for about half of his output. And, finally, most books of his photography are not organized by the name of the sitter, precluding, thereby, easy comparison of photographs of the same individual. This book is designed to fill these three niches. Included also, are eight prints never before published.

Most of the biographies in the book have been adapted, augmented and corrected from those appearing in Wikipedia. Shown beneath each photograph, enclosed in parentheses, is the date it was taken, and the name of the photographer if other than Lewis Carroll. The over 200 photographs by Carroll are arranged alphabetically by the first name of the sitter or by the surname name if there are multiple family member photographs included or in cases when the first name was unavailable. Because of Alice Liddell's importance to Carroll's story, the first set of photographs is of the Liddell sisters.

Words of thanks are in order to my dear wife Diane who proofread the book; Alina Nachescu from the Christ Church library who helped make the previously unpublished Christ Church photographs available for my use and, most significantly, to Lisa Budd for rekindling my interest in Lewis Carroll which stimulated me to undertake this project and for proofreading multiple iterations of the book. She suggested additions, deletions and corrections to the text and to the photographs and provided other insightful comments during her reviews all of which helped improve and shape the book's final content, which however, remains solely my responsibility.

James A. Shneer

Palos Verdes, California

Charles Lutwidge Dodgson (Lewis Carroll)

Family

Charles Dodgson was born on January 27, 1832 at All Saints' Vicarage in Daresbury, Cheshire, the oldest boy and the third oldest of 11 children.

His family was predominantly northern English and conservative. Most of his male ancestors were army officers or Anglican clergymen. His great-grandfather, Charles Dodgson, had risen through the ranks of the church to become the Bishop of Elphin in rural Ireland. His paternal grandfather, another Charles, had been an army captain, killed in action in Ireland in 1803, 20 days prior to the birth of his second son, Charles Lutwidge Dodgson's uncle. The older of these sons, yet another Charles Dodgson, was Charles' father. He went to Westminster School and then to Christ Church, Oxford. He reverted to the other family tradition and took holy orders. He was mathematically gifted and won a double first degree, which could have been the prelude to a brilliant academic career. Instead, he married his first cousin Frances Jane Lutwidge in 1830 and became a country parson.

In 1843, when Charles was 11, his father became Rector at Croft-on-Tees, Yorkshire, and the whole family moved to the spacious rectory.

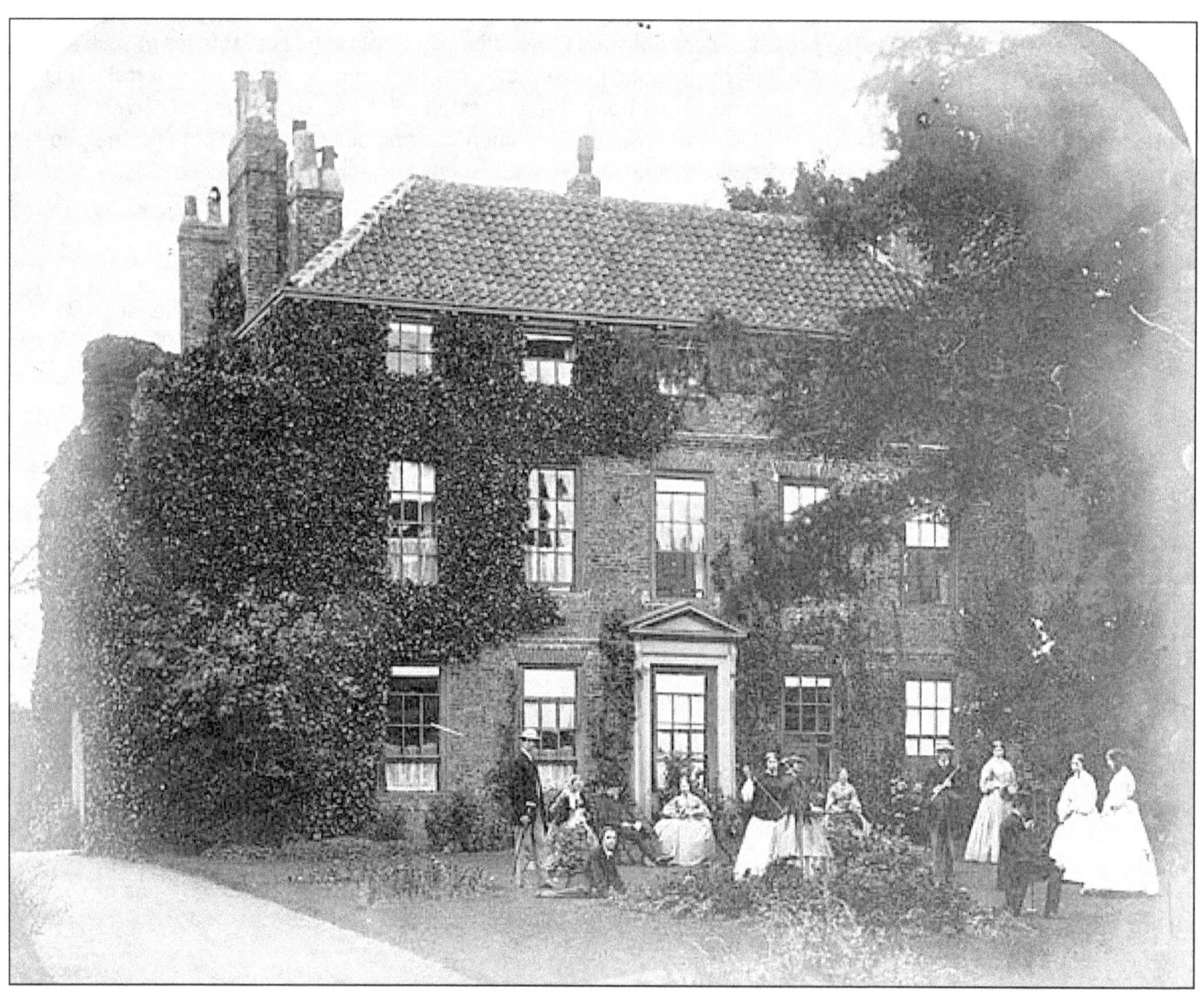

The rectory (Robert Wilfred Skeffington Lutwidge - 1860)

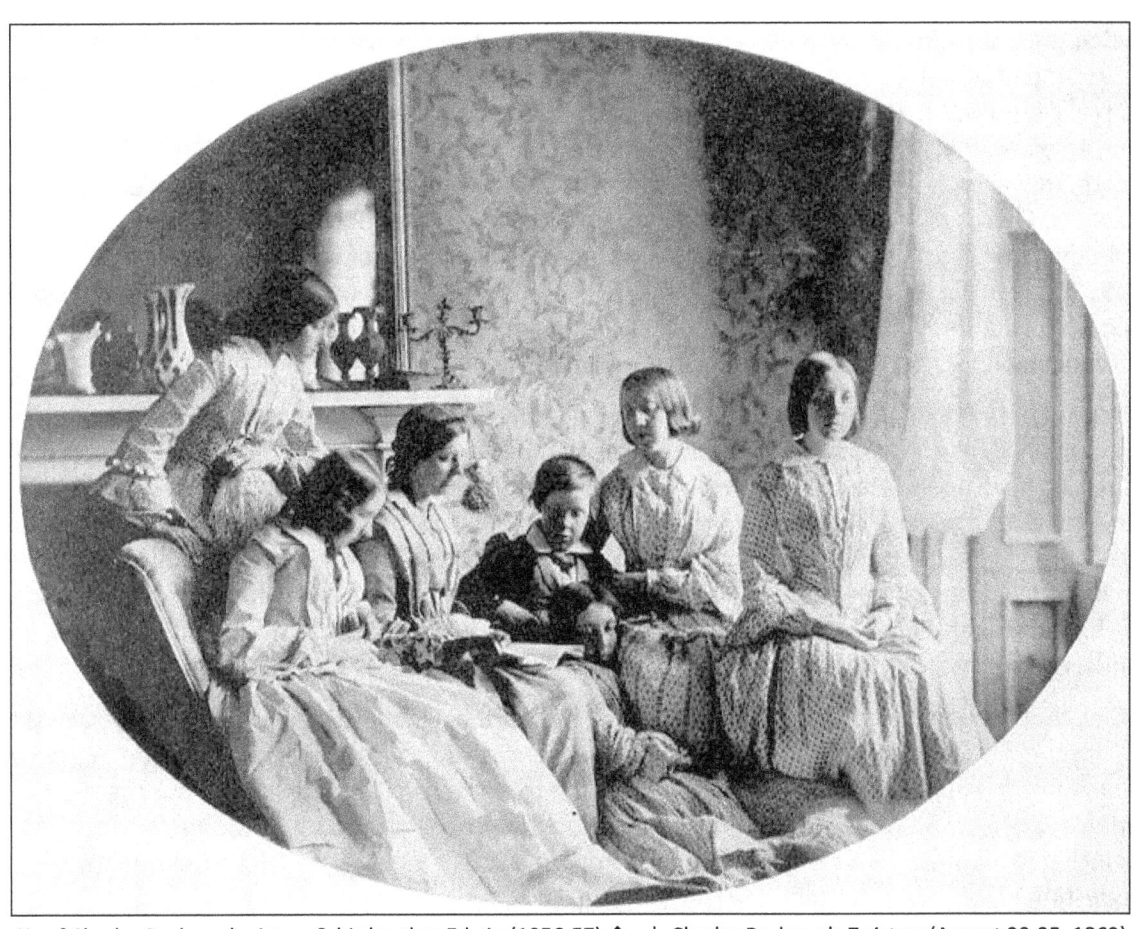
Six of Charles Dodgson's sisters & his brother Edwin (1856-57) ↑ ↓ Charles Dodgson's 7 sisters (August 20-25, 1863)
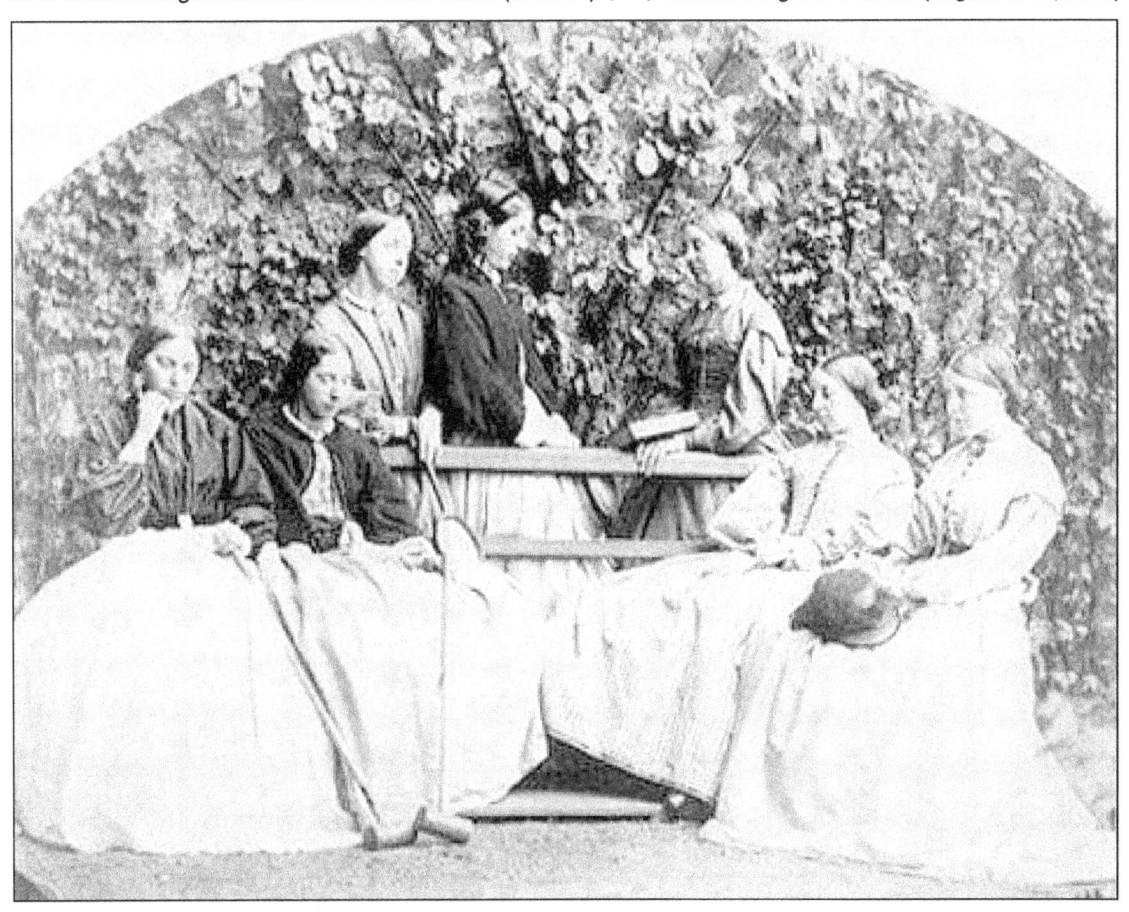

This remained their home for the next 25 years. Charles' father was an active and highly conservative cleric of the Church of England who later became the Archdeacon of Richmond and involved himself, sometimes influentially, in the intense religious disputes that were dividing the church. He was high-church, inclining toward Anglo-Catholicism, an admirer of John Henry Newman and the Tractarian movement, and did his best to instill such views in his children. However, Charles developed an ambivalent relationship with his father's values and with some of the tenets of the Church of England. During his early youth, Dodgson was educated at home. His "reading lists" preserved in the family archives testify to a precocious intellect: at the age of seven, he was reading books such as The Pilgrim's Progress. He also spoke with a stammer, a condition shared by most of his siblings, which often inhibited his social life throughout his life. In 1844, at the age of twelve, he was sent to Richmond Grammar School (now part of Richmond School) in Richmond, North Yorkshire.

In 1846 Dodgson entered Rugby School, where he was evidently unhappy, as he wrote some years after leaving: "I cannot say ... that any earthly considerations would induce me to go through my three years again ... I can honestly say that if I could have been ... secure from annoyance at night, the hardships of the daily life would have been comparative trifles to bear." He did not claim he suffered from bullying, but cited little boys as the main targets of older bullies at Rugby. Stuart Dodgson Collingwood, Dodgson's nephew, wrote that "even though it is hard for those who have only known him as the gentle and retiring don to believe it, it is nevertheless true that long after he left school, his name was remembered as that of a boy who knew well how to use his fists in defense of a righteous cause", which is the protection of the smaller boys.

Scholastically, though, he excelled with apparent ease. "I have not had a more promising boy at his age since I came to Rugby", observed mathematics master R. B. Mayor. Francis Walkingame's *The Tutor's Assistant; Being a Compendium of Arithmetic* - the mathematics textbook that the young Dodgson used - still survives and it contained an inscription in Latin, which translates to: "This book belongs to Charles Lutwidge Dodgson: hands off!" Some pages also included annotations such as the one found on p. 129, where he wrote "Not a fair question in decimals" next to a question.

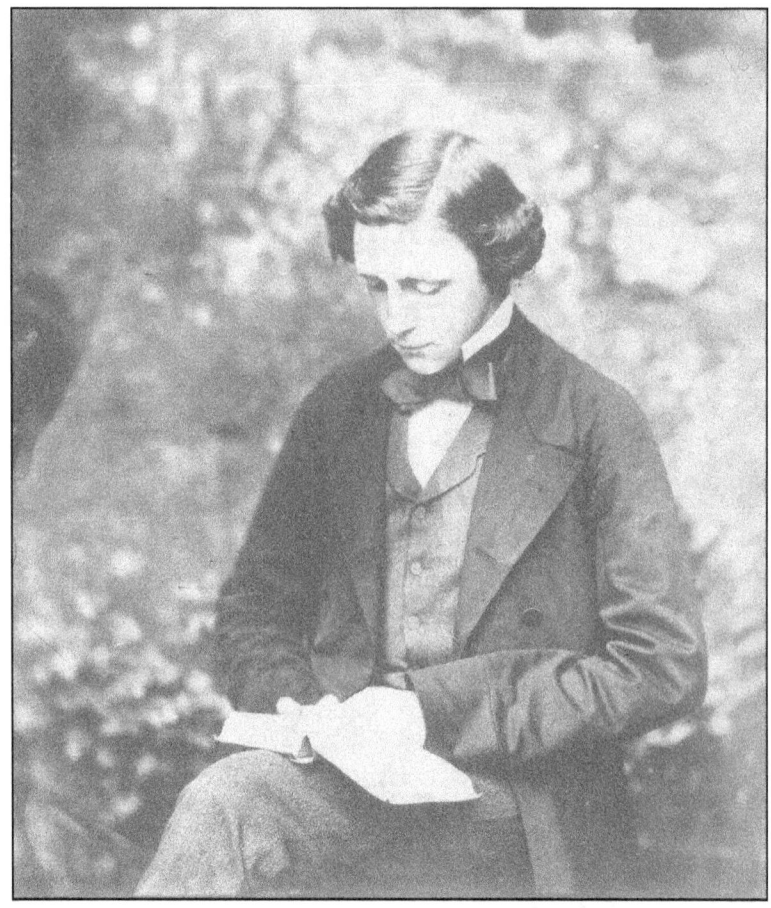

Charles Dodgson self-portrait c. 1856, aged 24 at that time

He left Rugby at the end of 1849 and matriculated at the University of Oxford in May 1850 as a member of his father's old college, Christ Church. After waiting for rooms in the college to become available, he went into residence in January 1851. He had been at Oxford only two days when he received a summons home. His mother had died of "inflammation of the brain" - perhaps meningitis or a stroke - at the age of 47.

His early academic career veered between high promise and irresistible distraction. He did not always work hard, but was exceptionally gifted, and achievement came easily to him. In 1852, he obtained first-class honors in Mathematics Moderations and was soon afterwards nominated to a Studentship by his father's old friend Canon Edward Pusey. In 1854, he obtained first-class honors in the Final Honors School of Mathematics, standing first on the list, and thus graduated as Bachelor of Arts. He remained at Christ Church studying and teaching, but the next year he failed an important scholarship exam through his self-confessed inability to apply himself to study. Even so, his talent as a mathematician won him the Christ Church Mathematical Lectureship in 1855, which he continued to hold for the next 26 years. Despite early unhappiness, Dodgson remained at Christ Church, in various capacities, until his death, including that of Sub-Librarian of the Christ Church library, where his office was close to the Deanery, where Alice Liddell lived.

Health

The young adult Charles Dodgson was about 6 feet tall and slender, and he had curly brown hair and blue or grey eyes (depending on the account). He was described in later life as somewhat asymmetrical, and as carrying himself rather stiffly and awkwardly, although this might be on account of a knee injury sustained in middle age. As a very young child, he suffered an attack of mumps that left him deaf in one ear. At the age of 17, he suffered a severe attack of whooping cough, which was probably responsible for his chronically weak chest in later life. In early childhood, he acquired a stammer, which he referred to as his "hesitation"; it remained throughout his life.

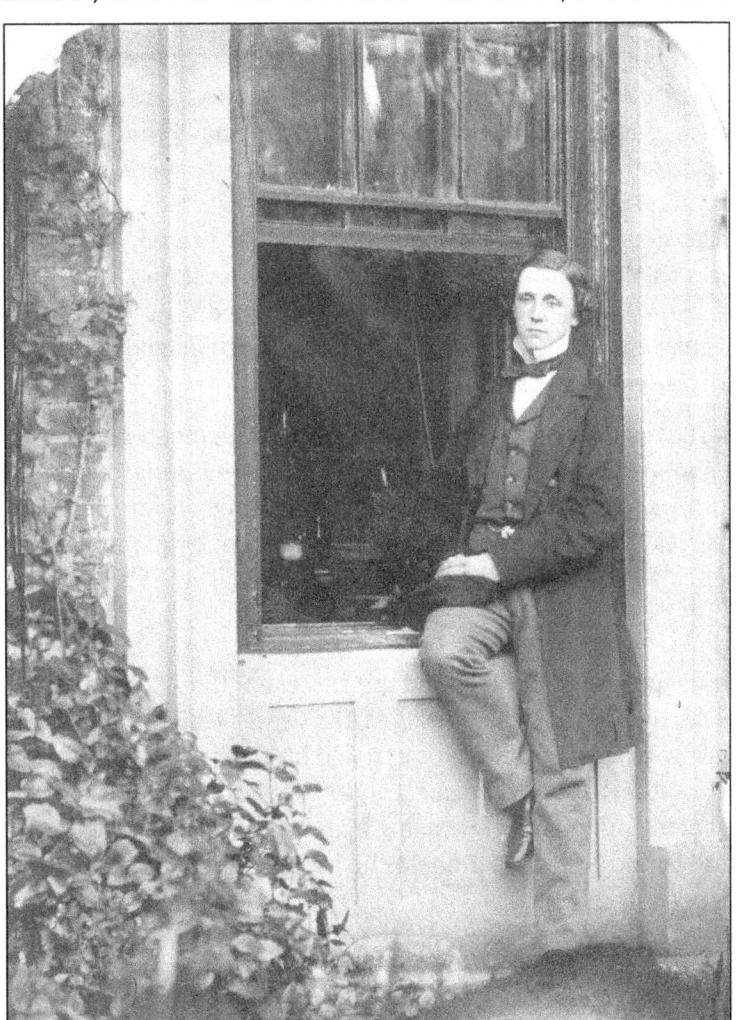

Charles Dodgson (self-portrait) seated on a windowsill of the Old Rectory at Croft, Darlington, Yorkshire

(July/August 1857)

The stammer has always been a significant part of the image of Dodgson. While one apocryphal story says that he stammered only in adult company and was free and fluent with children, there is no evidence to support this idea. Many children of his acquaintance remembered the stammer, while many adults failed to notice it. Dodgson himself seems to have been far more acutely aware of it than most people whom he met; it is said that he caricatured himself as the Dodo in Alice's Adventures in Wonderland, referring to his difficulty in pronouncing his last name, but this is one of the many supposed facts often repeated for which no first-hand evidence remains. He did indeed refer to himself as a dodo, but whether or not this reference was to his stammer is simply speculation.

Dodgson's stammer did trouble him, but it was never so debilitating that it prevented him from applying his other personal qualities to do well in society. He lived in a time when people commonly devised their own amusements and when singing and recitation were required social skills, and the young Dodgson was well equipped to be an engaging entertainer. He could reportedly sing at a passable level and was not afraid to do so before an audience. He was also adept at mimicry and storytelling, and reputedly quite good at charades.

In his diary for 1880, Dodgson recorded experiencing his first episode of migraine with aura, describing very accurately the process of "moving fortifications" that are a manifestation of the aura stage of the syndrome. Unfortunately, there is no clear evidence to show whether this was his first experience of migraine per se, or if he may have previously had the far more common form of migraine without aura, although the latter seems most likely, given the fact that migraine most commonly develops in the teens or early adulthood. Another form of migraine aura called Todd's Syndrome or Alice in Wonderland syndrome has been named after Dodgson's little heroine because its manifestation can resemble the sudden size-changes in the book. It is also known as micropsia and macropsia, a brain condition affecting the way that objects are perceived by the mind. For example, an afflicted person may look at a larger object such as a basketball and perceive it as if it were the size of a golf ball. Some authors have suggested that Dodgson may have experienced this type of aura and used it as an inspiration in his work, but there is no evidence that he did.

Dodgson also had two attacks in which he lost consciousness. He was diagnosed by three doctors who believed the attack and a subsequent attack to be an "epileptiform" seizure. Some have concluded from this that he had this condition for his entire life, but there is no evidence of this in his diaries beyond the diagnosis of the two attacks already mentioned. Some authors, Sadi Ranson in particular, have suggested that Carroll may have had temporal lobe epilepsy in which consciousness is not always completely lost but altered, and in which the symptoms mimic many of the same experiences as Alice in Wonderland. Carroll had at least one incident in which he suffered full loss of consciousness and awoke with a bloody nose, which he recorded in his diary and noted that the episode left him not feeling himself for "quite sometime afterward". This attack was diagnosed as possibly "epileptiform" and Carroll himself later wrote of his seizures in the same diary.

Most of the standard diagnostic tests of today were not available in the nineteenth century. Yvonne Hart, consultant neurologist at the John Radcliffe Hospital, Oxford, considered Dodgson's symptoms. Her conclusion, quoted in Jenny Woolf's 2010 *The Mystery of Lewis Carroll*, is that Dodgson very likely had migraine and may have had epilepsy, but she emphasizes that she would have considerable doubt about making a diagnosis of epilepsy without further information.

Social connections

In the interim between his early published writings and the success of the Alice books, Dodgson began to move in the pre-Raphaelite social circle. He first met John Ruskin in 1857 and became friendly with him. Around 1863, he developed a close relationship with Dante Gabriel Rossetti and his family. He would often take pictures of the family in the garden of the Rossettis' house in Chelsea, London. He also knew William Holman Hunt, John Everett Millais, and Arthur Hughes, among other artists. He knew fairy-tale author George MacDonald well - it was the enthusiastic reception of Alice by the young MacDonald children that persuaded him to submit the work for publication.

Politics, religion, and philosophy

In broad terms, Dodgson has traditionally been regarded as politically, religiously, and personally conservative. Martin Gardner labels Dodgson as a Tory who was "awed by lords and inclined to be snobbish towards inferiors".

William Tuckwell, in his *Reminiscences of Oxford* (1900), regarded him as "austere, shy, precise, absorbed in mathematical reverie, watchfully tenacious of his dignity, stiffly conservative in political, theological, social theory, his life mapped out in squares like Alice's landscape". Dodgson was ordained a deacon in the Church of England on 22 December 1861. In *The Life and Letters of Lewis Carroll*, the editor states that "his Diary is full of such modest depreciations of himself and his work, interspersed with earnest prayers (too sacred and private to be reproduced here) that God would forgive him the past, and help him to perform His holy will in the future." When a friend asked him about his religious views, Dodgson wrote in response that he was a member of the Church of England, but "doubt[ed] if he was fully a 'High Churchman'". He added: "I believe that when you and I come to lie down for the last time, if only we can keep firm hold of the great truths Christ taught us-our own utter worthlessness and His infinite worth; and that He has brought us back to our one Father, and made us His brethren, and so brethren to one another-we shall have all we need to guide us through the shadows. Most assuredly I accept to the full the doctrines you refer to-that Christ died to save us, that we have no other way of salvation open to us but through His death, and that it is by faith in Him, and through no merit of ours, that we are reconciled to God; and most assuredly I can cordially say, I owe all to Him who loved me, and died on the Cross of Calvary."

Dodgson also expressed interest in other fields. He was an early member of the Society for Psychical Research, and one of his letters suggests that he accepted as real what was then called "thought reading". Dodgson wrote some studies of various philosophical arguments. In 1895, he developed a philosophical regresses-argument on deductive reasoning in his article "What the Tortoise Said to Achilles", which appeared in one of the early volumes of Mind. The article was reprinted in the same journal a hundred years later in 1995, with a subsequent article by Simon Blackburn titled "Practical Tortoise Raising".

Artistic activities

Literature

From a young age, Dodgson wrote poetry and short stories, contributing heavily to the family magazine Mischmasch and later sending them to various magazines, enjoying moderate success. Between 1854 and 1856, his work appeared in the national publications The Comic Times and The Train, as well as smaller magazines such as the Whitby Gazette and the Oxford Critic. Most of this output was humorous, sometimes satirical, but his standards and ambitions were exacting. "I do not think I have yet written anything worthy of real publication (in which I do not include the Whitby Gazette or the Oxonian Advertiser), but I do not despair of doing so someday," he wrote in July 1855. Sometime after 1850, he did write puppet plays for his siblings' entertainment, of which one has survived: La Guida di Bragia.

In March 1856, he published his first piece of work under the name that would make him famous. A romantic poem called "Solitude" appeared in The Train under the authorship of "Lewis Carroll". This pseudonym was a play on his real name. Lewis was the anglicized form of Ludovicus, which was the Latin for Lutwidge, and Carroll an Irish surname similar to the Latin name Carolus, from which comes the name Charles. The transition went as follows: "Charles Lutwidge" translated into Latin as "Carolus Ludovicus". This was then translated back into English as "Carroll Lewis" and then reversed to make "Lewis Carroll". This pseudonym was chosen by editor Edmund Yates from a list of four submitted by Dodgson, the others being Edgar Cuthwellis and Edgar U. C. Westhill, both anagrams of his name, and Louis Carroll.

Alice books

In 1856, Dean Henry Liddell arrived at Christ Church, bringing with him his young family, all of whom would figure largely in Dodgson's life over the following years, and would greatly influence his writing career. Dodgson became close friends with Liddell's wife Lorina and their children, particularly the three sisters Lorina, Edith, and Alice Liddell. He was widely assumed for many years to have derived his own "Alice" from Alice Liddell; the acrostic poem at the end of *Through the Looking-Glass* spells out her name in full, and there are also many superficial references to her hidden in the text of both books. It has been noted that Dodgson himself repeatedly denied in later life that his "little heroine" was based on any real child, and he frequently dedicated his works to girls of his acquaintance, adding their names in acrostic poems at the beginning of the text. Gertrude Chataway's name appears in this form

at the beginning of *The Hunting of the Snark*, but it is not suggested that this means that any of the characters in the narrative are based on her.

Information is scarce since his diaries for the years 1858-1862 are missing, but it seems clear that his friendship with the Liddell family was an important part of his life in the late 1850s, and he grew into the habit of taking the children on rowing trips (first the boy, Harry, and later the three girls) accompanied by an adult friend to nearby Nuneham Courtenay or Godstow.

It was on one such expedition on July 4, 1862 that Dodgson invented the outline of the story that eventually became his first and greatest commercial success. He told the story to Alice Liddell and she begged him to write it down, and Dodgson eventually presented her with a handwritten, illustrated manuscript entitled *Alice's Adventures Under Ground* in November 1864.

Before this, the family of friend and mentor George MacDonald read Dodgson's incomplete manuscript, and the enthusiasm of the MacDonald children encouraged Dodgson to seek publication. In 1863, he had taken the unfinished manuscript to Macmillan, the publisher, who liked it immediately. After the possible alternative titles were rejected - Alice Among the Fairies and Alice's Golden Hour - the work was finally published as *Alice's Adventures in Wonderland* in 1865 under the Lewis Carroll pen-name. The illustrations this time were by Sir John Tenniel; Dodgson evidently thought that a published book would need the skills of a professional artist. Annotated versions provide insights into many of the ideas and hidden meanings that are prevalent in these books. Critical literature has often proposed Freudian interpretations of the book as "a descent into the dark world of the subconscious", as well as seeing it as a satire upon contemporary mathematical advances.

The overwhelming commercial success of the first Alice book changed Dodgson's life in many ways. The fame of his alter ego "Lewis Carroll" soon spread around the world. He was inundated with fan mail and with sometimes unwanted attention. Indeed, according to one popular story, Queen Victoria herself enjoyed *Alice in Wonderland* so much that she commanded that he send his next book to her, and was accordingly presented with his next work, a scholarly mathematical volume entitled *An Elementary Treatise on Determinants*. Dodgson himself vehemently denied this story, commenting "... It is utterly false in every particular: nothing even resembling it has occurred"; and it is unlikely for other reasons. As T. B. Strong comments in a Times article, "It would have been clean contrary to all his practice to identify [the] author of Alice with the author of his mathematical works." He also began earning quite substantial sums of money but continued with his seemingly disliked post at Christ Church.

Late in 1871, he published the sequel *Through the Looking-Glass, and What Alice Found There*. The title page of the first edition erroneously gives "1872" as the date of publication. Its somewhat darker mood possibly reflects changes in Dodgson's life. His father's death in 1868 plunged him into a depression that lasted some years.

The Hunting of the Snark

In 1876, Dodgson produced his next great work, *The Hunting of the Snark*, a fantastical "nonsense" poem, with illustrations by Henry Holiday, exploring the adventures of a bizarre crew of nine tradesmen and one beaver, who set off to find the snark. It received largely mixed reviews from Carroll's contemporary reviewers, but was enormously popular with the public, having been reprinted seventeen times between 1876 and 1908, and has seen various adaptations into musicals, opera, theatre, plays and music. Painter Dante Gabriel Rossetti reputedly became convinced that the poem was about him.

Sylvie and Bruno

In 1889, 30 years after the publication of his masterpieces, Carroll attempted a comeback, producing a two-volume tale of the fairy siblings Sylvie and Bruno. Carroll entwines two plots set in two alternative worlds, one set in rural England and the other in the fairytale kingdoms of Elfland, Outland, and others. The fairytale world satirizes English society, and more specifically the world of academia. *Sylvie and Bruno* came out in two volumes and is considered a lesser work, although it has remained in print for over a century.

Photography (1856-1880)

According to his diary, Dodgson took his first photograph on June 3, 1856 under the influence first of his uncle Skeffington Lutwidge, and later of his Oxford friend Reginald Southey. He soon excelled at the art and became a well-known gentleman-photographer, and he seems even to have toyed with the idea of deriving income out of it in his very early years.

Dodgson's favorite subjects were children, especially girls, but he also made many studies of men, women, and landscapes; his subjects also include skeletons, dolls, dogs, statues, paintings, and trees. His pictures of children were taken with a parent often in attendance and many of the pictures were taken in the Liddell garden because natural sunlight was required for good exposures.

He used the wet collodion[1] process which requires the photographic material to be coated, sensitized, exposed, and developed within the span of about fifteen minutes, necessitating a portable darkroom for use in the field.

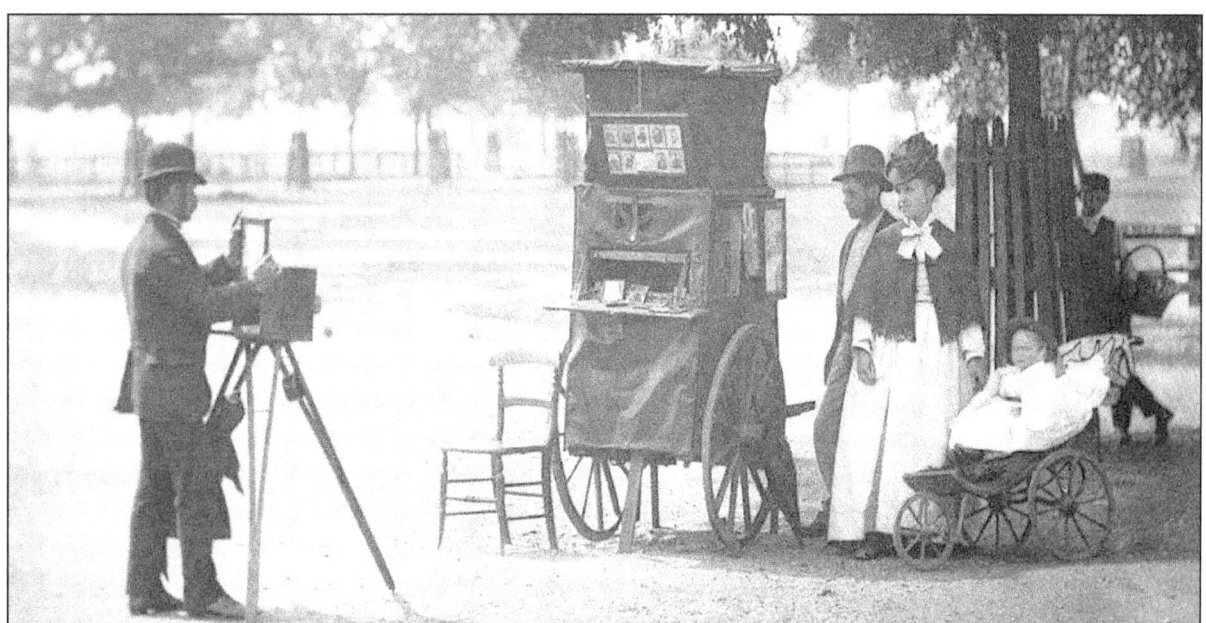

Example 19th century outdoor photo session with a camera and portable darkroom (John Thomson)

He also found photography to be a useful entrée into higher social circles. During the most productive part of his career, he made portraits of notable sitters such as John Everett Millais, Ellen Terry, Dante Gabriel Rossetti, Michael Faraday, Lord Salisbury, and Alfred Tennyson.

Although he continued to travel to various outdoor locations to take photographs, in 1863 he acquired a studio in Badcock's Yard across St. Aldate's from his quarters and used it until 1872. About 275 of his existing photographs were taken there. In 1872, he established his own studio on the roof of above his living quarters. With the permission of the college authorities he had a studio constructed which included a room for photography, a dressing room for his sitters and an interior stairway from his quarters below. And it was heated. His first photo there was one of Julia Arnold which he took on March 17, 1872 and almost all of his subsequent photographs were taken there. Approximately 375 photographs from this studio remain. Dodgson's diary records his last photograph as being taken on July 15th, 1880. Dodgson gave up photography because, he writes, "of the effort required for

[1] Carroll used two of the more popular 19th century photographic processes, wet-collodion glass plate negatives and albumen prints. The wet-collodion process is one of the earliest photographic processes. Photographers created their own negatives from glass plates which they coated with a solution of collodion (cellulose nitrate) and a soluble iodide. The plate was then immersed in a solution of silver nitrate in the darkroom. The plate was still wet when exposed and then immediately developed and fixed. Finally, a protective varnish was applied. When working in the field, photographers needed to use portable darkrooms, in many cases horse-drawn wagons. In the 1860s through the mid-1880s, albumen was the dominant print format. To create albumen prints, paper was floated in a mixture of fermented chloride and egg white, dried and then floated on a solution of silver nitrate. The paper would then be placed in a frame in direct contact with the negative. Sunlight was used during the exposure process. Carroll had three cameras with adjustable plate holders so he could create glass plate negatives in various sizes. He used six plate sizes ranging from 3¼"x4¼" to 8"x10".

purchasing the chemicals, getting out the photographic equipment, preparing the studio and the other preparitory needs". He knew that if he wanted a photograph taken, he could take the sitter to the ever growing number of photographers everywhere and have the picture taken for him. He often did this during his summer holidays in Eastbourne where he spent his summers from 1877 until 1897, a year before he died.

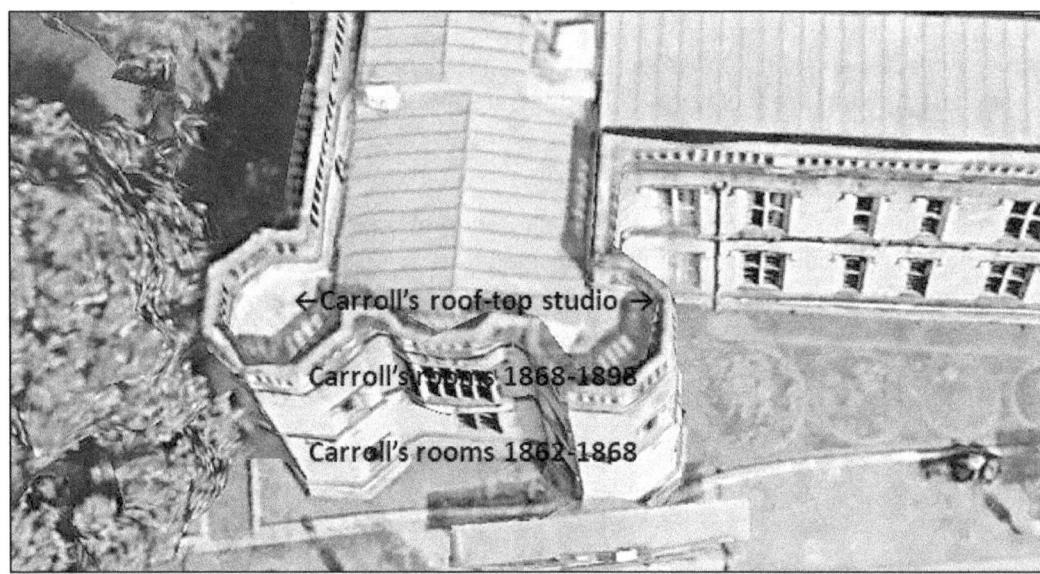

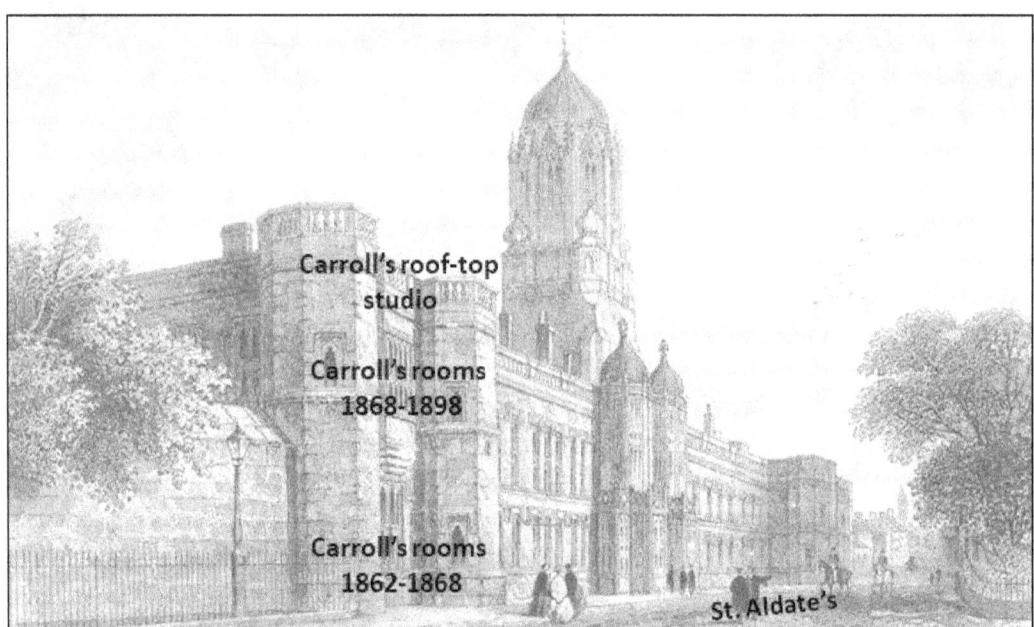

Two views of the west front of Christ Church fronting on St.Aldate's

Five of Carroll's hand-colored nude photographs are included in this volume. All are watercolors painted by Anne Lydia Bond (1822-1881) under Carroll's supervision. Bond was an author, an artist and a photographic colorist.

The three nude photographs of the Hatch sisters and the one of the Henderson sisters first came to public notice in 1978 when they were displayed in an exhibit at Philadelphia's Rosenbach Museum and appeared in print for the first time in Morton Cohen's *Lewis Carroll, Photographer of Children: Four Nude Studies*, a short book published in conjunction with the exhibit.

Quoting from the New York Times June 27, 1978 issue, "In all four pictures, an imaginary outdoor landscape or seascape background has been painted in as a setting for the figures photographed in the studio. One of the pictures is actually a watercolor drawing,… by Anne Lydia Bond … ,who probably used tracing paper to reproduce the figure of the subject, a girl named Beatrice Hatch. She is shown seated on a rock at the seaside (see page 57).

Another picture, depicting Beatrice's sister, Evelyn, is photographically printed on curved glass, painted with oils on the underside and mounted on another glass plate on which more details have been painted in oils. This is the most openly provocative of the nude pictures, showing a full figure reclining in a landscape (see page 58)."

"In the other two pictures (see), where the paint has been applied directly to albumen prints, there are fanciful backgrounds that hint at exotic scenarios. In one, the girl is shown seated beside a tree at the water's edge with a gypsy encampment in the distance. In the other, two little girls—one seated and one standing—are shown beside the sea, with an image of a shipwreck in the distance."

The fifth picture (see page 60), the one of Annie Henderson, first appeared in print in Diane Waggoner's book *Lewis Carroll's Photography and Modern Childhood*.

A discussion of Lewis Carroll's photography would not be complete without reference to the now infamous photograph in Museé Cantini located in Marseille, France. The photograph is a full frontal nude image of a 14 year girl alleged to be Lorina Liddell photographed by Lewis Carroll[2]. The photo has been examined by experts and pseudo-experts in various pertinent fields. The photo has been determined to be genuine in the sense that it was produced by the wet collodion process using the type of camera and paper Carroll (and many others) would have used, and dates from the period when Carroll was an active photographer. The only direct Carroll connection is the writing on the reverse side of the image.

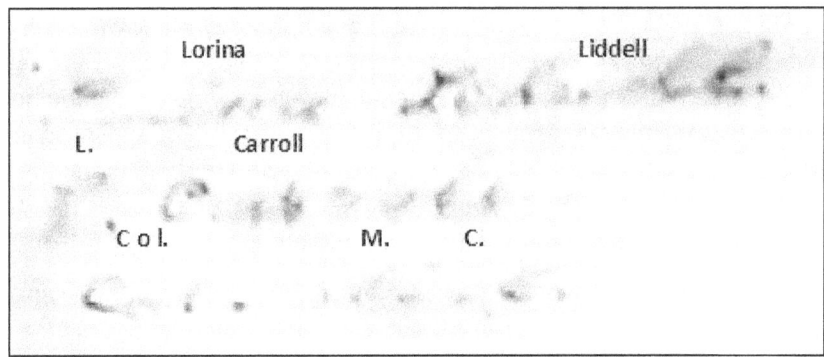

Writing on the reverse side of the alleged Lorina Liddell photograph

Col. is an abbreviation for collection and M. C. could refer to the Musee Cantini, although the museum claims not. It is mostly likely a photograph dealer's notation. As far as facial image analysis is concerned, the consensus is that it could be Lorina Liddell but no one will say so definitively. The image on the left is Lorina Liddell at the age of 20; the one on the right is of the unknown teenager at about the age of 14.

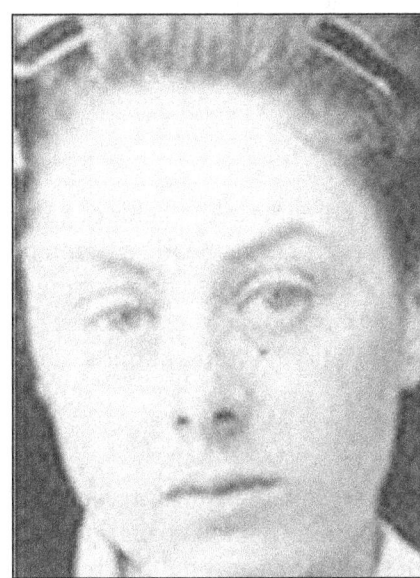 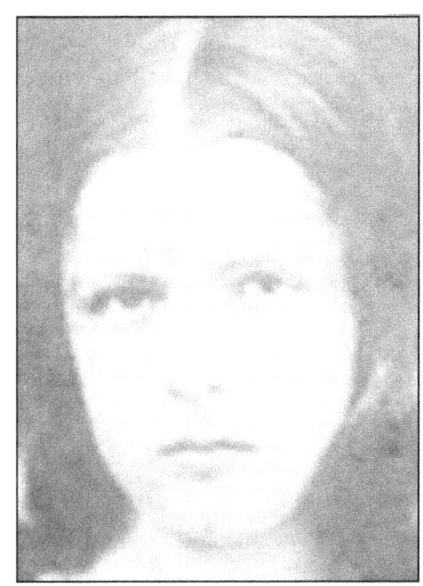

[2] The full image may be seen at https://www.mediastorehouse.com/fine-art-finder/artists/french-school/portrait-lorina-liddell-alices-sister-25235578.html?mp=1

The museum denies that the photo is the work of Lewis Carroll as does Edward Wakeling, probably the most respected expert in Carrollian photography, who examined the picture in 1993. In short, there is nothing that precludes the work from being Carroll's or an image of Liddell, but there is nothing to establish the validity of either assertion.

Inventions

To promote letter writing, Dodgson invented "The Wonderland Postage-Stamp Case" in 1889. This was a cloth-backed folder with twelve slots, two marked for inserting the most commonly used penny stamp, and one each for the other current denominations up to one shilling. The folder was then put into a slipcase decorated with a picture of Alice on the front and the Cheshire Cat on the back. It intended to organize stamps wherever one stored their writing implements; Carroll expressly notes in "Eight or Nine Wise Words about Letter-Writing" it is not intended to be carried in a pocket or purse, as the most common individual stamps could easily be carried on their own. The pack included a copy of a pamphlet version of this lecture.

Another invention was a writing tablet called the nyctograph that allowed note-taking in the dark, thus eliminating the need to get out of bed and strike a light when one woke with an idea. The device consisted of a gridded card with sixteen squares and a system of symbols representing an alphabet of Dodgson's design, using letter shapes similar to the Graffiti writing system on a Palm device.

He also devised a number of games, including an early version of what today is known as Scrabble. Devised some time in 1878, he invented the "doublet" a form of brain-teaser that is still popular today, changing one word into another by altering one letter at a time, each successive change always resulting in a genuine word. For instance, CAT is transformed into DOG by the following steps: CAT, COT, DOT, DOG. It first appeared in the 29 March 1879 issue of Vanity Fair, with Carroll writing a weekly column for the magazine for two years; the final column dated 9 April 1881. The games and puzzles of Lewis Carroll were the subject of Martin Gardner's March 1960 Mathematical Games column in Scientific American and of numbers of books as well.

Other items include a rule for finding the day of the week for any date; a means for justifying right margins on a typewriter; a steering device for a velociman (a type of tricycle); fairer elimination rules for tennis tournaments; a new sort of postal money order; rules for reckoning postage; rules for a win in betting; rules for dividing a number by various divisors; a cardboard scale for the Senior Common Room at Christ Church which, held next to a glass, ensured the right amount of liqueur for the price paid; a double-sided adhesive strip to fasten envelopes or mount things in books; a device for helping a bedridden invalid to read from a book placed sideways; and at least two ciphers for cryptography.

He also proposed alternative systems of parliamentary representation. He proposed the so-called Dodgson's method, using the Condorcet method. In 1884, he proposed a proportional representation system based on multi-member districts, each voter casting only a single vote, quotas as minimum requirements to take seats, and votes transferable by candidates through what is now called liquid democracy.

Mathematical work

Within the academic discipline of mathematics, Dodgson worked primarily in the fields of geometry, linear and matrix algebra, mathematical logic, and recreational mathematics, producing nearly a dozen books under his real name. Dodgson also developed new ideas in linear algebra (e.g., the first printed proof of the Kronecker-Capelli theorem), probability, and the study of elections (e.g., Dodgson's method) and committees; some of this work was not published until well after his death. His occupation as Mathematical Lecturer at Christ Church gave him some financial security.

Mathematical logic

His work in the field of mathematical logic attracted renewed interest in the late 20th century. Martin Gardner's book on logic machines and diagrams and William Warren Bartley's posthumous publication of the second part of Dodgson's symbolic logic book have sparked a reevaluation of Dodgson's contributions to symbolic logic. It is recognized that in his *Symbolic Logic Part II*, Dodgson introduced the Method of Trees, the earliest modern use of a truth tree.

Algebra

Robbins' and Rumsey's investigation of Dodgson condensation, a method of evaluating determinants, led them to the alternating sign matrix conjecture, now a theorem.

Recreational mathematics

The discovery in the 1990s of additional ciphers that Dodgson had constructed, in addition to his "Memoria Technica", showed that he had employed sophisticated mathematical ideas in their creation.

Correspondence

Dodgson wrote and received as many as 98,721 letters, according to a special letter register which he devised. He documented his advice about how to write more satisfying letters in a missive entitled "Eight or Nine Wise Words about Letter-Writing".

Sexuality

Some late twentieth-century biographers have suggested that Dodgson's interest in children had an erotic element, including Morton N. Cohen in his *Lewis Carroll: A Biography* (1995), Donald Thomas in his *Lewis Carroll: A Portrait with Background*, and Michael Bakewell in his *Lewis Carroll: A Biography* (1996). Cohen, in particular, speculates that Dodgson's "sexual energies sought unconventional outlets", and further writes: "We cannot know to what extent sexual urges lay behind Charles's preference for drawing and photographing children in the nude. He contended the preference was entirely aesthetic. But given his emotional attachment to children as well as his aesthetic appreciation of their forms, his assertion that his interest was strictly artistic is naïve. He probably felt more than he dared acknowledge, even to himself."

Cohen goes on to note that Dodgson "apparently convinced many of his friends that his attachment to the nude female child form was free of any eroticism", but adds that "later generations look beneath the surface". He argues that Dodgson may have wanted to marry the 11-year-old Alice Liddell and that this was the cause of the unexplained "break" with the family in June 1863, an event for which other explanations are offered. Biographers Derek Hudson and Roger Lancelyn Green stop short of identifying Dodgson as a pedophile, but they concur that he had a passion for small female children and next to no interest in the adult world. Catherine Robson refers to Carroll as "the Victorian era's most famous (or infamous) girl lover".

Several other writers and scholars have challenged the evidential basis for Cohen's and others' views about Dodgson's sexual interests. Hugues Lebailly has endeavored to set Dodgson's child photography within the "Victorian Child Cult", which perceived child nudity as essentially an expression of innocence. Lebailly claims that studies of child nudes were mainstream and fashionable in Dodgson's time and that most photographers made them as a matter of course, including Oscar Gustave Rejlander and Julia Margaret Cameron. Lebailly continues that child nudes even appeared on Victorian Christmas cards, implying a very different social and aesthetic assessment of such material. Lebailly concludes that it has been an error of Dodgson's biographers to view his child-photography with 20th- or 21st-century eyes, and to have presented it as some form of personal idiosyncrasy, when it was a response to a prevalent aesthetic and philosophical movement of the time.

Karoline Leach's reappraisal of Dodgson focused in particular on his controversial sexuality. She argues that the allegations of pedophilia rose initially from a misunderstanding of Victorian morals, as well as the mistaken idea - fostered by Dodgson's various biographers - that he had no interest in adult women. She termed the traditional image of Dodgson "the Carroll Myth". She drew attention to the large amounts of evidence in his diaries and letters that he was also keenly interested in adult women, married and single, and enjoyed several relationships with them that would have been considered scandalous by the social standards of his time. Gertrude Chataway, for example, stayed with him at Eastbourne in September of 1893. Leach also pointed to the fact that many of those whom he described as "child-friends" were girls in their late teens and even twenties. She argues that suggestions of pedophilia emerged only many years after his death, when his well-meaning family had suppressed all evidence of his relationships with women in an effort to preserve his reputation, thus giving a false impression of a man interested only in little girls. Similarly, Leach points to a 1932 biography by Langford Reed as the source of the dubious claim that many of Carroll's female friendships ended when the girls reached the age of fourteen.

In Stuart Dodgson Collingwood's *The Life and Letter of Lewis Carroll* he writes of Carroll's last book, *Three Sunsets*, "One cannot read this little volume without feeling that the shadow of some disappointment lay over Lewis Carroll's life. Such I believe to have been the case, and it was this that gave him his wonderful sympathy with all who suffered. But those who loved him would not wish to lift the veil from these dead sanctities, nor would any purpose be served by so doing." Several other writers about Carroll view this passage as a veiled reference to a failed love affair; further affirming Carroll's interest in adult women.

In addition to the biographical works that have discussed Dodgson's sexuality, there are modern artistic interpretations of his life and work that do so as well - in particular, Dennis Potter in his play *Alice* and his screenplay for the motion picture *Dreamchild*, and Robert Wilson in his musical *Alice*.

Ordination

Dodgson had been groomed for the ordained ministry in the Church of England from a very early age and was expected to be ordained within four years of obtaining his master's degree, as a condition of his residency at Christ Church. He delayed the process for some time but was eventually ordained as a deacon on 22 December 1861. But when the time came a year later to be ordained as a priest, Dodgson appealed to the dean for permission not to proceed. This was against college rules and, initially, Dean Liddell told him that he would have to consult the college ruling body, which would almost certainly have resulted in his being expelled. For unknown reasons, Liddell changed his mind overnight and permitted him to remain at the college in defiance of the rules. Dodgson never became a priest, unique amongst senior students of his time.

There is currently no conclusive evidence about why Dodgson rejected the priesthood. Some have suggested that his stammer made him reluctant to take the step because he was afraid of having to preach. Wilson quotes letters by Dodgson describing difficulty in reading lessons and prayers rather than preaching in his own words. But Dodgson did indeed preach in later life, even though not in priest's orders, so it seems unlikely that his impediment was a major factor affecting his choice. Wilson also points out that the Bishop of Oxford, Samuel Wilberforce, who ordained Dodgson, had strong views against clergy going to the theatre, one of Dodgson's great interests. He was interested in minority forms of Christianity and "alternative" religions, e.g. theosophy. Dodgson became deeply troubled by an unexplained sense of sin and guilt in the early 1860s and frequently expressed the view in his diaries that he was a "vile and worthless" sinner, unworthy of the priesthood and this sense of sin and unworthiness may well have affected his decision to abandon being ordained to the priesthood.

Missing diaries

At least four complete volumes and around seven pages of text are missing from Dodgson's 13 diaries. The loss of the volumes remains unexplained; the pages have been removed by an unknown hand. Most scholars assume that the diary material was removed by family members in the interests of preserving the family name, but this has not been proven. Except for one page, material is missing from his diaries for the period between 1853 and 1863, when Dodgson was 21-31 years old. During this period, Dodgson began experiencing great mental and spiritual anguish and confessing to an overwhelming sense of his own sin. This was also the period of time when he composed his extensive love poetry, leading to speculation that the poems may have been autobiographical. Many theories have been put forward to explain the missing material. A popular explanation for one missing page (27 June 1863) is that it might have been torn out to conceal a proposal of marriage on that day by Dodgson to the 11-year-old Alice Liddell. However, there has never been any evidence to suggest that this was so, and a paper offers some evidence to the contrary which was discovered by Karoline Leach in the Dodgson family archive in 1996.

This paper is known as the "cut pages in diary" document, and was compiled by various members of Carroll's family after his death. Part of it may have been written at the time when the pages were destroyed, though this is unclear. The document offers a brief summary of two diary pages that are missing, including the one for 27 June 1863. The summary for this page states that Mrs. Liddell told Dodgson that there was gossip circulating about him and the Liddell family's governess, as well as about his relationship with "Ina", Alice's older sister Lorina Liddell. The "break" with the Liddell family that occurred soon after was presumably in response to this gossip. An alternative interpretation has been made regarding Carroll's rumored involvement with "Ina": Lorina was also the name of Alice Liddell's mother. What is deemed most crucial and surprising is that the document seems to imply that

Dodgson's break with the family was not connected with Alice at all; until a primary source is discovered, the events of 27 June 1863 will remain in doubt.

Later years

Dodgson's existence remained little changed over the last twenty years of his life, despite his growing wealth and fame. He continued to teach at Christ Church until 1881 and remained in residence there until his death. Public appearances included attending the West End musical *Alice in Wonderland*, the first major live production of his Alice books, at the Prince of Wales Theatre on December 30, 1886. The two volumes of his last novel, *Sylvie and Bruno*, were published in 1889 and 1893, but the intricacy of this work was apparently not appreciated by contemporary readers; it achieved nothing like the success of the Alice books, with disappointing reviews and sales of only 13,000 copies.

The only known occasion on which he travelled abroad was a trip to Russia in 1867 as an ecclesiastic, together with the Reverend Henry Liddon. He recounts the travel in his "Russian Journal", which was first commercially published in 1935. On his way to Russia and back, he also visited Belgium, Germany, partitioned Poland, and France.

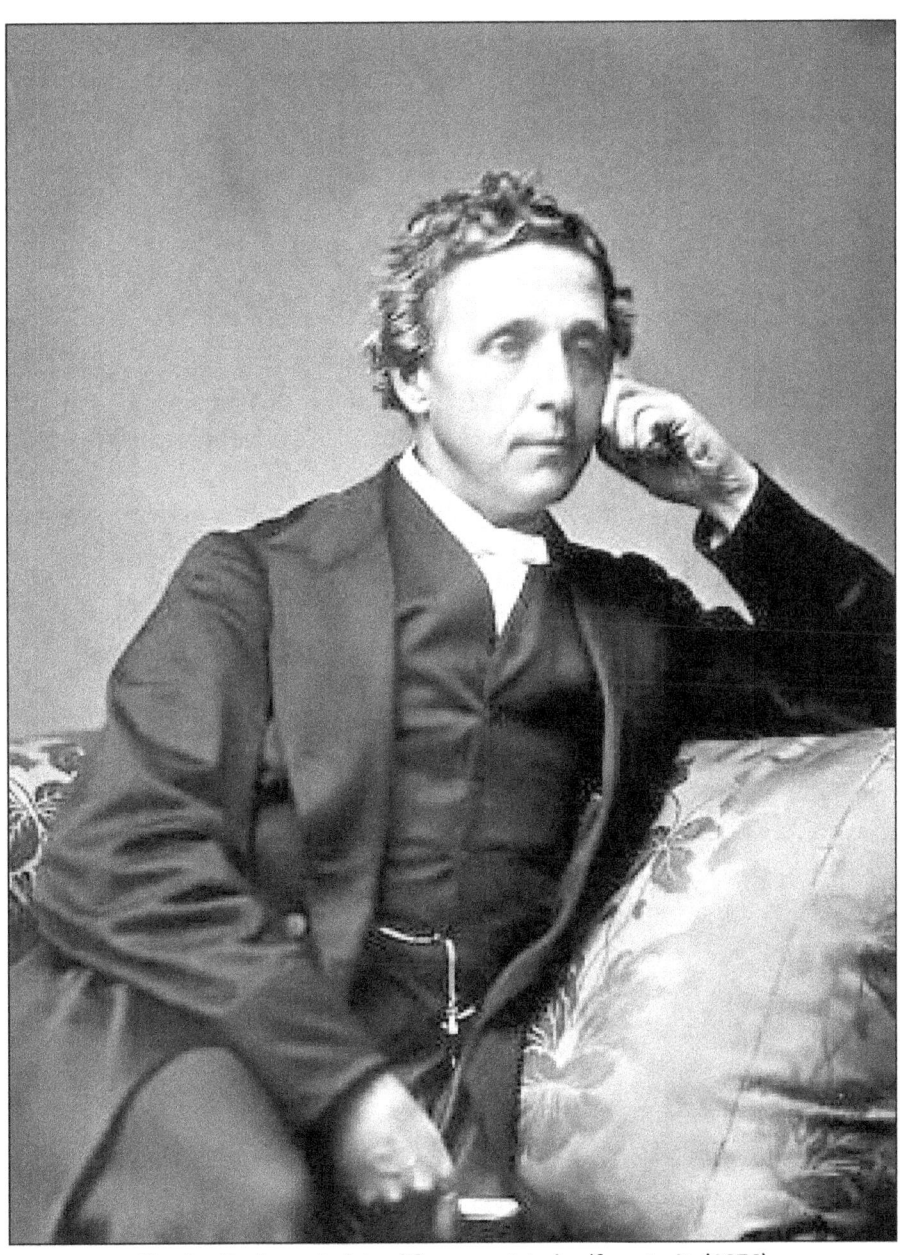

Charles Dodgson in later life, an assisted self-portrait (1876)

Death

Dodgson died of pneumonia following influenza on 14 January 1898 at his sisters' home, "The Chestnuts", in Guildford in the county of Surrey, just four days before the death of Henry Liddell. He was two weeks away from turning 66 years old. His funeral was held at the nearby St Mary's Church. His body was buried at the Mount Cemetery in Guildford. Interestingly, all of his siblings survived into the 20th century.

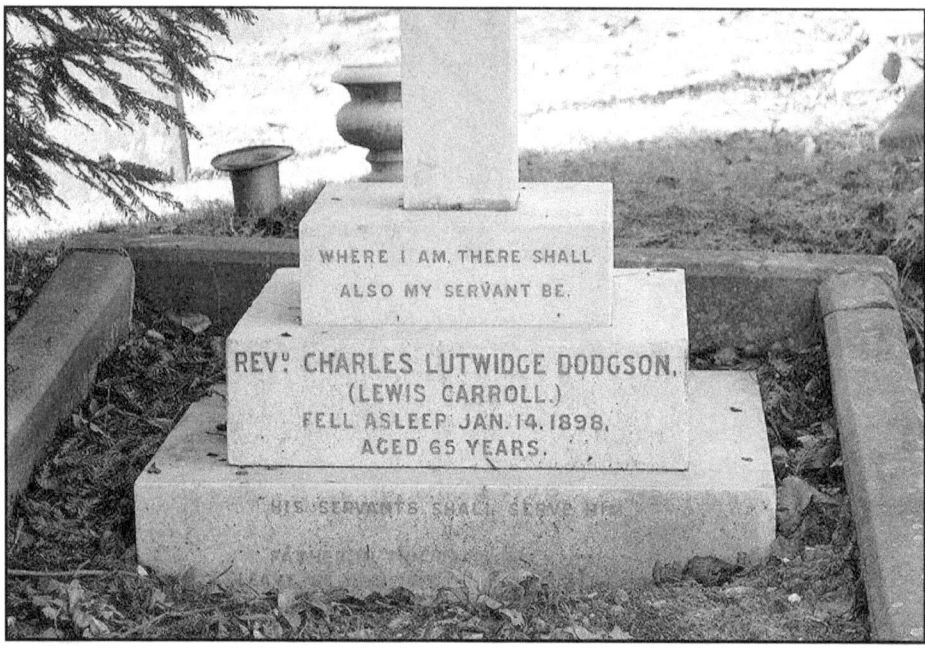

Memorials

Born in All Saints' Vicarage, Daresbury, Cheshire, in 1832, Lewis Carroll is commemorated at All Saints' Church, Daresbury in its stained glass windows depicting characters from Alice's Adventures in Wonderland. In March 2012, the Lewis Carroll Centre, attached to the church, was opened.

Lewis Carroll memorial window (Mad Hatter, Dormouse and March Hare pictured) at All Saints' Church, Daresbury, Cheshire (unidentified artist)

There are societies in many parts of the world dedicated to the enjoyment and promotion of Carroll's works and the investigation of his life. Copenhagen Street in Islington, north London is the location of the Lewis Carroll Children's Library.

In 1982, his great-nephew unveiled a memorial stone to him in Poets' Corner, Westminster Abbey.

Memorial stone in Westminster Abbey

In January 1994, an asteroid was discovered and named 6984 Lewiscarroll after Carroll. The Lewis Carroll Centenary Wood near his birthplace in Daresbury opened in 2000.

Legacy

Youthful Writings
The Rectory Magazine [manuscript] (C1848)
The Rectory Umbrella [manuscript - published 1932] (C1850-53)
Mischmasch [manuscript with press cuttings - published 1932] (1855-1862)

Literary works
La Guida di Bragia, a Ballad Opera for the Marionette Theatre (around 1850)
"Miss Jones", comic song (1862)
Alice's Adventures in Wonderland (1865)
Phantasmagoria and Other Poems (1869)
Through the Looking-Glass, and What Alice Found There (includes "Jabberwocky" and "The Walrus and the Carpenter") (1871)
The Hunting of the Snark (1876)
Rhyme? And Reason? (1883) - shares some contents with the 1869 collection, including the long poem "Phantasmagoria"
A Tangled Tale (1885)
Sylvie and Bruno (1889)
The Nursery "Alice" (1890)

Sylvie and Bruno Concluded (1893)
What the Tortoise Said to Achilles (1895)
Three Sunsets and Other Poems (1898)
The Manlet (1903)

Mathematical works
A Syllabus of Plane Algebraic Geometry (1860)
The Fifth Book of Euclid Treated Algebraically (1858 and 1868)
An Elementary Treatise on Determinants, With Their Application to Simultaneous Linear Equations and Algebraic Equations (1867)
Euclid and his Modern Rivals (1879)
Symbolic Logic Part I (1896)
Symbolic Logic Part II (published posthumously in 1977)
The Alphabet Cipher (1868)
The Game of Logic (1887)
Curiosa Mathematica I (1888, 1889, 1890 and 1895)
Curiosa Mathematica II [Pillow Problems] (1893, 1893 again, 1894 and 1895))

Other works
Some Popular Fallacies about Vivisection (1875)
Eight or Nine Wise Words About Letter-Writing (1890)
Notes by an Oxford Chiel (1865-1874)
The Principles of Parliamentary Representation (1884)
Doublets - a word game (1879)
Memoria Technica (1877)
Christmas Greetings from a Fairy to a Child(1884)
The Guildford Gazette Extraordinary (1869)
An Easter Greeting to Every Child who loves Alice (1876)
Useful and Instructive Poetry (manuscript - published 1954) (1845)
Isa's Visit to Oxford [in 1888] (1899)

Photography related
Photography Extrordinary (1855)
Hiawatha's Photographing (1857)
The Legend of Scotland (1858-1860)
A Photographers Day Out (1860)

Other Posthumous Publications
Isa's Visit to Oxford (1888). A humorous diary written out by Carroll for Isa Bowman recording events which took place during a visit which Isa made to stay with Carroll in Oxford. (1899)
Maggie's Visit to Oxford (1889). Similar to Isa's Visit, although this account of Maggie's visit is entirely in verse.
Feeding the Mind (a printing of a lecture delivered 1884) (1907)

Carroll's Photographic Sitters

Liddell siblings (Alice, Lorina, Edith and Harry)

Alice Liddell

Alice Pleasance Hargreaves (née Liddell), May 4, 1852 – November 16, 1934, was an Englishwoman who, in her childhood, was an acquaintance and photography subject of Lewis Carroll. One of the stories he told her during a boating trip became the children's classic 1865 novel *Alice's Adventures in Wonderland*. She shared her name with "Alice", the heroine of the story, but scholars disagree about the extent to which the character was based on her.

Early life

Alice Liddell was the fourth of the ten children of Henry Liddell, ecclesiastical dean of Christ Church, Oxford, one of the editors of A Greek-English Lexicon, and his wife Lorina Hanna Liddell (née Reeve). She had two older brothers, Harry (born 1847) and Arthur (1850–53), an older sister Lorina (born 1849), and six younger siblings, including her sister Edith (born 1854) to whom she was very close and her brother Frederick (born 1865), who became a lawyer and senior civil servant.

At the time of her birth, her father was the Headmaster of Westminster School but was soon after appointed to the deanery of Christ Church, Oxford. The Liddell family moved to Oxford in 1856. Soon after this move, Alice met Charles Lutwidge Dodgson (Lewis Carroll), who encountered the family while he was photographing the cathedral on 25 April 1856. He became a close friend of the Liddell family in subsequent years.

Alice was three years younger than Lorina and two years older than Edith, and the three sisters were constant childhood companions. She and her family regularly spent holidays at their holiday home Penmorfa, which later became the Gogarth Abbey Hotel, on the West Shore of Llandudno in North Wales.

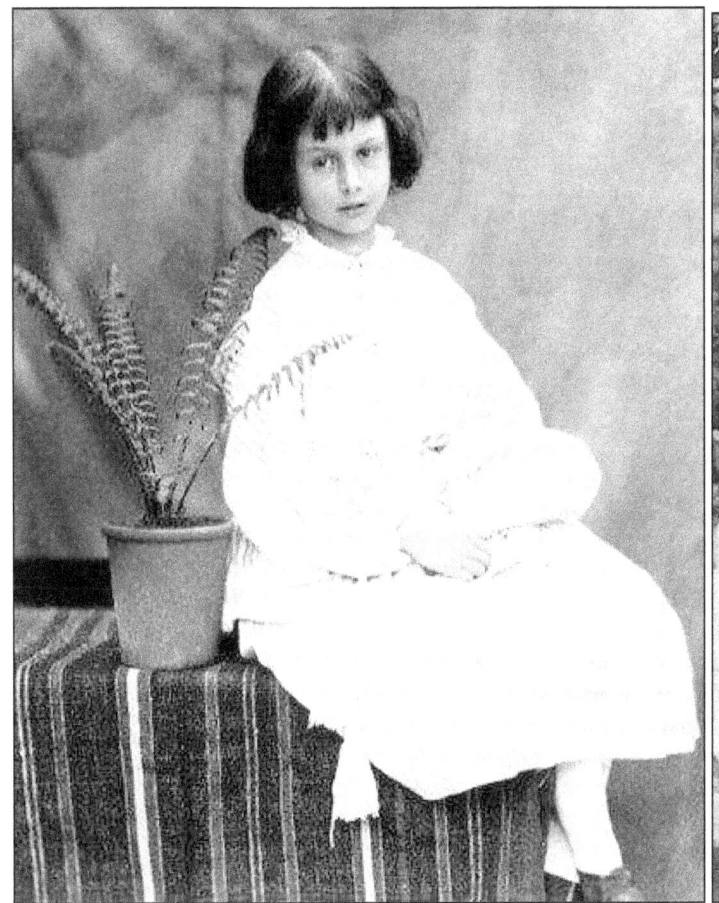
Alice Liddell, age 8 (July 1860)

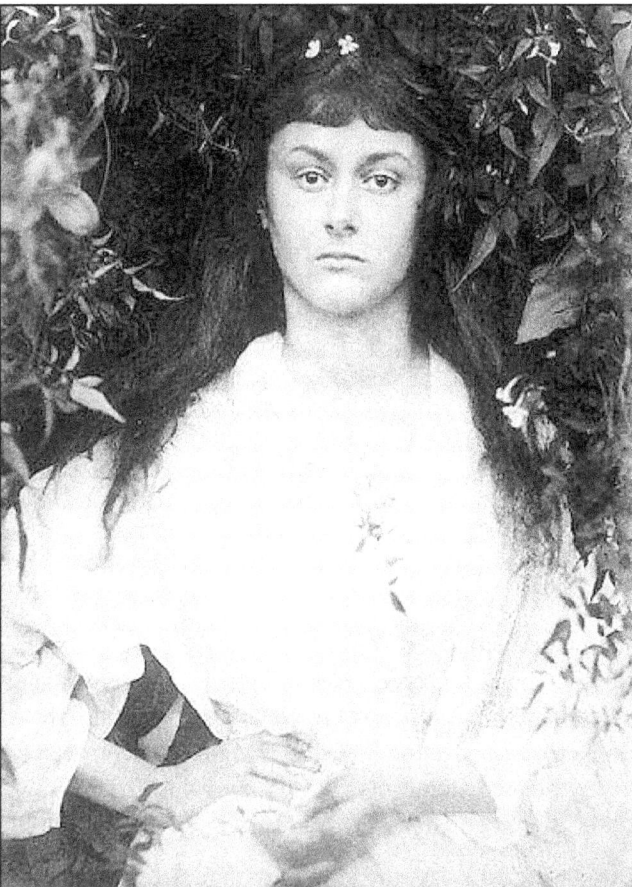
Alice Liddell, age 20 (Julia Margaret Cameron)

When Alice Liddell was a young woman, she set out on a grand tour of Europe with Lorina and Edith. One story has it that she became a romantic interest of Prince Leopold, the youngest son of Queen Victoria, during the four years he spent at Christ Church, but the evidence for this is sparse. It is true that years later, Leopold named his first child Alice, and acted as godfather to Alice's second son Leopold. However, it is possible Alice was named in honor of Leopold's deceased elder sister instead, the Grand Duchess of Hesse.

A recent biographer of Leopold suggests it is far more likely that Alice's sister Edith was the true recipient of Leopold's attention. Edith died on 26 June 1876, possibly of measles or peritonitis (accounts differ), shortly before she was to be married to Aubrey Harcourt, a cricket player. At her funeral on 30 June 1876, Prince Leopold served as a pall-bearer.

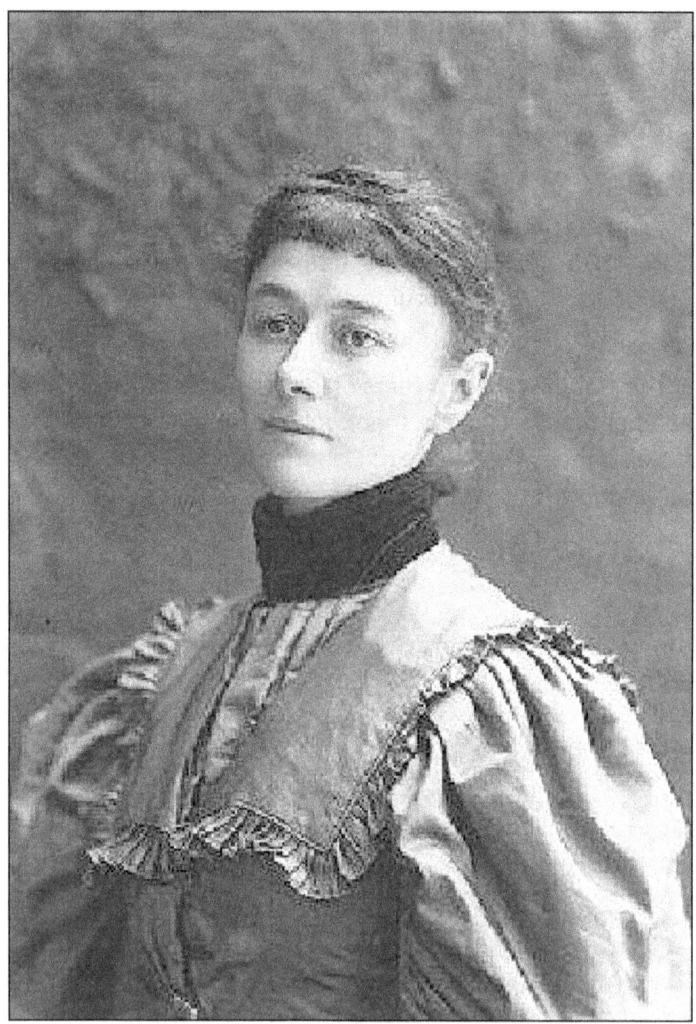

Alice in her late 30s' (Henry Bullingham)

Later life

Alice Liddell married Reginald Hargreaves, a cricketer, on September 15, 1880, at the age of 28 in Westminster Abbey. They had three sons: Alan Knyveton Hargreaves and Leopold Reginald "Rex" Hargreaves who were both killed in action in World War I; and Caryl Liddell Hargreaves, who survived to have a daughter of his own. Liddell denied that the name 'Caryl' was in any way associated with Charles Dodgson's pseudonym. Reginald Hargreaves inherited a considerable fortune, and was a local magistrate; he also played cricket for Hampshire. Alice became a noted society hostess and was the first president of Emery Down Women's Institute.

During World War I she joined the Red Cross as a volunteer, for which she was awarded a medal which is currently on display in the Museum of Oxford.

After her husband's death in 1926, the cost of maintaining their home, Cuffnells, was such that she deemed it necessary to sell her copy of Alice's Adventures under Ground, Lewis Carroll's earlier title for Alice's Adventures in

Wonderland. The manuscript fetched £15,400 an equivalent to £1,000,000 in 2021, and nearly four times the reserve price given to it by Sotheby's auction house. It later became the possession of Eldridge R. Johnson and was displayed at Columbia University on the centennial of Carroll's birth. It is now in the British Library.

In May 1932 Alice Pleasance Hargreaves, the "Alice" of Lewis Carroll's works, came to New York City and Columbia University, in particular, to help celebrate the 100th anniversary of Lewis Carroll's birth. Festivities at the University included an exhibition held in the Avery Library of "Carrolliana" assembled from collectors throughout the country.

Mrs. Hargreaves' participation took two forms. On May 2, in a private ceremony, she was awarded an honorary Doctor of Letters degree by Columbia President Nicholas Murray Butler in the Rotunda of Low Memorial Library. In her acceptance speech, Mrs. Hargreaves said: "I shall remember it and prize it for the rest of my days, which may not be very long. I love to think, however unworthy I am, that Mr. Dodgson – Lewis Carroll – knows and rejoices with me."

On May 4, 1932, in the University Gymnasium, she was the guest of honor at the Final ceremony in the Carroll Centennial celebrations – which coincided with her own 80th birthday. Mrs. Hargreaves, President Butler and Professor Harry M. Ayers of the Department of English all spoke at the ceremony attended by some 2,000 guests of the University.

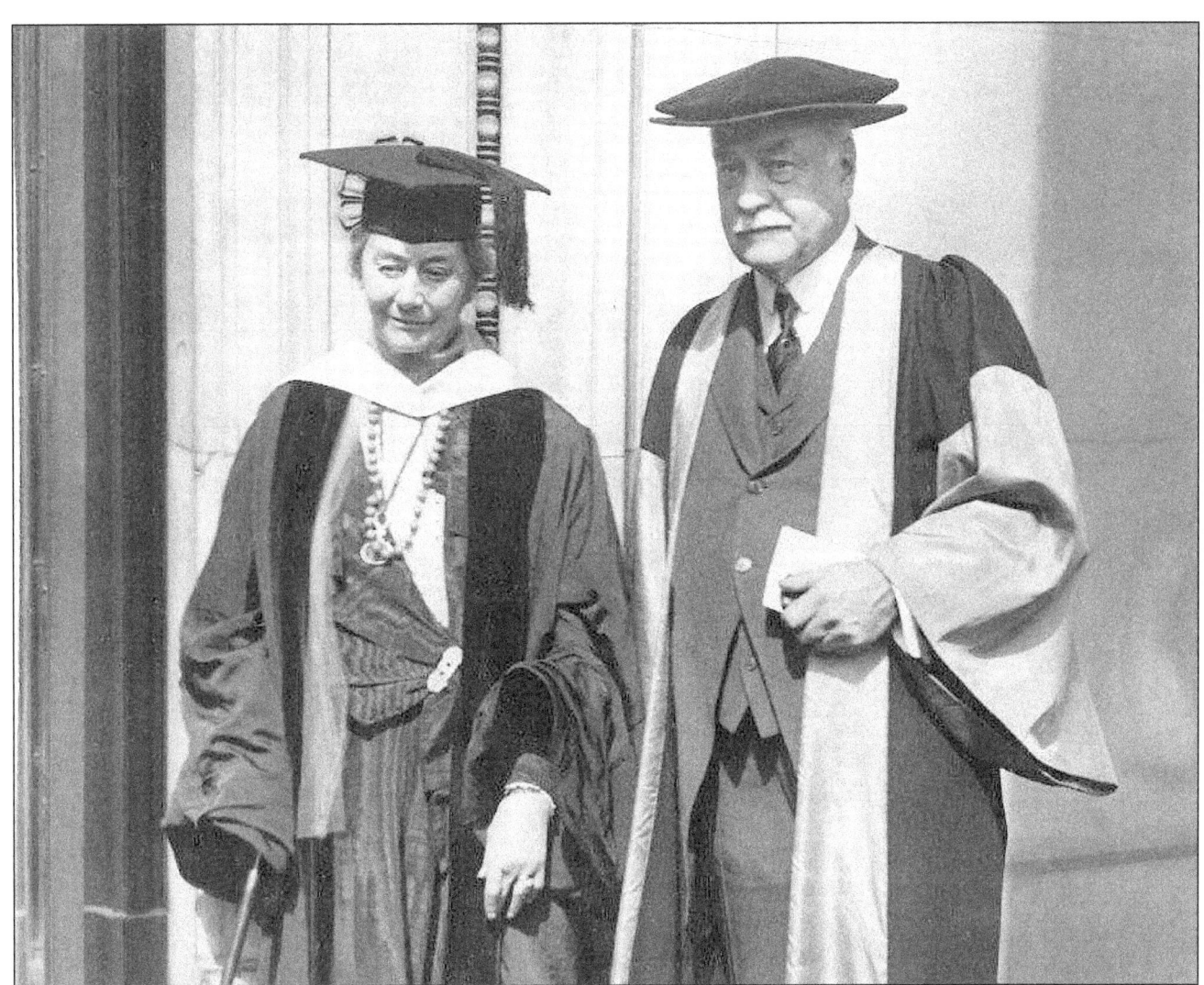

Alice Hargreaves and President Nicholas Murray Butler (Columbia University Collection)

The Herald Tribune photo below shows that behind the speakers, the stage was decorated with a colorful banner depicting the various fantastic characters from the books, all patterned after the original illustrations by John Tenniel.

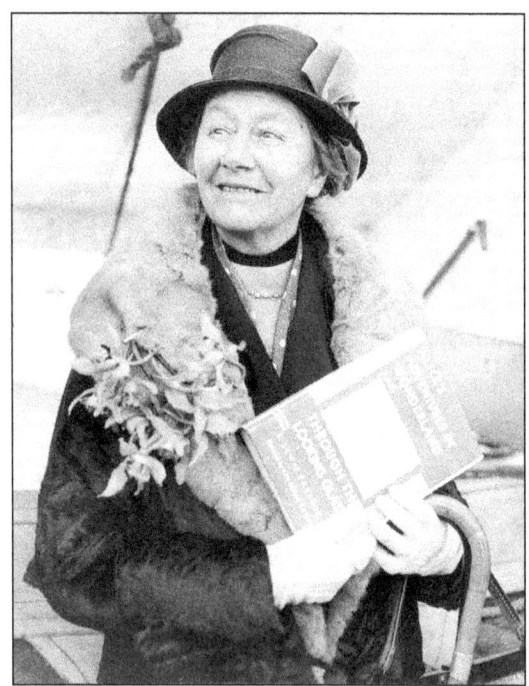
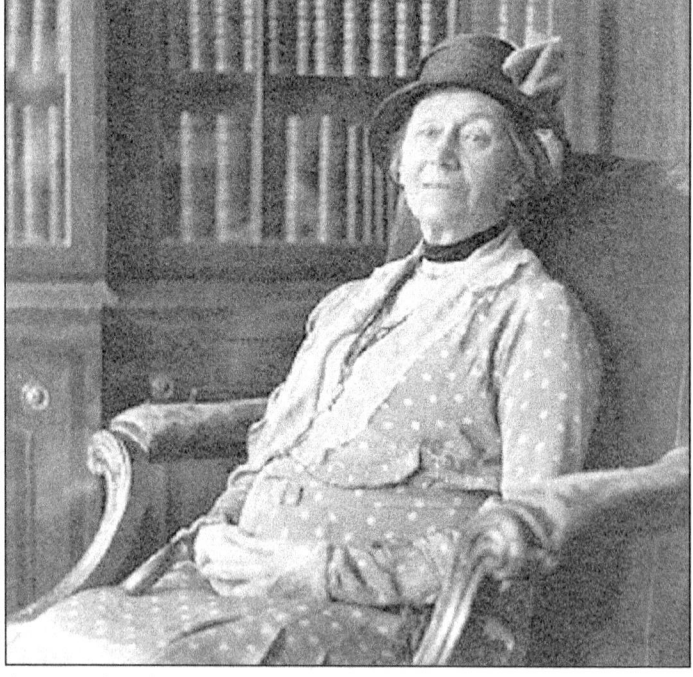

Alice Hargreaves in 1932, at the age of 80 (photographers not identified)

Death

Alice Hargreaves died on November 16, 1934 in Westerham, Kent County, England, TN16, United Kingdom.

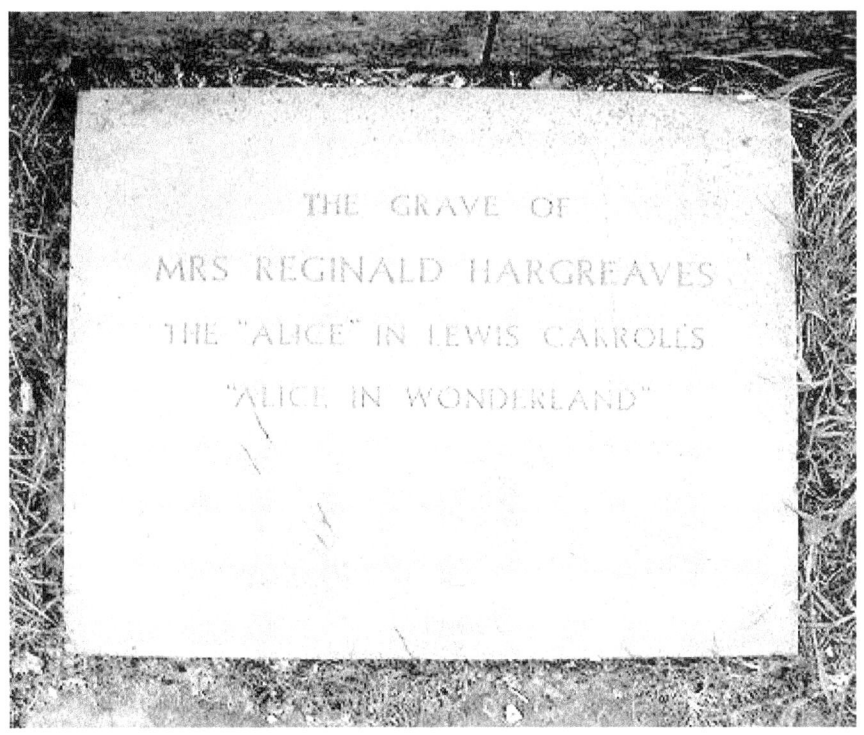

The grave of Alice Hargreaves in the graveyard of the church of St Michael and All Angels, Lyndhurst, Hampshire

After her death, her body was cremated at Golders Green Crematorium, with her ashes being buried in the graveyard of the church of St. Michael and All Angels in Lyndhurst, Hampshire. A memorial plaque, naming her "Mrs. Reginald Hargreaves" can be seen in the picture in the monograph. Alice's mirror can be found on display at the New Forest Heritage Centre, Lyndhurst, a free museum sharing the history of the New Forest.

Origin of *Alice in Wonderland*

On 4 July 1862, in a row boat travelling on the Isis from Folly Bridge, Oxford, to Godstow for a picnic outing, 10-year-old Alice asked Carroll to entertain her and her sisters, Edith, age 8 and Lorina age 13 , with a story. As the Reverend Robinson Duckworth rowed the boat, Dodgson regaled the girls with fantastic stories of a girl, named Alice, and her adventures after she fell into a rabbit-hole. The story was not unlike those Dodgson had spun for the sisters before, but this time Liddell asked Mr. Dodgson to write it down for her. He promised to do so but did not get around to the task for some months. He eventually presented her with the hand printed manuscript of *Alice's Adventures Under Ground* in November 1864.

On the last page Carroll included a drawing of Alice and, disliking it, replaced it with a photograph.

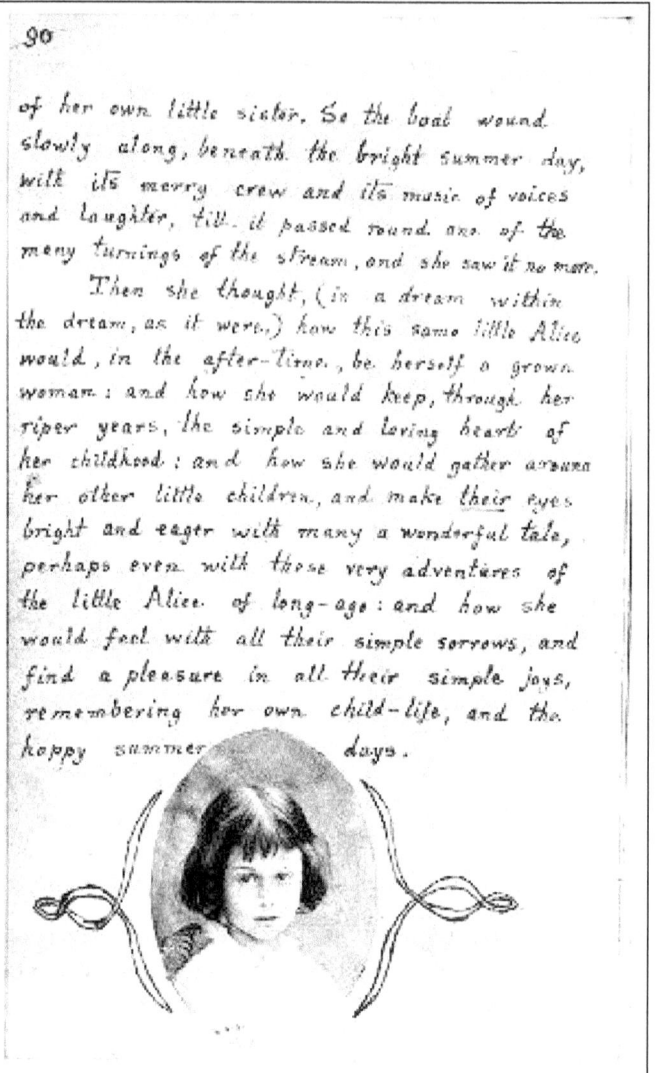

Original page 90 with a drawing of Alice Original page 90 with the photograph instead

In the meantime, Dodgson had decided to rewrite the story as a possible commercial venture. Probably with a view to canvassing his opinion, Dodgson sent the manuscript of Under Ground to a friend, the author George MacDonald, in the spring of 1863. The MacDonald children read the story and loved it, and this response probably persuaded Dodgson to seek a publisher. *Alice's Adventures in Wonderland*, with illustrations by John Tenniel, was published in 1865, under the name Lewis Carroll. The 2,000 copies printed, however, were sold in the U.S. instead of Britain because Tenniel objected to the print quality. A new edition was released in December 1865 and became an instant best-seller. A second book about the character Alice, *Through the Looking-Glass and What Alice Found There*, followed in 1871. In 1886, a facsimile of *Alice's Adventures Under Ground*, the original manuscript that Dodgson had given Liddell, was published.

Relationship with Lewis Carroll

The relationship between Liddell and Dodgson has been the source of much controversy. Dodgson met the Liddell family in 1855; he first befriended Harry, the older brother, and later took both Harry and Lorina on several boating trips and picnics to the scenic areas around Oxford. Later, when Harry went to school, Alice and her younger sister Edith joined the party. Dodgson entertained the children by telling them fantastic stories to while away the time. He also used them as subjects for his hobby, photography. It has often been stated that Alice was clearly his favorite subject in these years, but there is very little evidence to suggest that this is so; Dodgson's diaries from 18 April 1858 to 8 May 1862 are missing.

The relationship between the Liddells and Dodgson suffered a sudden break in June 1863. There was no record of why the rift occurred, since the Liddells never openly spoke of it, and the single page in Dodgson's diary recording 27–29 June 1863, which seems to cover the period in which it began, was missing. It has been speculated by biographers such as Morton N. Cohen that Dodgson may have wanted to marry the 11-year-old Alice Liddell, and that this was the cause of the unexplained break with the family in June 1863. Alice Liddell's biographer, Anne Clark, writes that Alice's descendants were under the impression that Dodgson wanted to marry her, but that "Alice's parents expected a much better match for her". Clark argues that in Victorian England such arrangements were not as improbable as they might seem; John Ruskin, for example, fell in love with a 12-year-old girl while Dodgson's younger brother sought to marry a 14-year-old, but postponed the wedding for six years.

In 1996, Karoline Leach found what became known as the "Cut pages in diary" document—a note allegedly written by Charles Dodgson's niece, Violet Dodgson, summarizing the missing page from 27–29 June 1863, apparently written before she (or her sister Menella) removed the page. The note reads: "Lewis Carroll learns from Mrs. Liddell that he is supposed to be using the children as a means of paying court to the governess—he is also supposed by some to be courting Ina."

This might imply that the break between Dodgson and the Liddell family was caused by concern over alleged gossip linking Dodgson to the family governess and to "Ina" (Alice's older sister, Lorina). In her biography, *The Mystery of Lewis Carroll*, Jenny Woolf suggests that the problem was caused by Lorina becoming too attached to Dodgson and not the other way around. Woolf then uses this theory to explain why "Menella [would] remove the page itself, yet keep a note of what was on it." The note, she submits, is a "censored version" of what really happened, intended to prevent Lorina from being offended or humiliated at having her feelings for Dodgson made public.

It is uncertain who wrote the note. Leach has said that the handwriting on the front of the document most closely resembles that of either Menella or Violet Dodgson, Dodgson's nieces. However, Morton N. Cohen in an article published in the Times Literary Supplement in 2003 said that in the 1960s, Dodgson's great-nephew Philip Dodgson Jacques told him that Jacques had written the note himself based on conversations he remembered with Dodgson's nieces. Cohen's article offered no evidence to support this, however, and known samples of Jacques' handwriting do not seem to resemble the writing of the note.

After this incident, Dodgson avoided the Liddell home for six months but eventually returned for a visit in December 1863. However, the former closeness does not seem to have been re-established, and the friendship gradually faded away, possibly because Dodgson was in opposition to Dean Liddell over college politics.

Comparison with fictional Alice

The extent to which Dodgson's Alice may be or could be identified with Liddell is controversial. The two Alices are clearly not identical, and though it was long assumed that the fictional Alice was based very heavily on Liddell, recent research has contradicted this assumption. Dodgson himself claimed in later years that his Alice was entirely imaginary and not based upon any real child at all.

There was a rumor that Dodgson sent Tenniel a photo of one of his other child-friends, Mary Hilton Badcock, suggesting that he used her as a model, but attempts to find documentary support for this theory have proved fruitless. That he did not use the photo is strongly is suggested by these lines from a letter Carroll wrote sometime after both Alice books had been published...

"Mr. Tenniel is the only artist, who has drawn for me, who has resolutely refused to use a model, and declared he no more need one than I should need a multiplication table to work a mathematical problem! I venture to think that he was mistaken and that for want of a model, he drew several pictures of 'Alice' entirely out of proportion—head decidedly too large and feet decidedly too small."

Dodgson's own drawings of the character in the original manuscript of *Alice's Adventures Under Ground* show little resemblance to Liddell. Biographer Anne Clark suggests that Dodgson might have used Edith Liddell as a model for his drawings.

There are at least four direct links to Liddell in the two books. First, he set them on May 4th (Liddell's birthday) and November 4th (her "half-birthday"), and in Through the Looking-Glass the fictional Alice declares that her age is

"seven and a half exactly", the same as Liddell on that date. Second, he dedicated them "to Alice Pleasance Liddell". Third, in the first book, the Dormouse tells a story which begins, "Once upon a time there were three little sisters... and their names were Elsie, Lacie, and Tillie." The name Liddell was pronounced with the accent on the first syllable and would sound like "little" as spoken with the "T" sound softened. Also the name "Lacie" is an anagram of "Alice", whilst 'Elsie' refers to Lorina, whose second name was Charlotte, giving her the initials L.C. and 'Tillie' refers to Edith's family nickname of 'Matilda'.

Fourth, there is an acrostic poem at the end of Through the Looking-Glass. Reading downward, taking the first letter of each line, spells out Liddell's full name - Alice Pleasance Liddell. The poem has no title in Through the Looking-Glass, but is usually referred to by its first line, "A Boat Beneath a Sunny Sky".

A boat beneath a sunny sky,
Lingering onward dreamily
In an evening of July-

Children three that nestle near,
Eager eye and willing ear,
Pleased a simple tale to hear-

Long has paled that sunny sky:
Echoes fade and memories die.
Autumn frosts have slain July.

Still she haunts me, phantomwise,
Alice moving under skies
Never seen by waking eyes.

Children yet, the tale to hear,
Eager eye and willing ear,
Lovingly shall nestle near.

In a Wonderland they lie,
Dreaming as the days go by,
Dreaming as the summers die:

Ever drifting down the stream-
Lingering in the golden gleam-
Life, what is it but a dream?

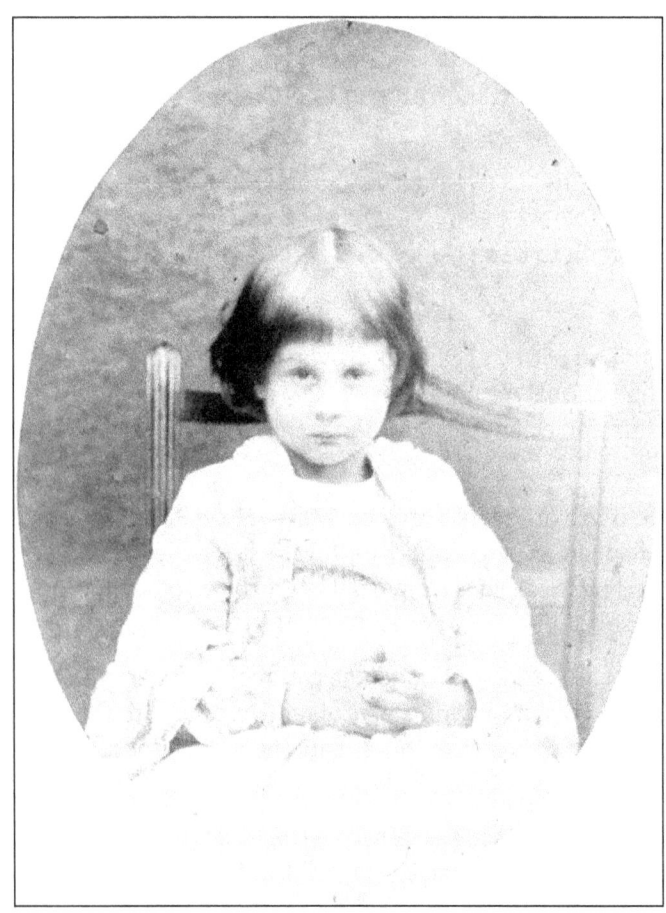

Alice Liddell (June 2, 1857)

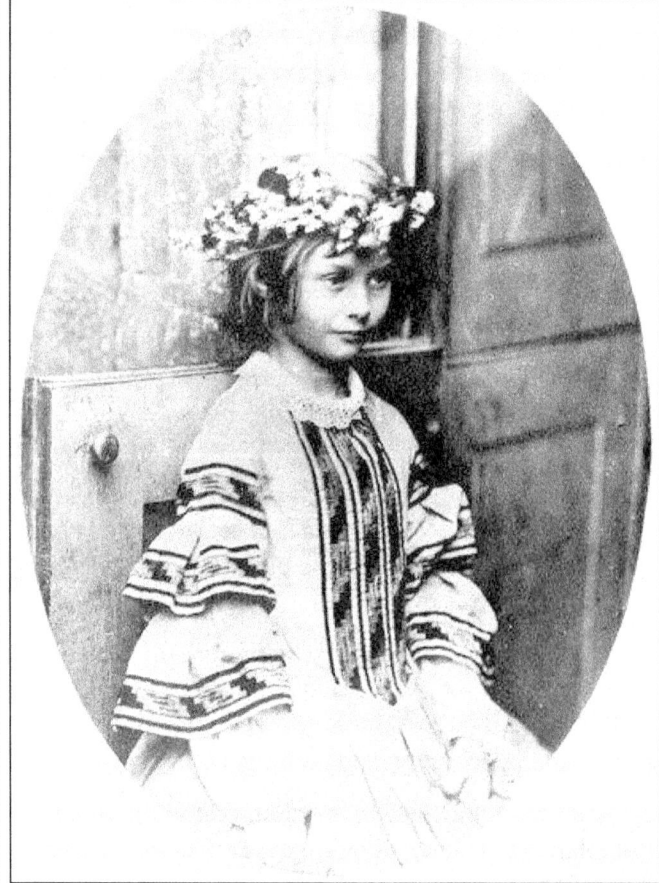

Alice as "Queen of the May" (May/June 1860)

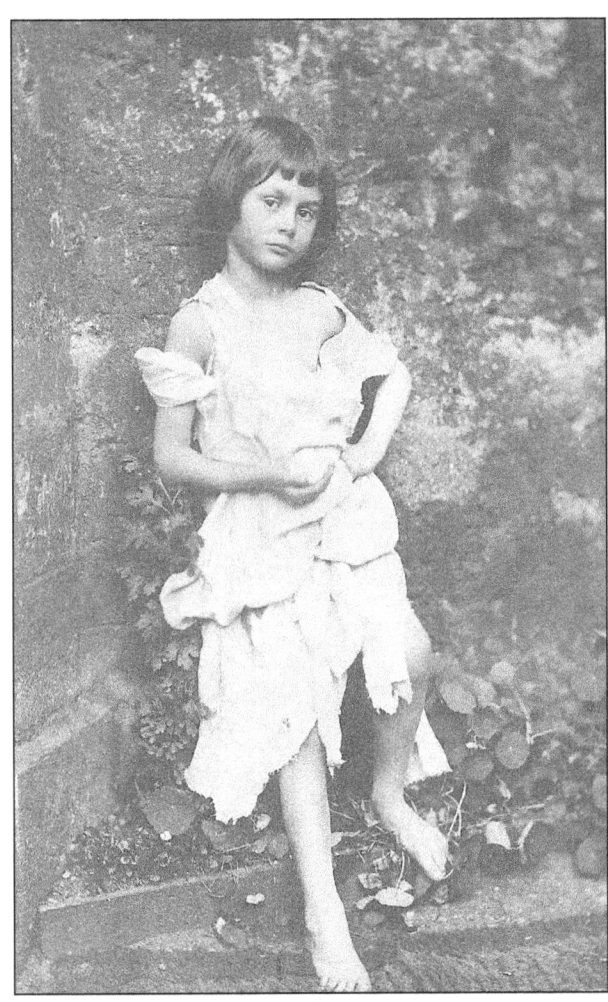
Alice Liddell, The Beggar Maid (summer 1858)

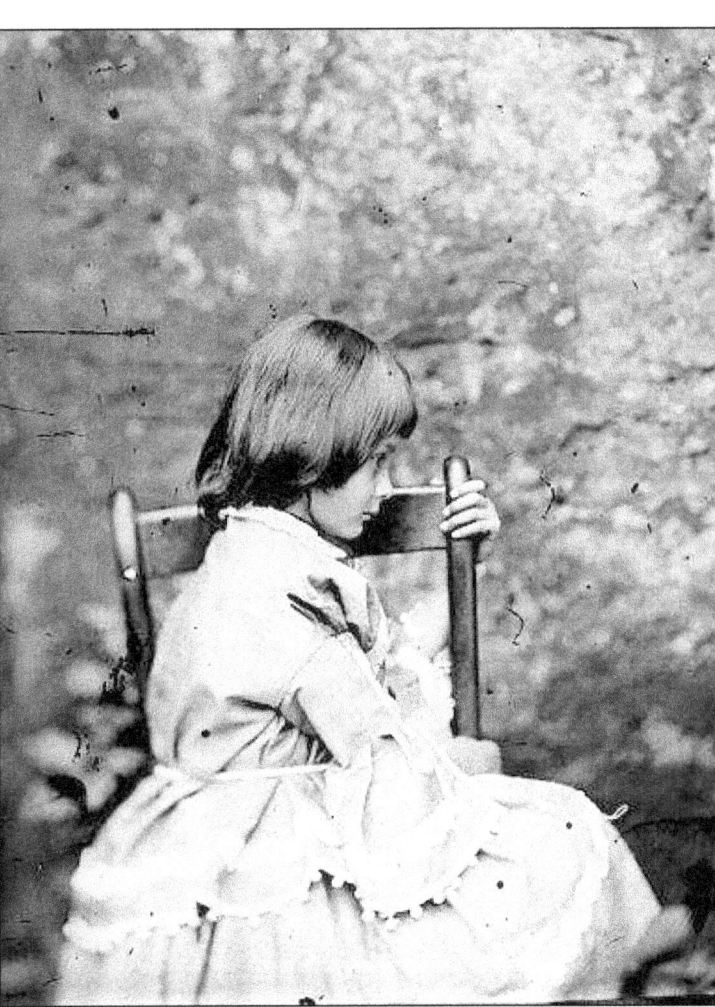
Alice Liddell (summer 1858)

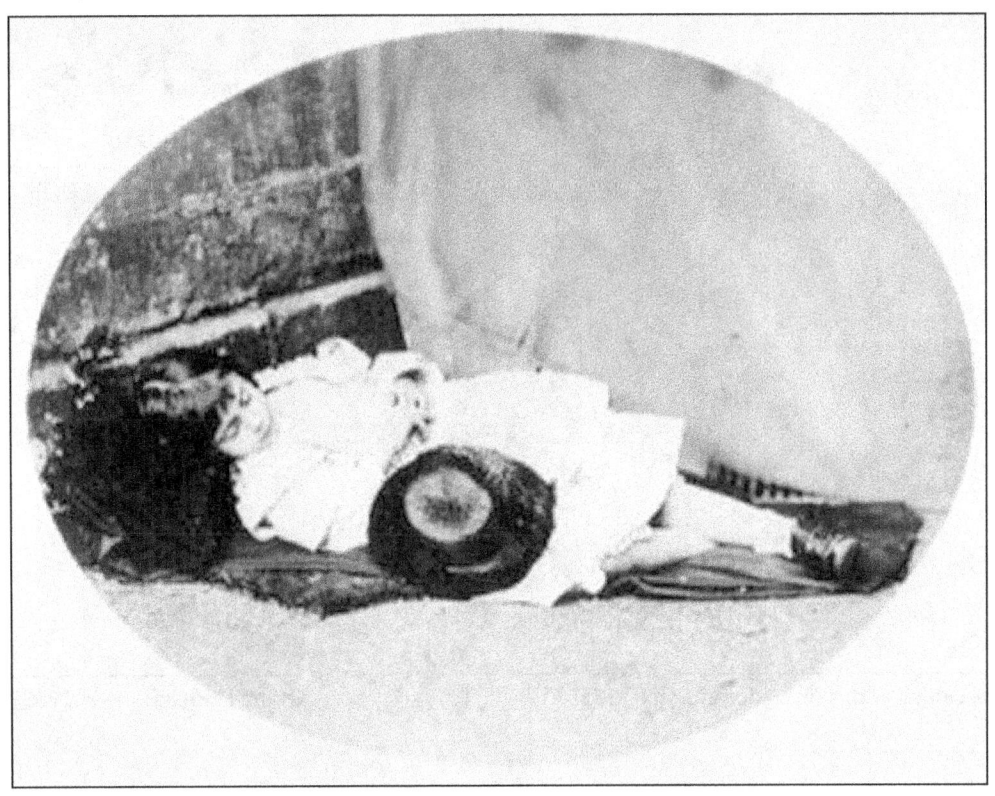
Alice pretending to be asleep (spring 1860)

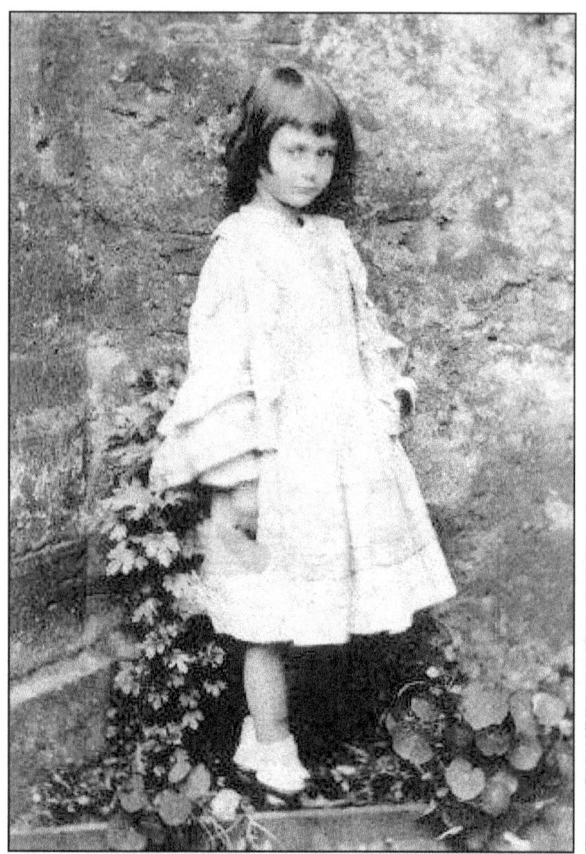

Alice Liddell (summer 1858) Alice Liddell, last sitting (June 27, 1870)

Lorina Liddell (May 11, 1849 – October 29, 1930)

Lorina Liddell with a black doll (summer 1858) Lorina Liddell (June 2, 1857)[3]

[3] This photograph is from the oldest of the 71 existing Carroll glass plate negatives

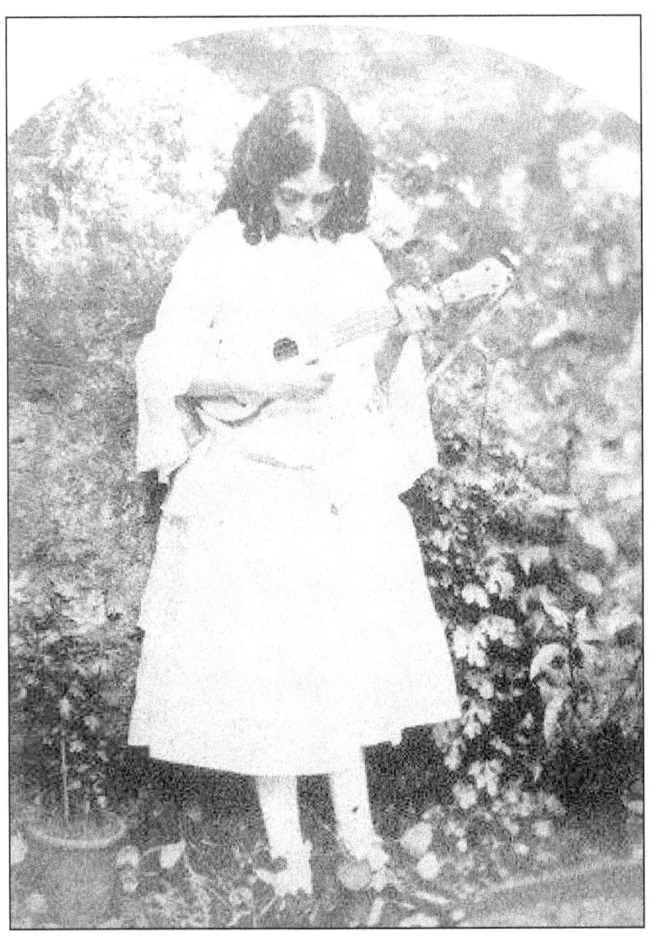

Lorina Liddell with Guitar (spring 1860)

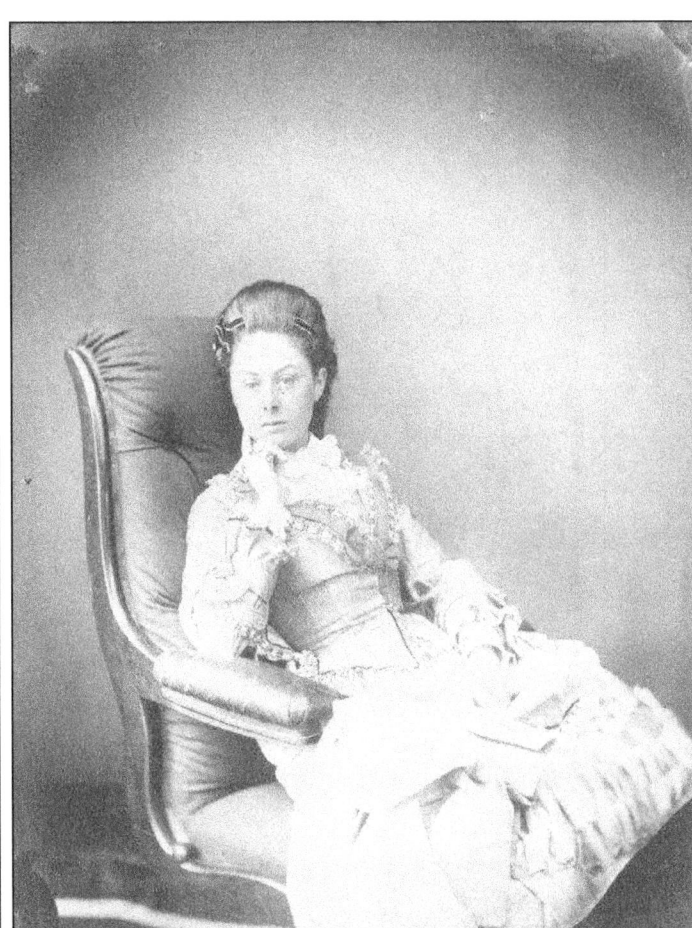

Lorina Liddell, last sitting (July 25, 1870)

Edith Liddell (1854-1876)

Edith Liddell (July 1860)

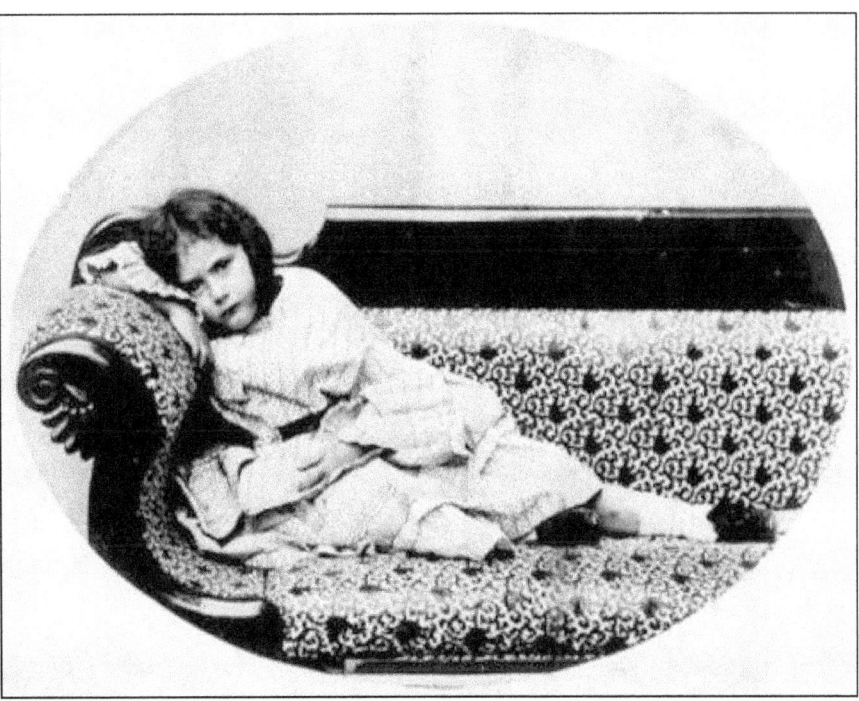

Edith Liddell (spring 1860)

Liddell sisters

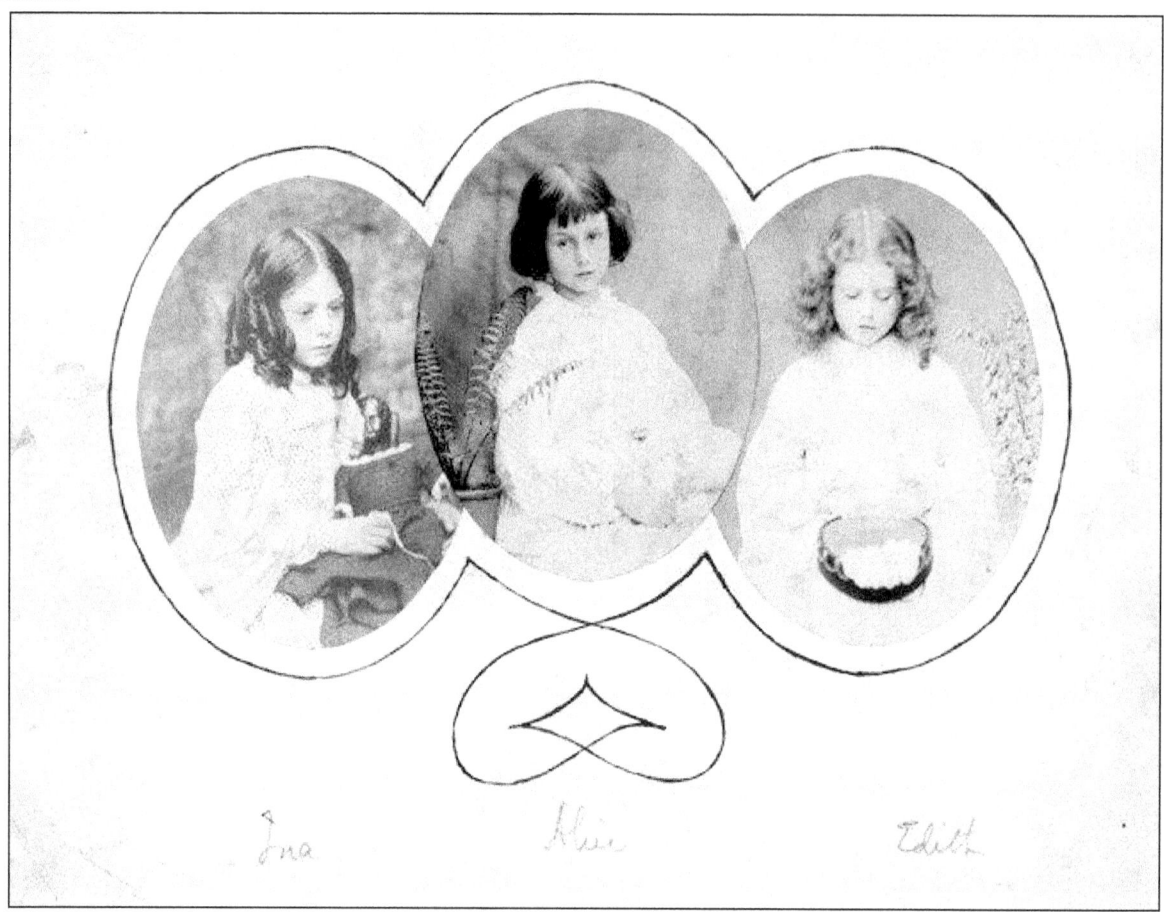
Lorina, Alice, Edith, 1858-1860 (The individual photos are Carroll's, but probably not the triptych)

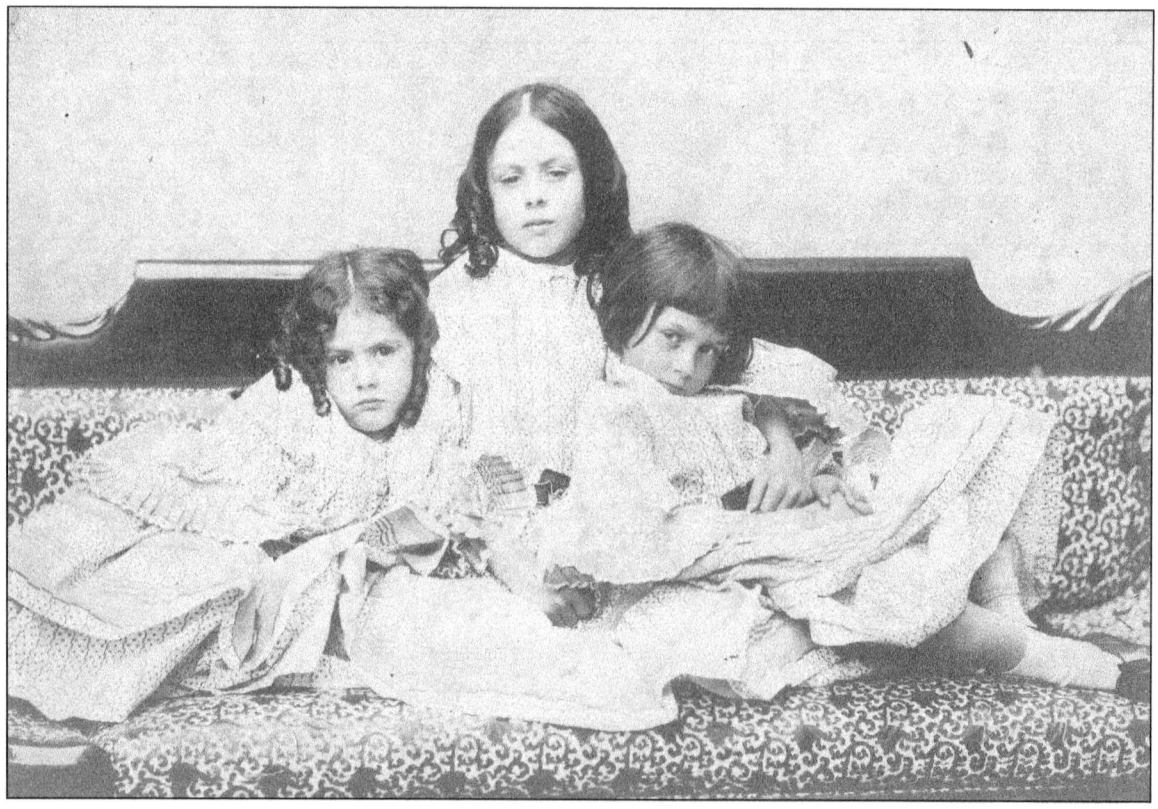
Lorina, Edith and Alice Liddell (summer 1858)

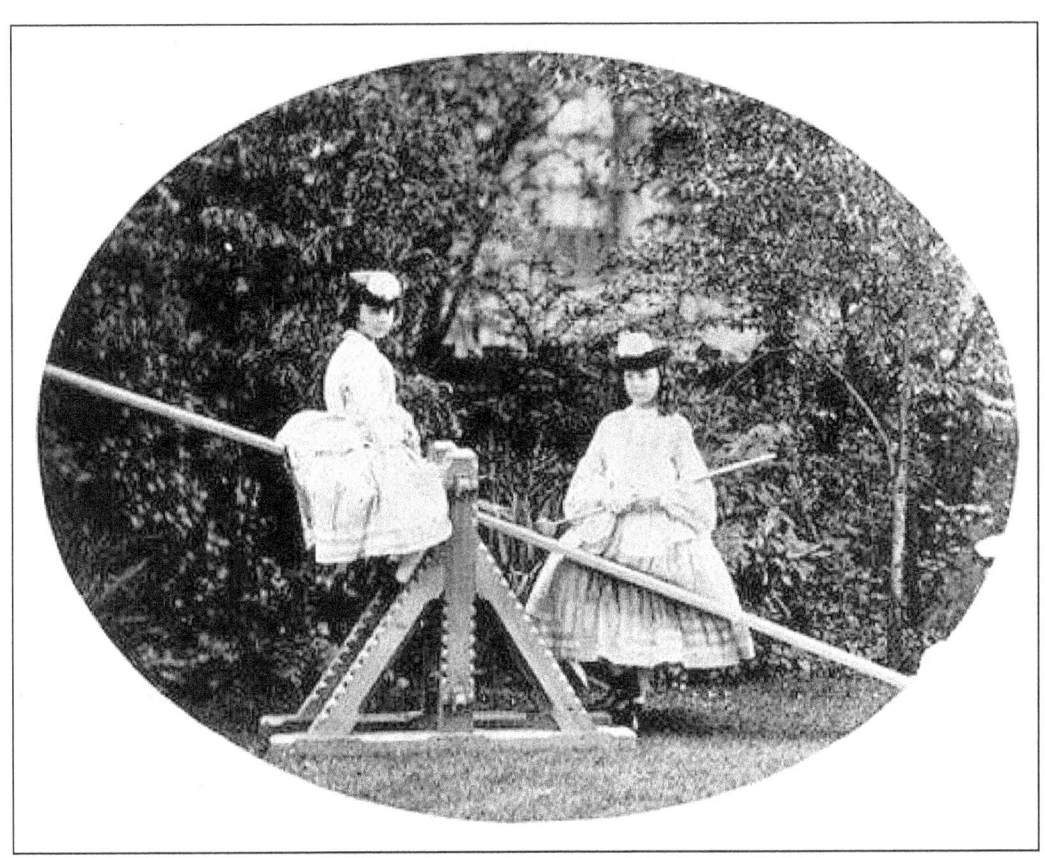

Alice Liddell and Lorina Liddell on a seesaw (May/June 1860)

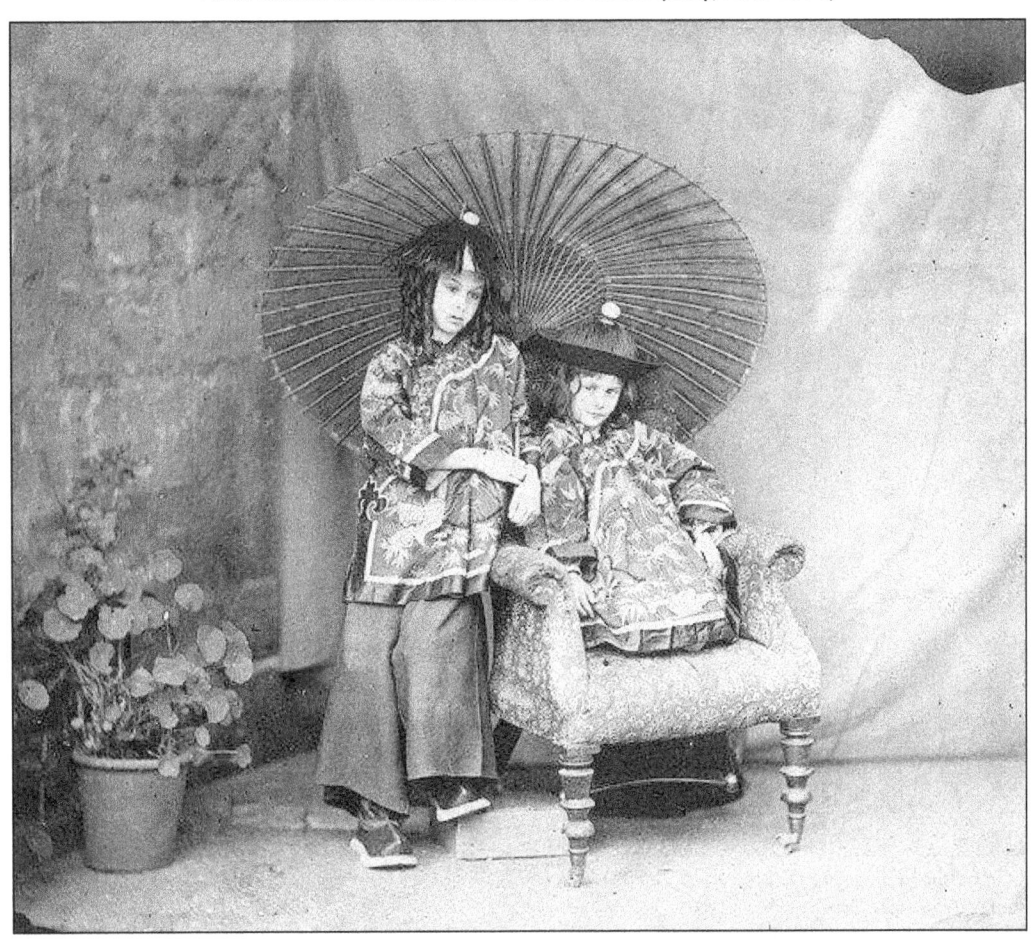

Lorina Liddell and Alice Liddell in Chinese dresses (spring 1860)

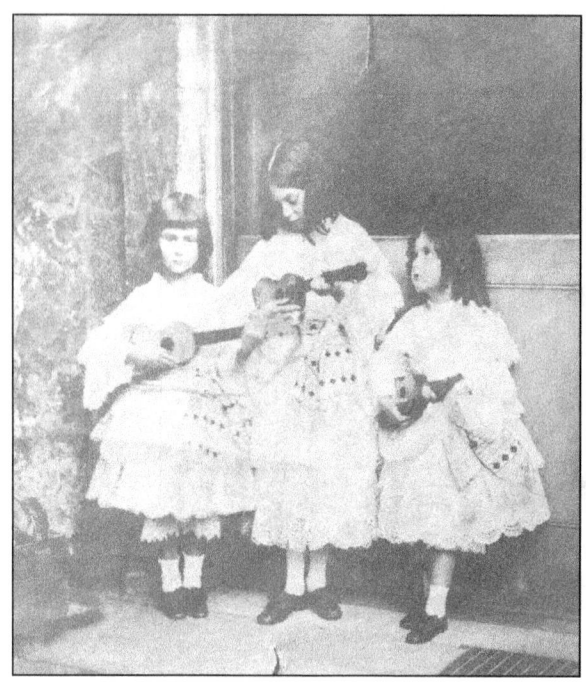

Alice, Lorina and Edith Liddell (1858)

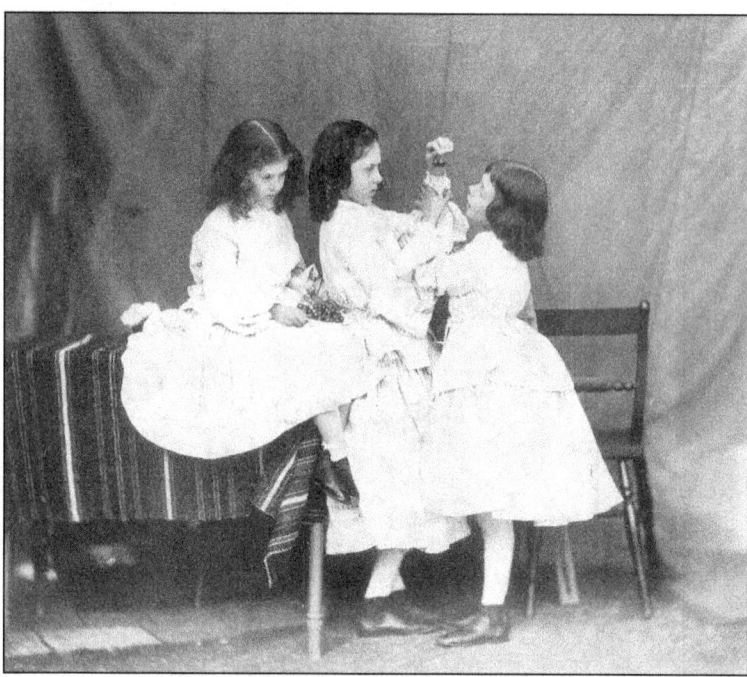

Edith, Lorina and Alice, "Open Your Mouth and Shut Your Eyes" (July 1860)

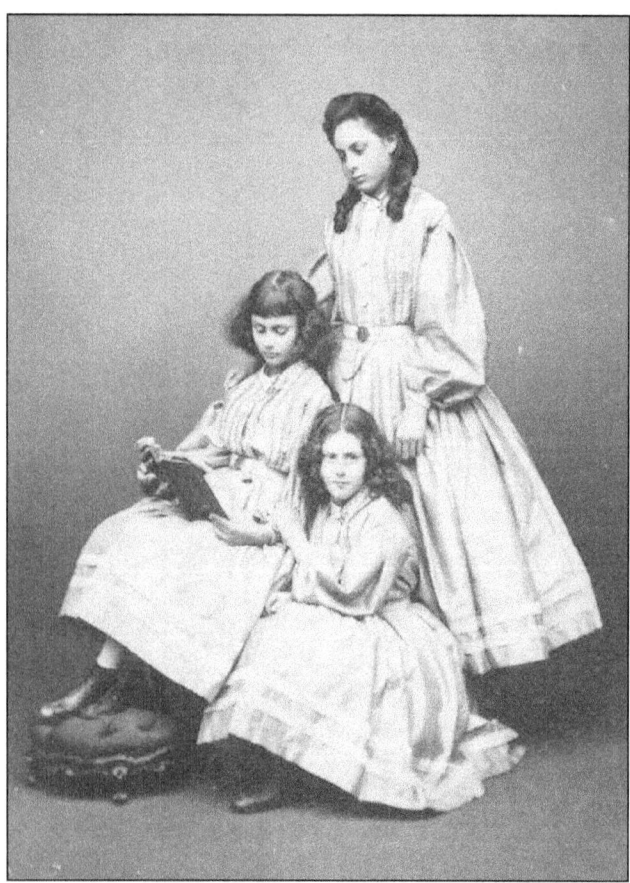

Alice, Edith, Lorina Liddell (Thomas Edge – mid 1860s)
[Note: This photo shows the sisters between 1860 and 1870 when Carroll did not photograph them.]

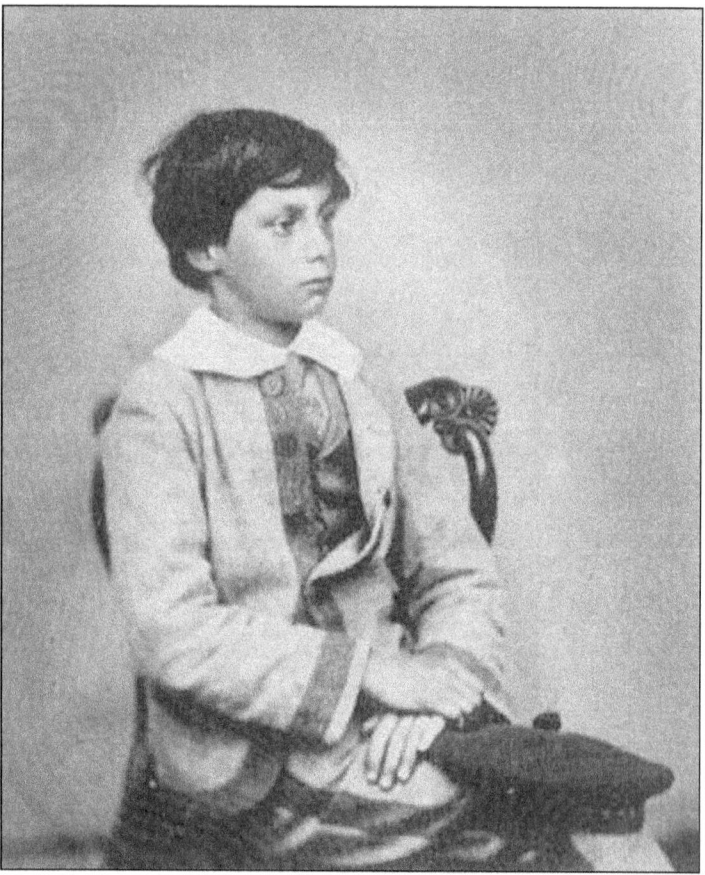

Harry Liddell (summer 1858)

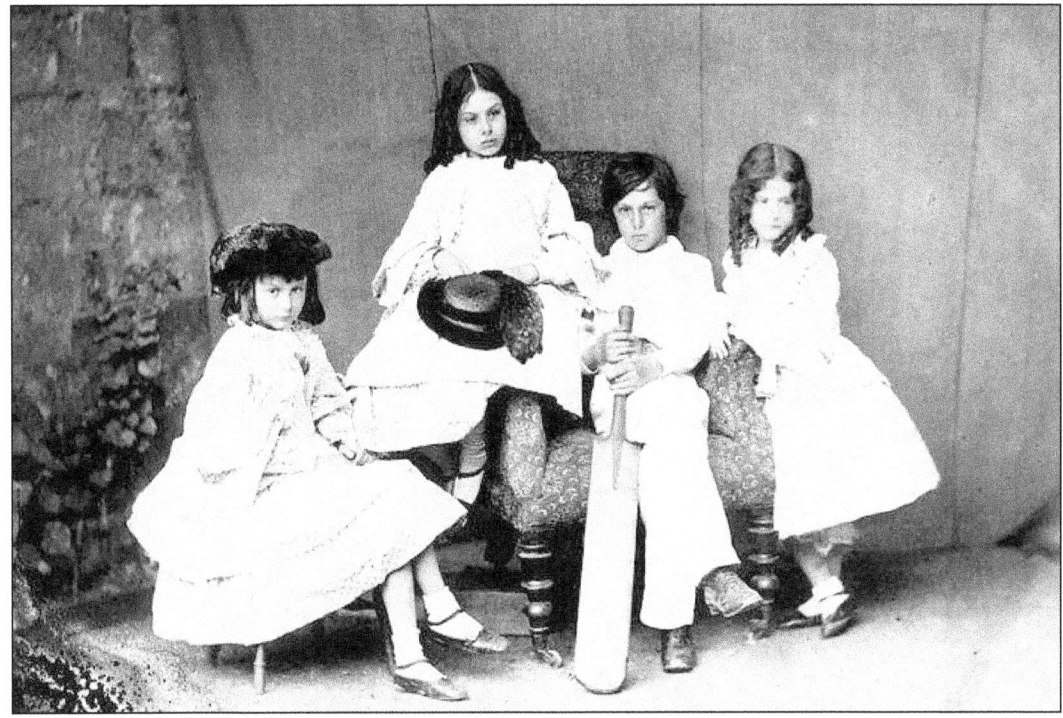

Alice, Ina, Harry, and Edith Liddell (1860)

Agnes Weld

On 8 February, 1849 Ann (Sellwood) Weld gave birth to a baby girl at Somerset House, in the Assistant Secretary's apartments where her husband, Charles worked at the Royal Society. Sixteen months later, in June of 1850, Alfred Tennyson married Emily Sellwood now aunt of baby Agnes Weld. In 1869 Agnes's father, Charles died unexpectedly leaving his widow, Anne and daughter, Agnes behind. During a stay with her sister, Emily and Alfred Tennyson at their home on the Isle of Wight, Farringford, she decided to build a house a mile away named Hawksridge. Agnes Weld never married; dedicating her life to Christian Charity giving away nearly all she had. She also published four books. Agnes died on 12 Dec 12, 1915 in Oxford.

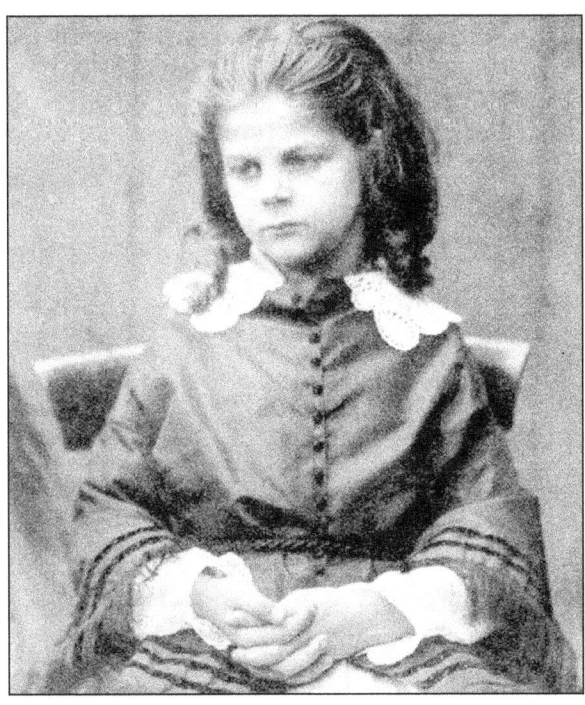
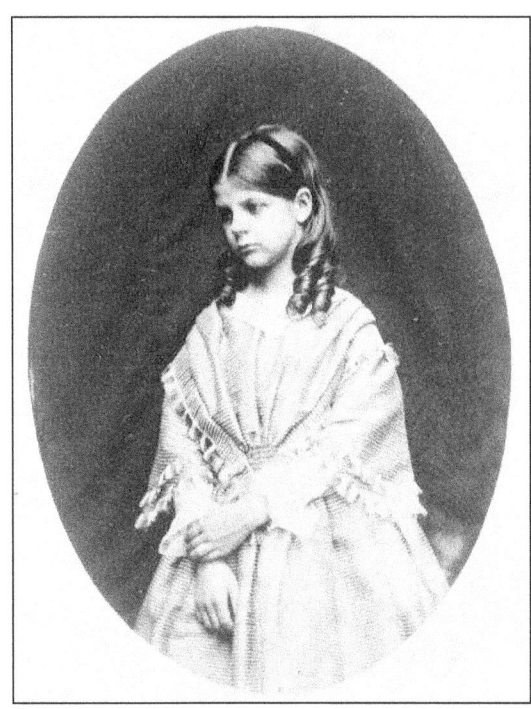

Agnes Weld (Aug 18, 1857)

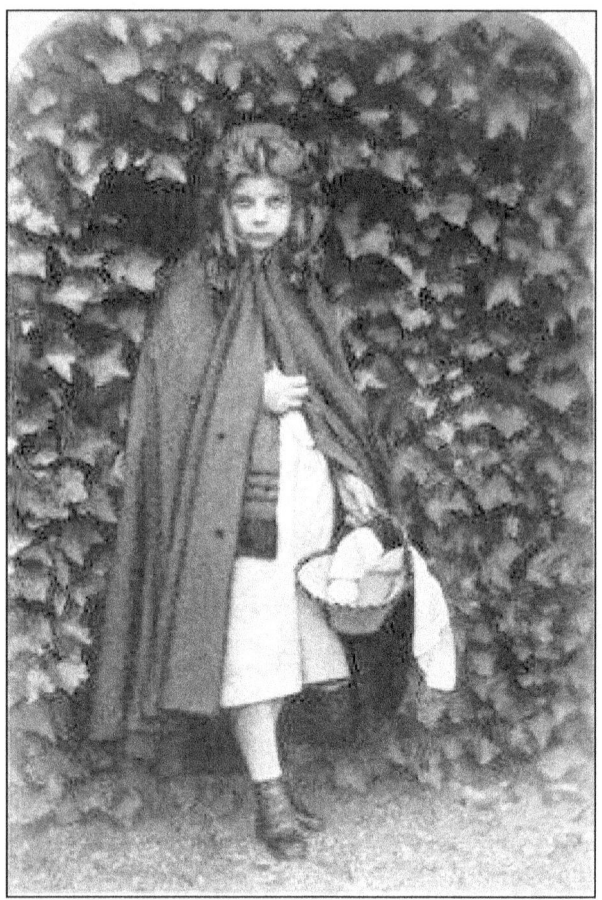

Agnes Weld as Little Red Riding Hood (Aug 18, 1857)

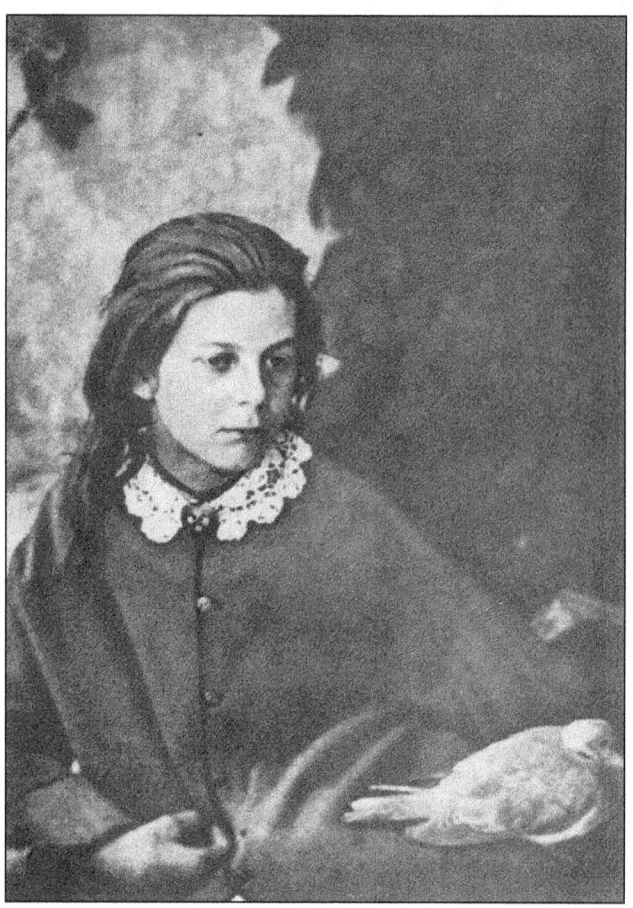

Agnes Weld (1862)

Agnes Florence Price

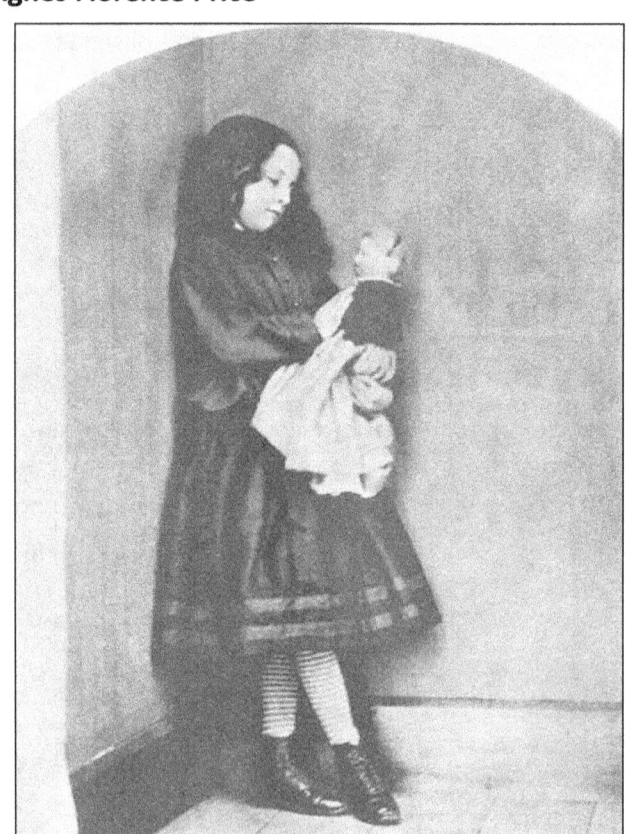

Agnes Florence Price (March 24, 1864)

The photograph above of Agnes Weld, often attributed to Carroll, has been reported to have been taken by Oscar Rejlander and printed by Lewis Carroll. Further Carroll's diary no shows record of this photograph being taken by him.

Alice Constance Westmacott

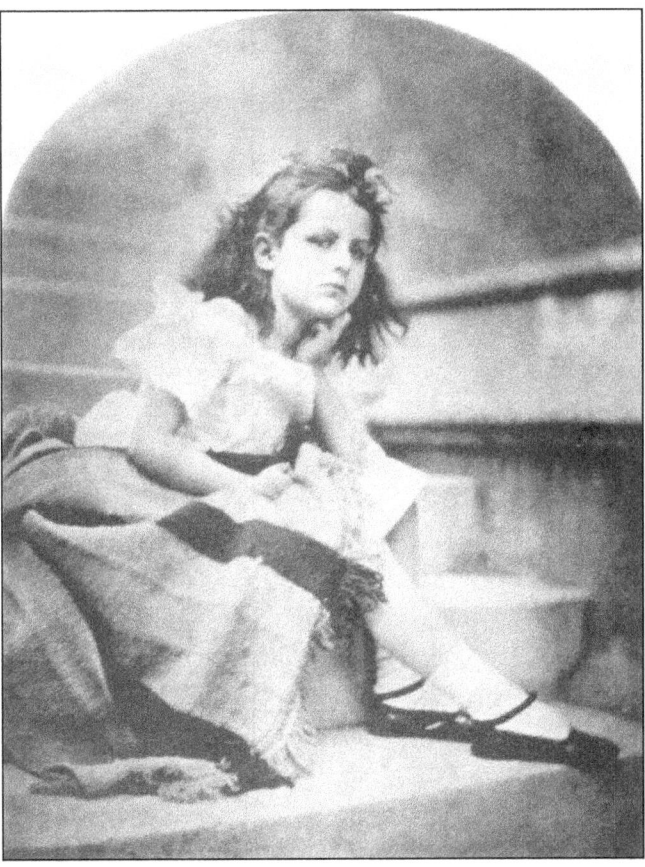

Alice Constance Westmacott (July 9, 1864)

Alice Murdoch

Alice Murdoch was the daughter of Sir Thomas William Clinton Murdoch, civil servant and later special commissioner to Canada; he was a friend of Carroll's uncle Hassard Dodgson.

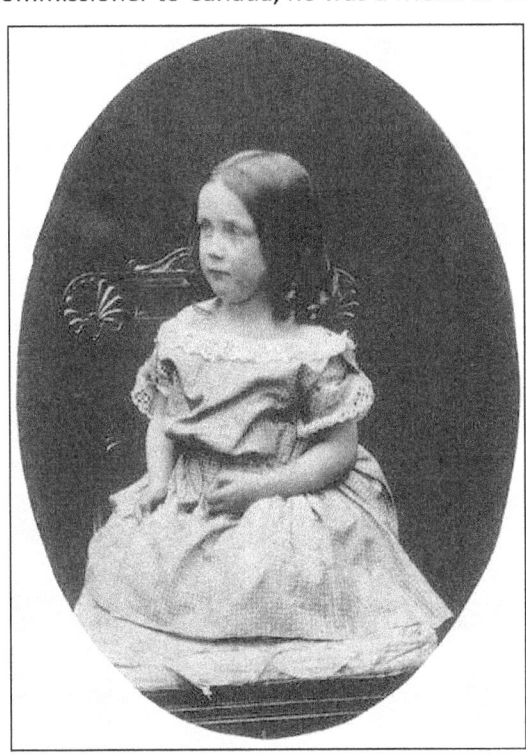

Alice Murdoch (June 19, 1865)

The following poem is written in Carroll's album on the page adjacent to Alice's photograph.

ALICE, daughter of C. MURDOCH. Esq.
O child! O new-born denizen
Of life's great city! on thy head
The glory of the morn is shed
Like a celestial benison!
Here at the portal thou dost stand,
And with thy little hand
Thou openest the mysterious gate
Into the future's undiscovered land.
I see valves expand
As the touch of Fate!
Into those realms of love and hate,
Into that darkness blank and drear,
By some prophets feeling taught,
Freighted with hope and fear;
As upon subterranean streams,
In caverns unexplored and dark,
Men sometimes launch a fragile bark,
Laden with flickering fire,
And watch it's [sic] swift-reeding beams,
Until at length they disappear,

Amy Raikes and Annie Parkes

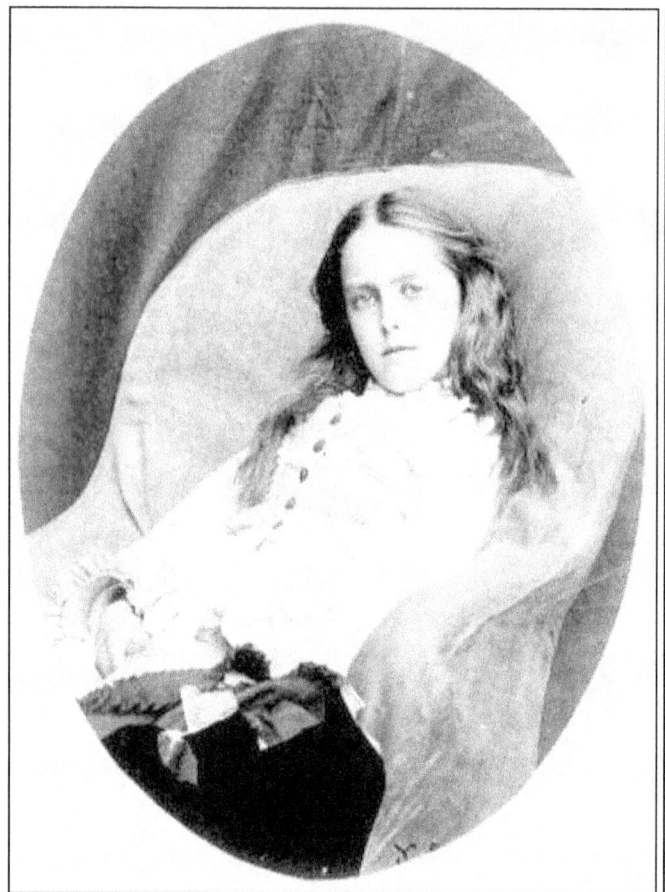
Amy Raikes (July 8, 1875)

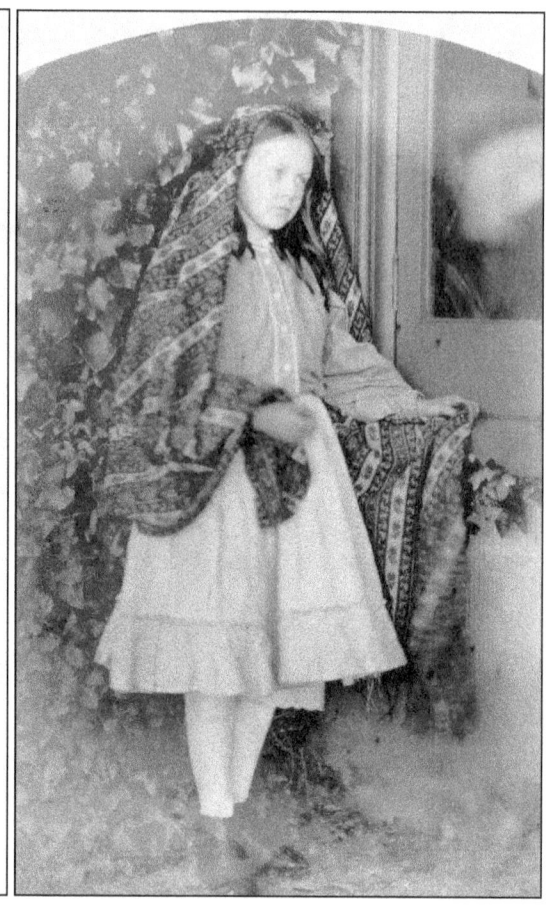
Annie Parkes (August 13, 1864)

Angus Douglas

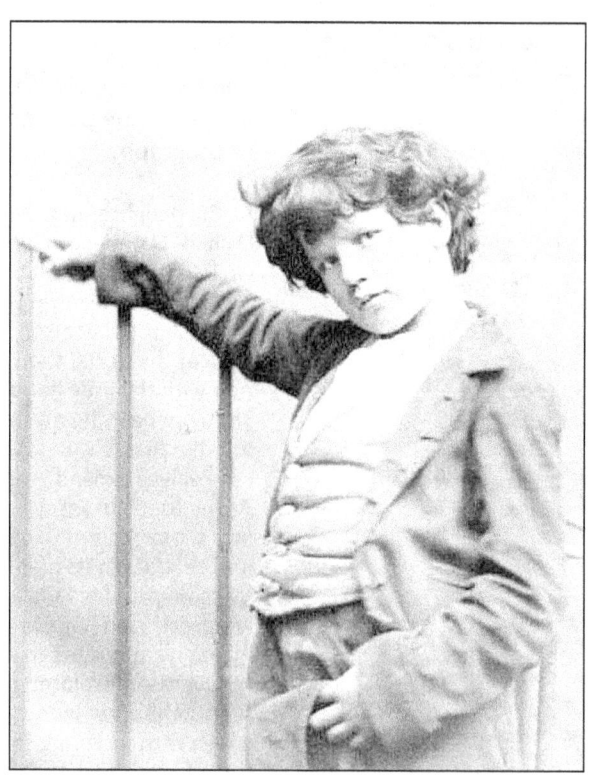
Angus Douglas (October 7, 1863)

Annie Coates

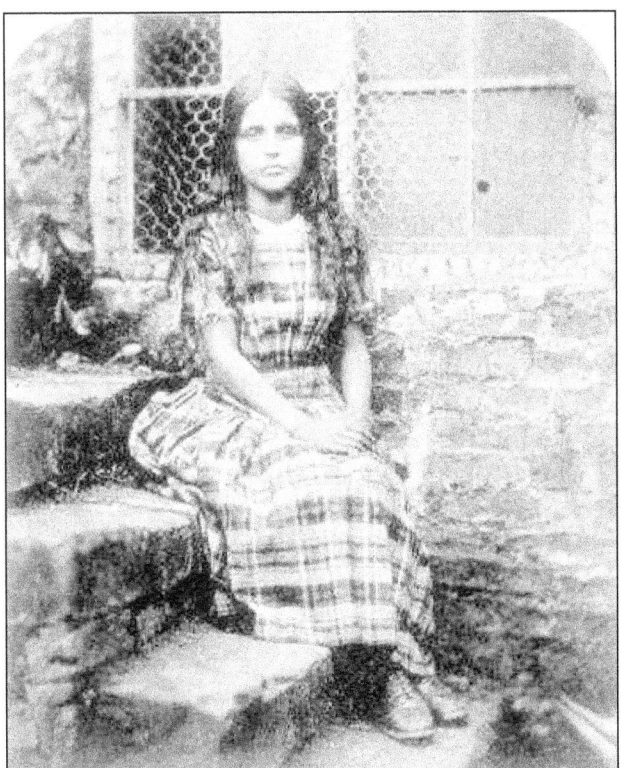 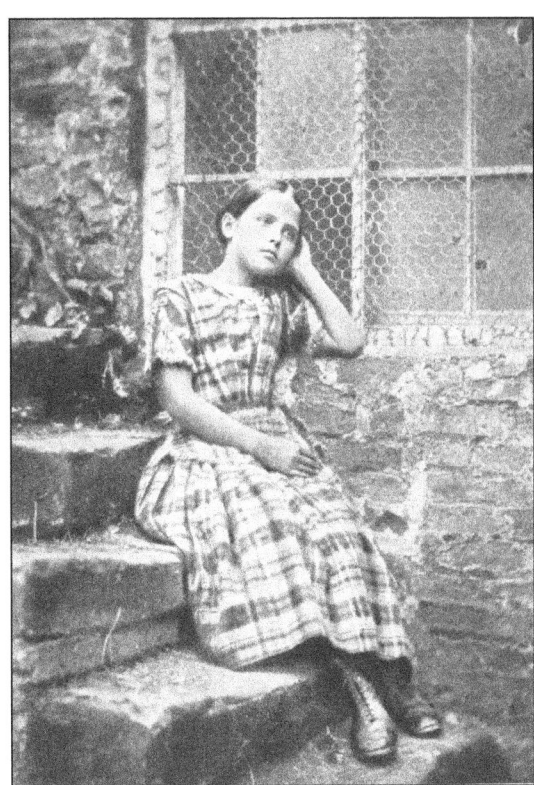

Annie Coates (August 1857)

Arnold sisters (Julia and Ethel)

Julia Frances Arnold married Leonard Huxley, son of Thomas Henry Huxley, an Engish biologist and anthropologist. Ethel Margaret Arnold never married but just before her death in 1930 she wrote an account of her friendship with Lewis Carroll. The Arnolds were the nieces of the poet Matthew Arnold.

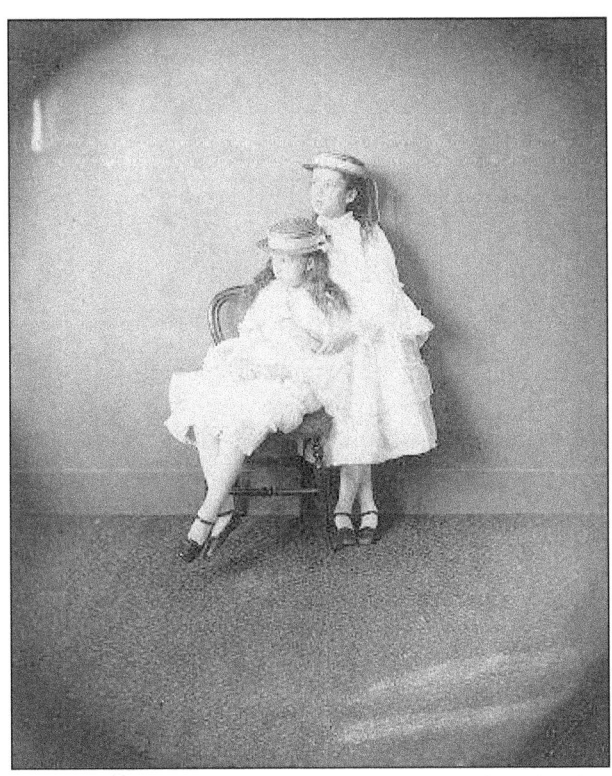

Julia and Ethel Arnold (July 15, 1872) Julia Arnold – mother of Julian and Aldous Huxley (March 14, 1874)

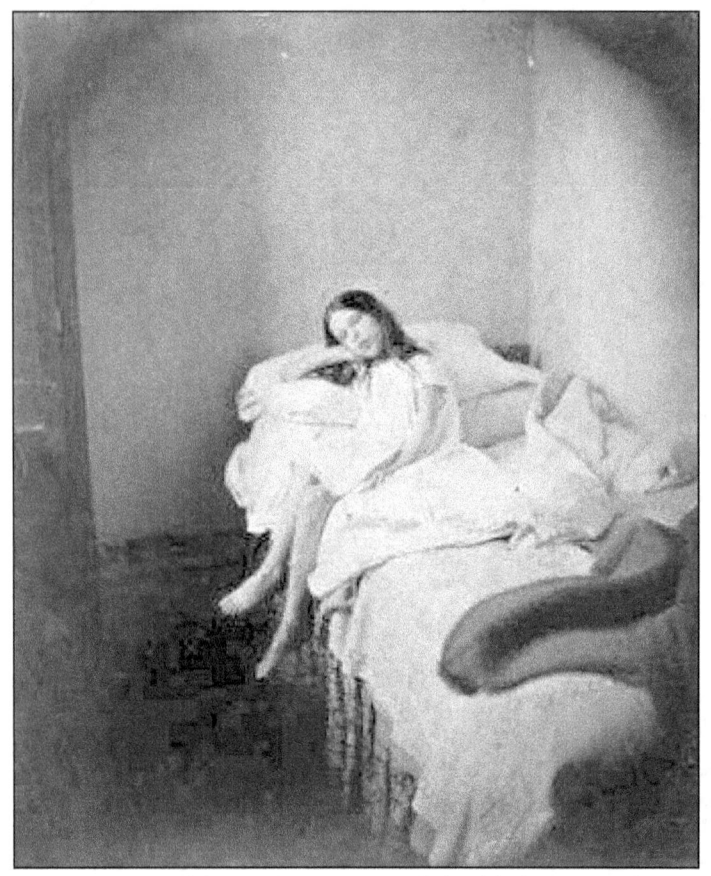
Julia Arnold seated on an unmade bed (July 15, 1872)

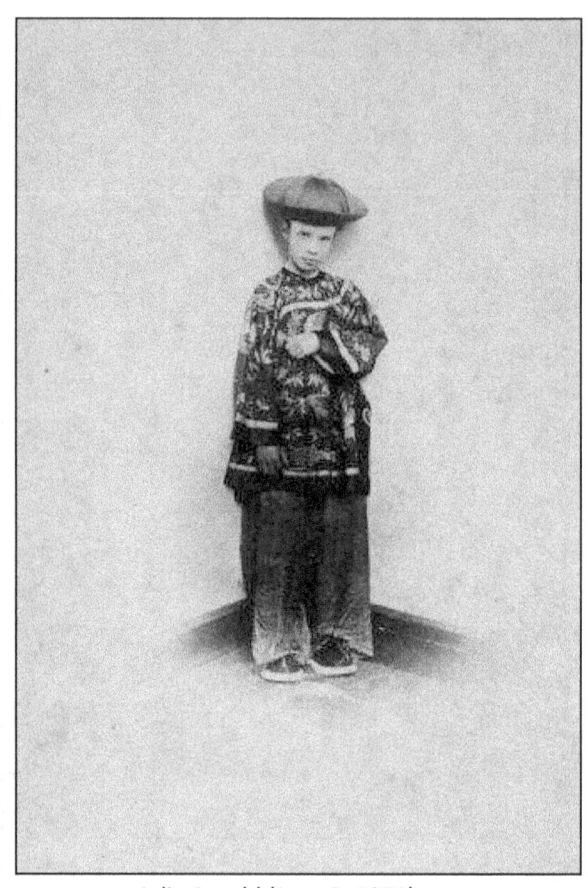
Julia Arnold (June 5, 1871)

Beatrice Mary Henley and Beatrix du Maurier

Beatrice Mary Henley, daughter of the Vicar of Putney (July 10, 1864)

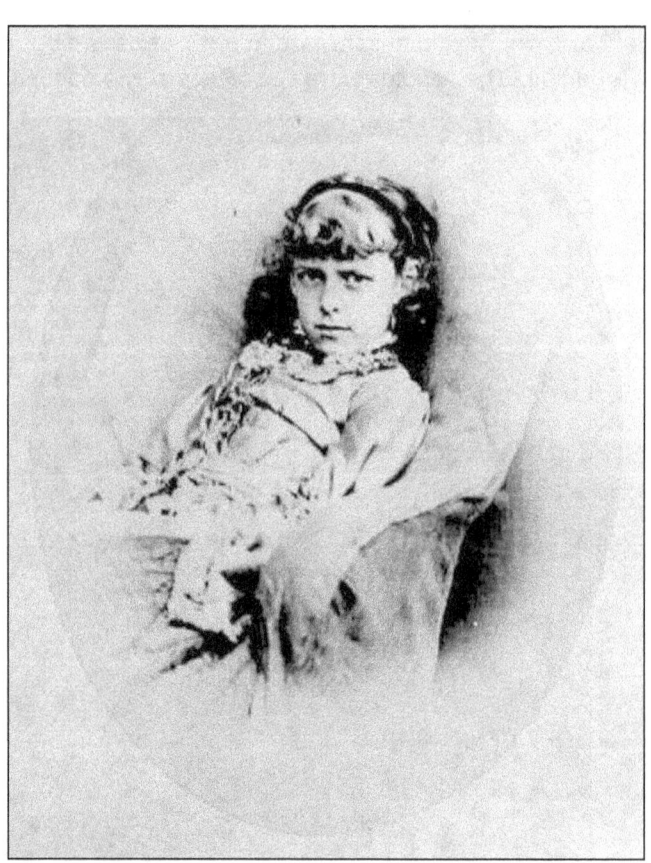
Beatrix du Maurier (July 12, 1875)

Bessie Slatter

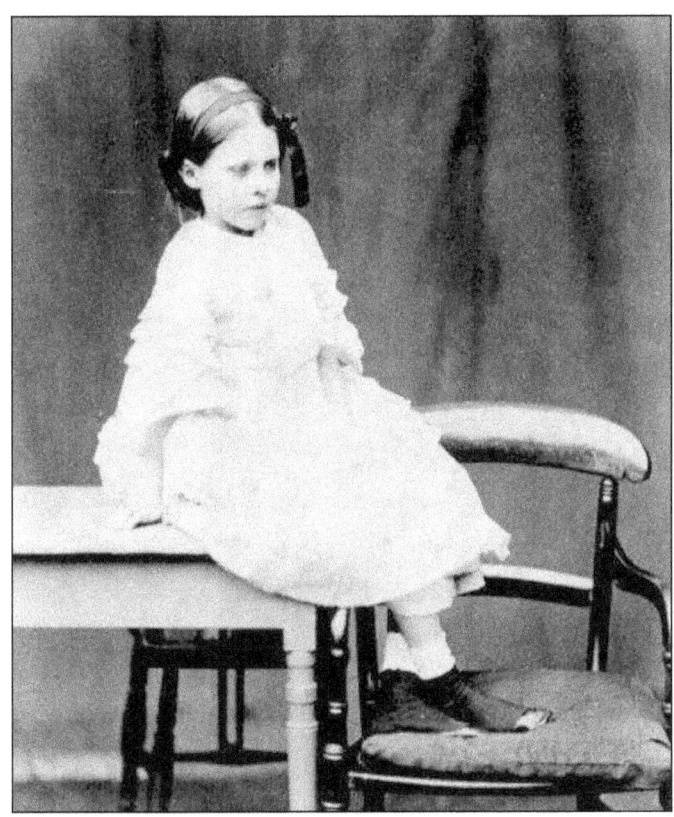

Elizabeth Anne "Bessie" Slatter (July 2, 1860)

Bessie Slatter and guinea pig (Spring 1862)

Barry family (Louisa, Johnnie and Emily Barry)

Louisa Barry, Johnnie Barry and Emily Barry, "The Dream" (August 26-29, 1863)

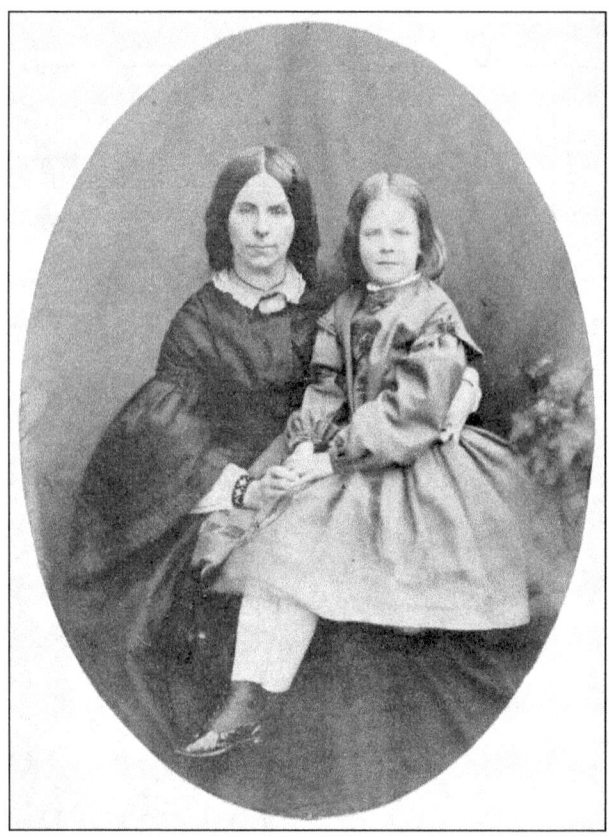
Mrs. Letitia Barry and Louisa (summer 1860)

Louisa D. Barry (summer 1860)

Bickersteth siblings (Cyril and Florence)

Montagu Cyril Bickersteth (September 7, 1865)

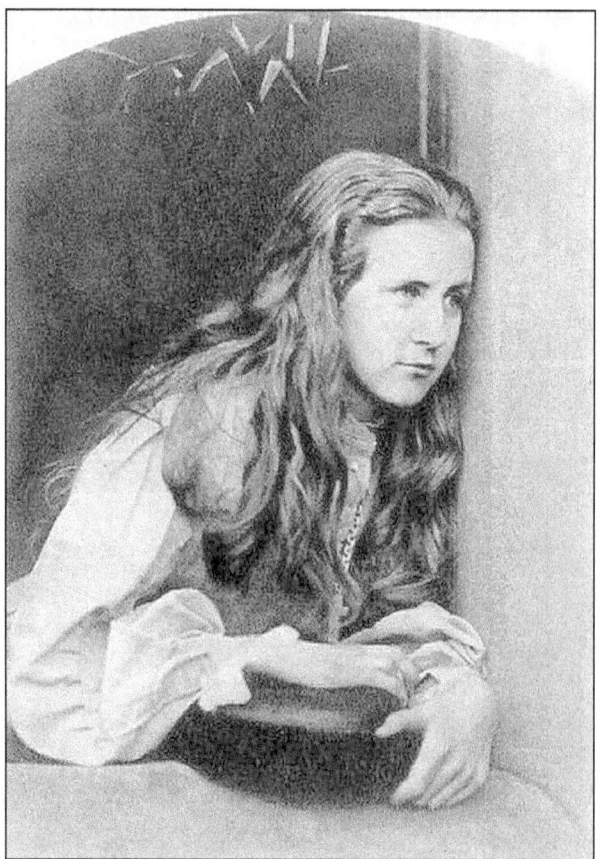
Florence Bickersteth (September 8, 1865)

Brodie sisters (Ethel, Lillian and Margaret Anne)

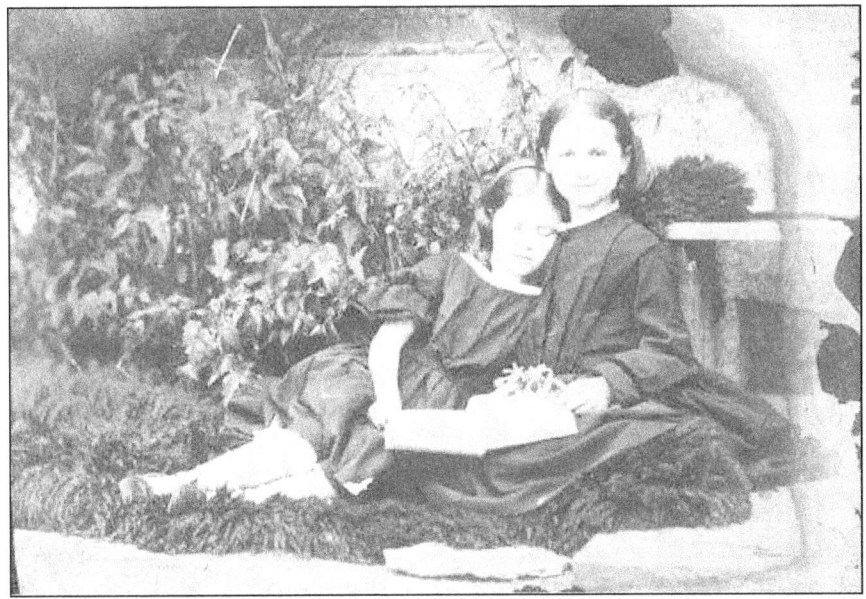
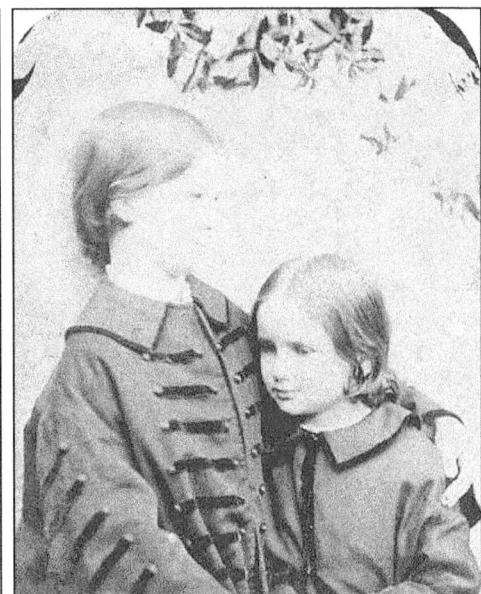

Ethel and Lilian Brodie (June 21, 1861) Margaret Anne and Lilian Brodie (Autumn 1860)

Brooke Sisters (Olive, Honor and Evelyn) and Miss Cole

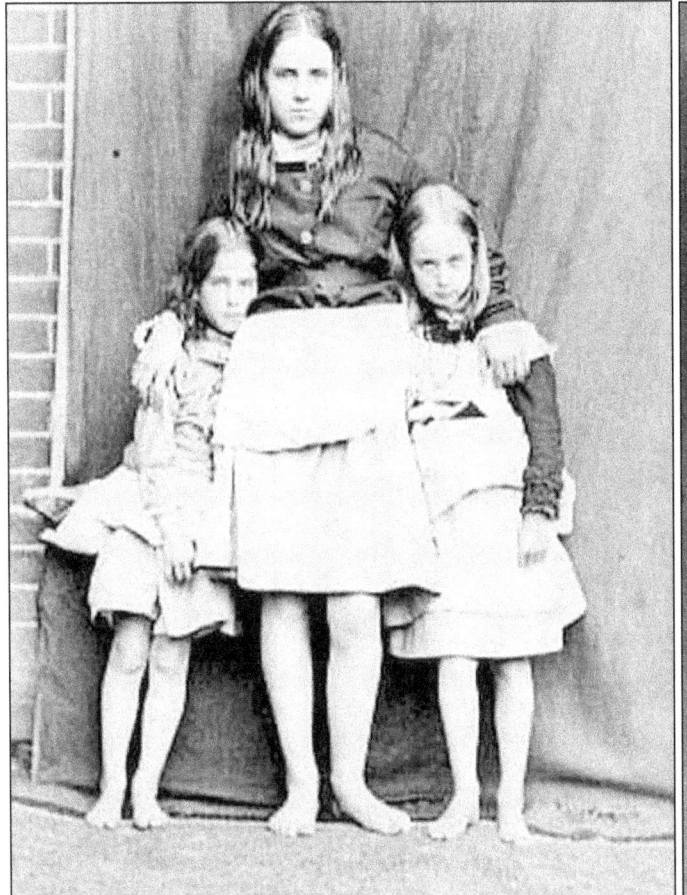
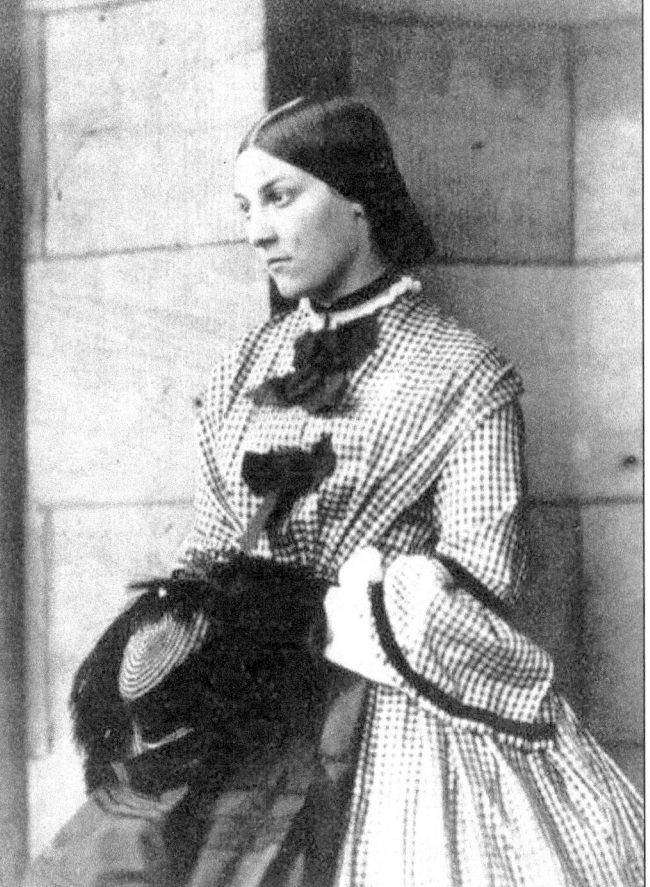

Olive [1868-1945] Honor [1861-1940] Evelyn [1866-1947] (July 13, 1875) Miss Cole (summer 1859)

Denham children (Charlotte Edith, Arthur and Grace)

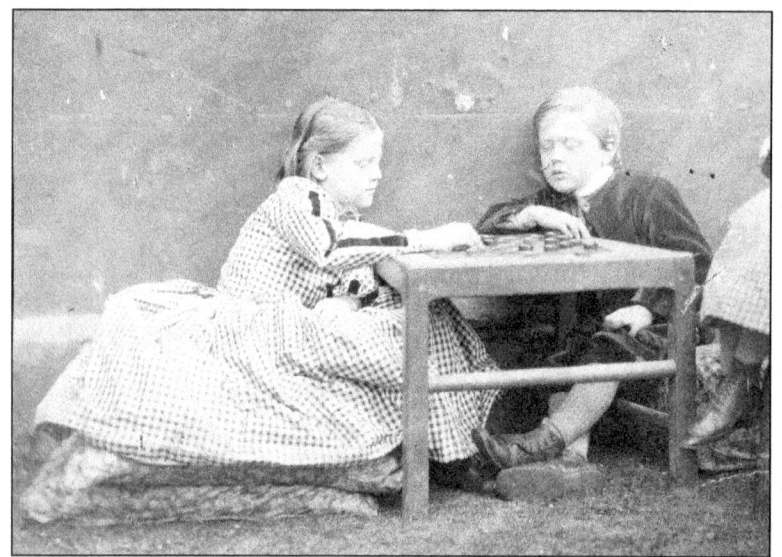
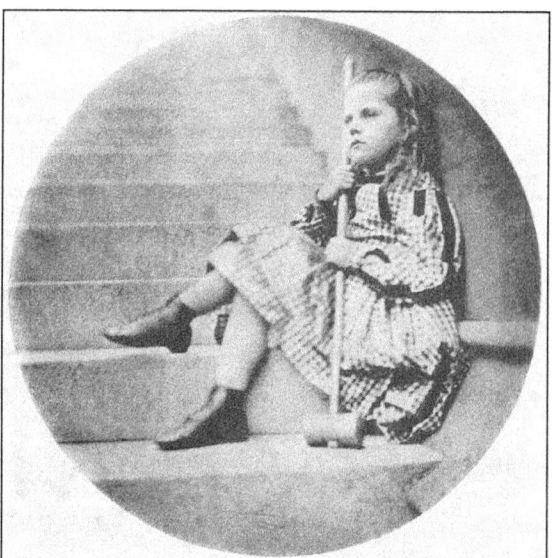

Charlotte Edith Denman, Arthur Denman and Grace Denman's legs (July 8, 1864) Grace Denman (July 8, 1864)

Dodgson families

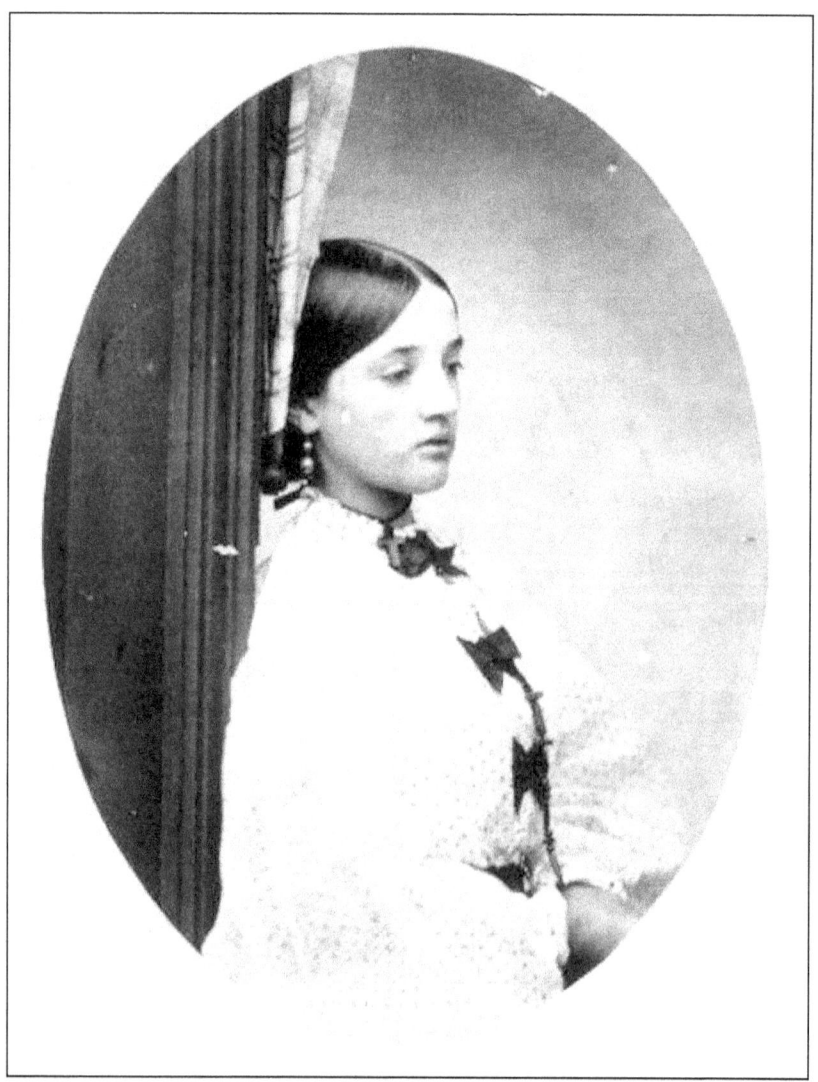

Charlotte Mary Dodgson, daughter of Carroll's uncle Hassard Dodgson (September 1, 1862)

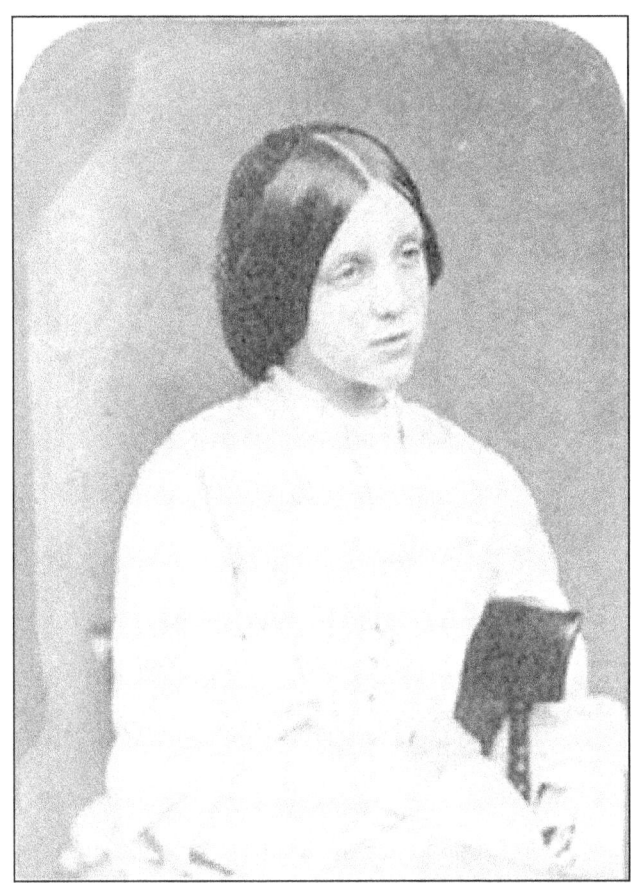
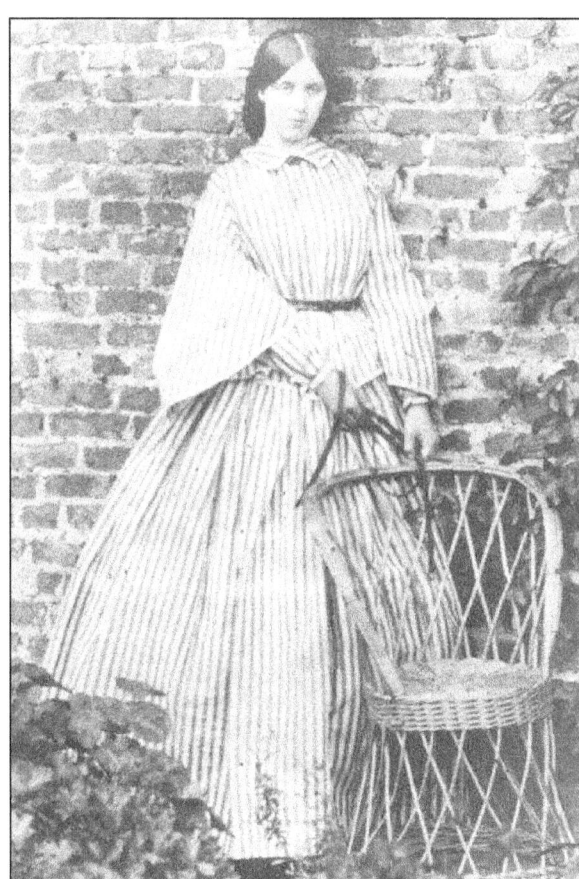

Henrietta Harrington Dodgson - Carroll's youngest sister (summer 1859) Henrietta Dodgson (Summer 1860)

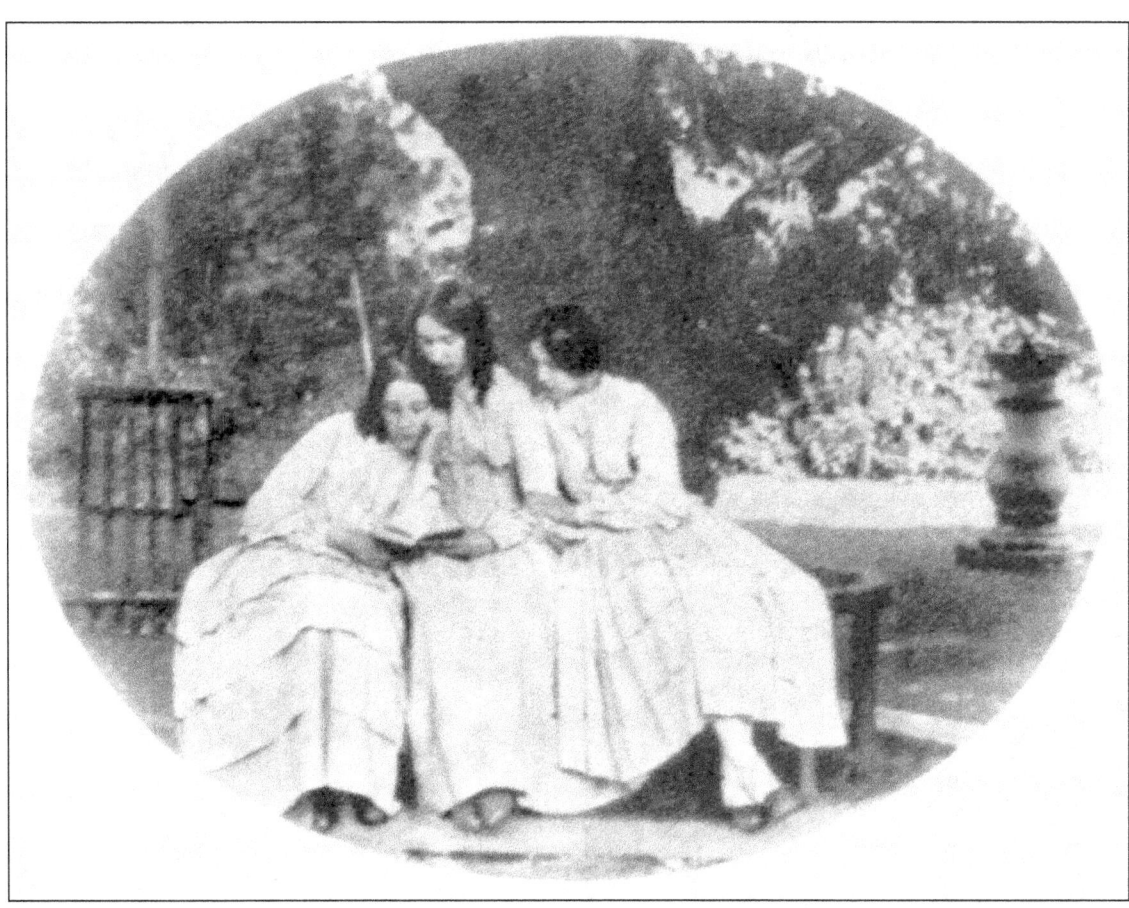

Carroll's sisters Louisa Fletcher Dodgson, Margaret Anne Didgson and Henrietta Dodgson (July/August, 1857)

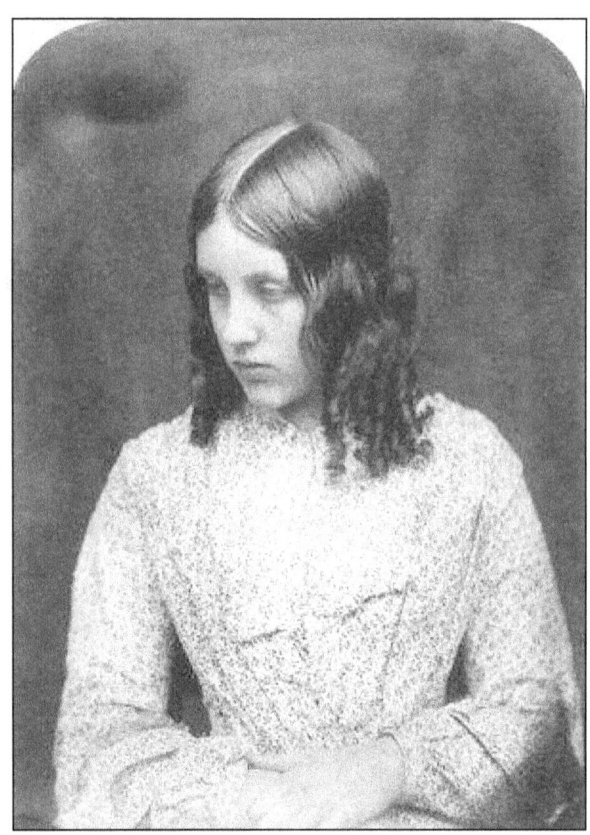

Carroll's sister Margaret Ann Ashley Dodgson (summer 1859) Margaret A. A. Dodgson in "Reflection" (September 1862)

Donkin cousins (Alice Emily Donkin and Alice Jane Donkin)

Alice Emily Donkin was born in 1849. She was a British painter who exhibited widely between the years 1871 and 1909. She and her family, based in Oxford, had associations with the Dodgson family, especially as Alice's first cousin Alice Jane married Lewis Carroll's brother Wilfred in 1871. She died in 1940.

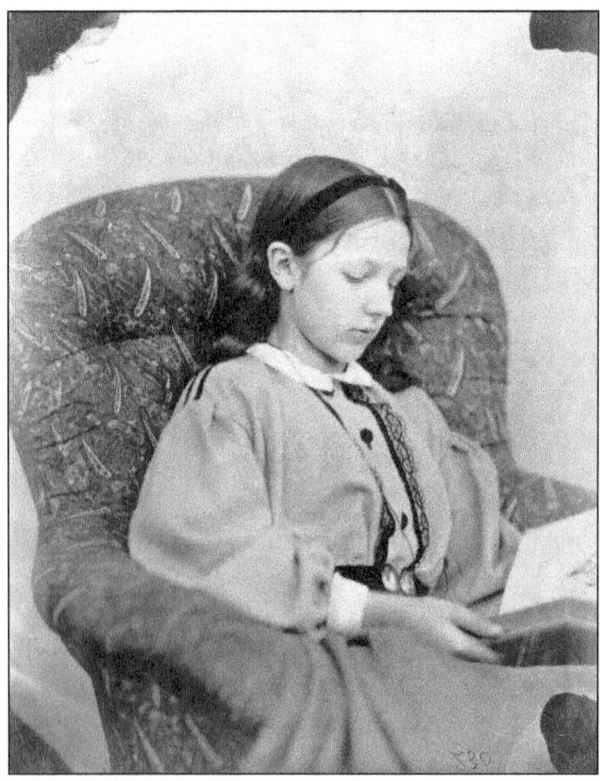
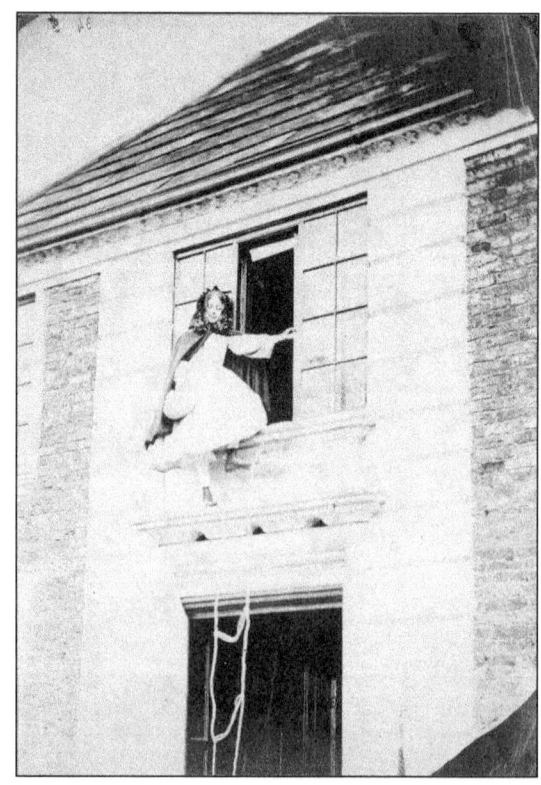

Alice Emily Donkin (July 1-3, 1863) Alice Emily Donkin "The Elopement" (October 9, 1862)

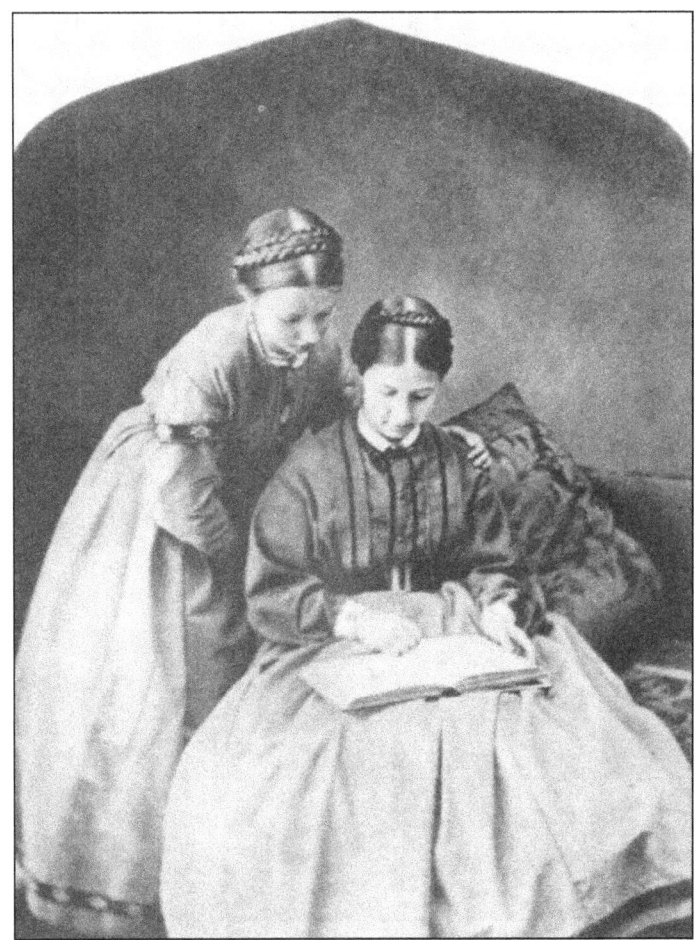

Alice Emily Donkin and cousin Alice Jane Donkin [1851-1929]

(May 14, 1866)

Dykes sisters (Gertrude, Mary and Caroline)

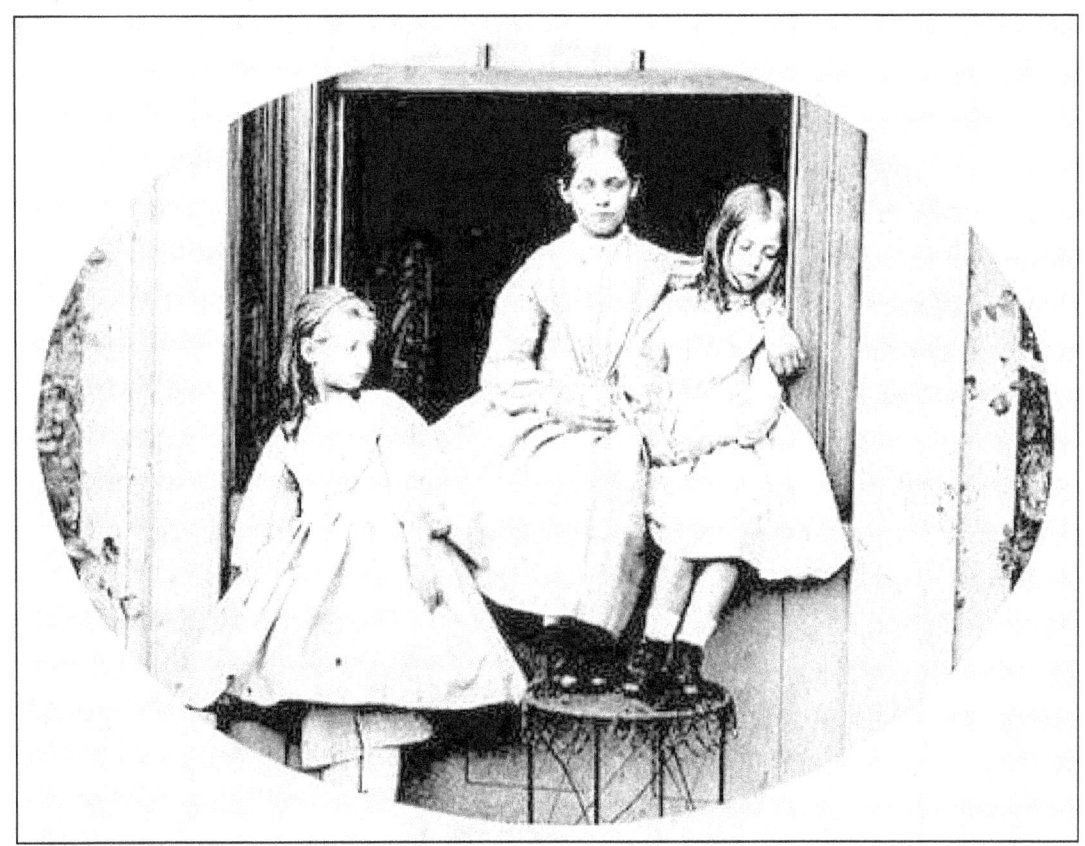

Gertrude, Mary and Caroline Dykes (September 1862)

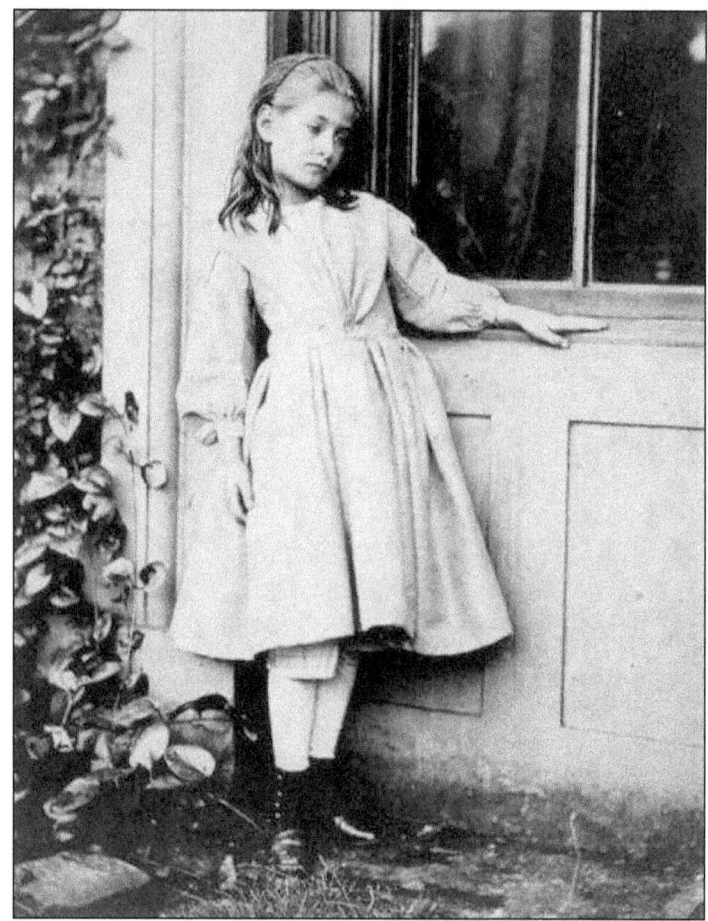

Gertrude Dykes
(September, 1862)

Edith Hulme and Eliza D. Hobson

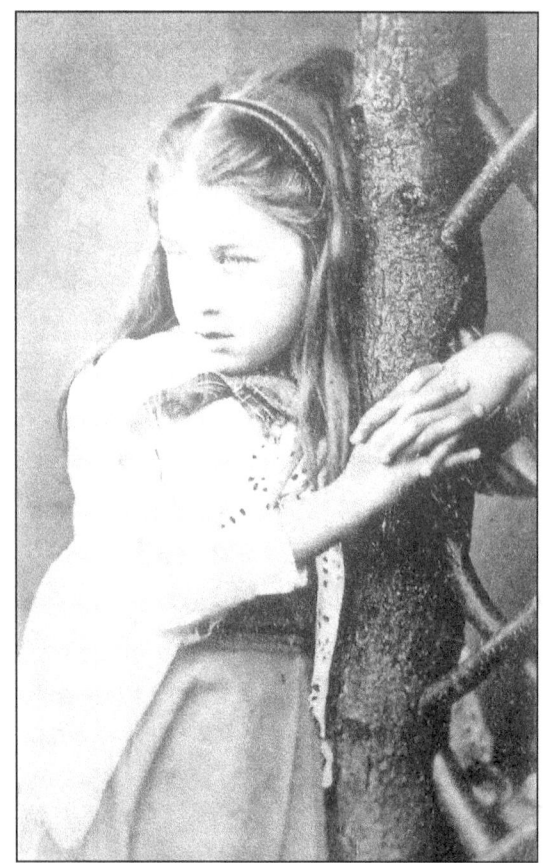

Edith Hulme (October 8, 1869)

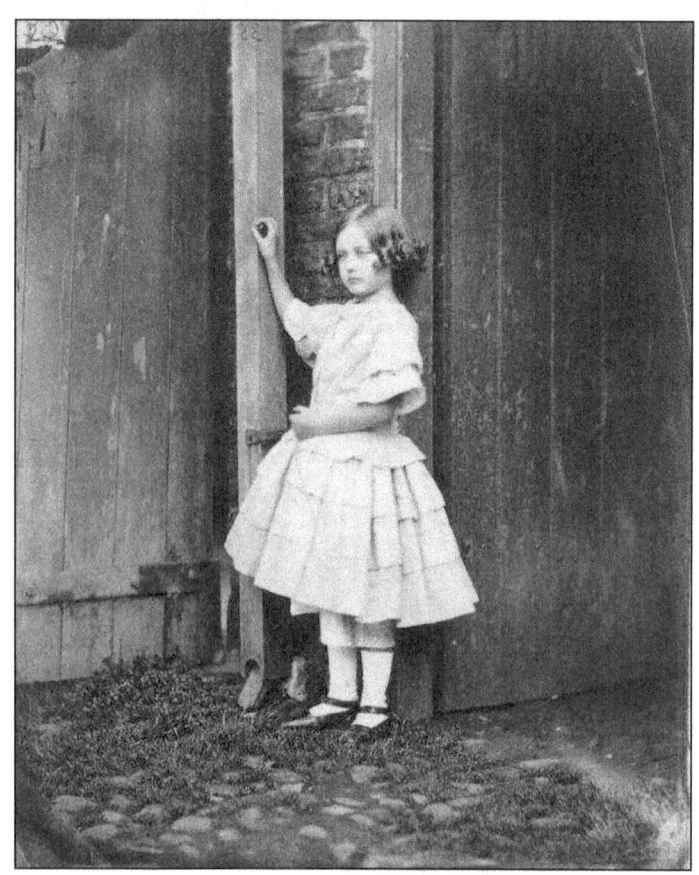

Eliza Hobson (summer 1860)

Eleanor Winifred Howes [probably] (Young Girl on Eastourne Beach)

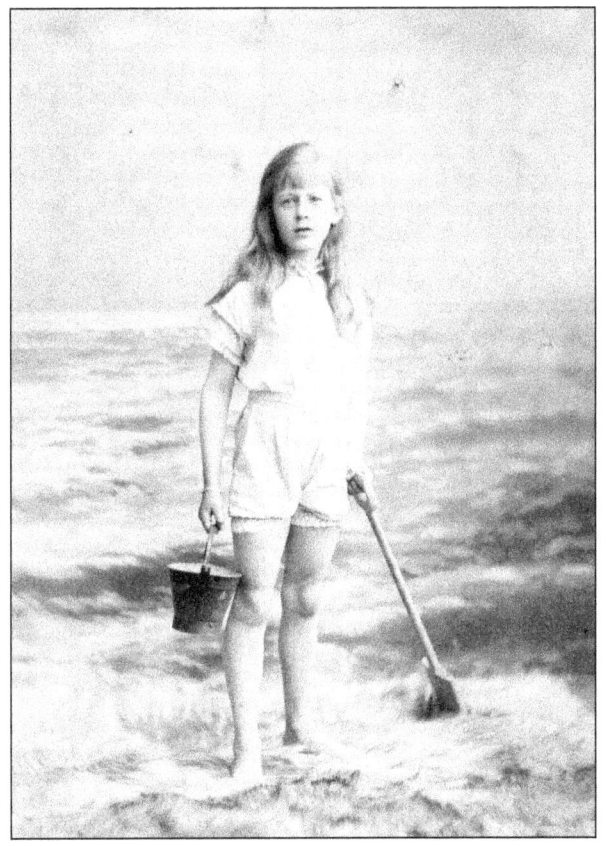

Eleanor Winifred Howes (1882)

Although Carroll's last diary entry regarding his photography was in 1880, he did make regular visits to Eastbourne, a seaside resort in E. Sussex. An expert from the London auctioneers said this photograph was probably taken with the help of commercial photographer William Kent of Eastbourne. He said: "It is quite possible that Lewis Carroll supervised the taking of the photograph himself, using Kent's studio, camera and equipment. "He frequented Kent's studio quite a few times in 1882. His 1882 diary recorded sessions on July 25, August 1 and 19, and September 3, 8, 16 and 25." It is thought the photo in question relates to the shoot on September 8. In his diary he said: "Took Alice to Mr Kent's at 2, and had two photos done: then Winnie Howes ditto in bathing dress." On the back of the photograph is the note "For Miss Symonds, from CL Dodgson, a memento of the beach at Eastbourne in the summer of 1883."

Ellison sisters (Constance and Mary)

Constance and Mary in "Tired of Play" (August 23, 1862)

Constance Ellison (August 23, 1862)

Elizabeth Ley Hussey

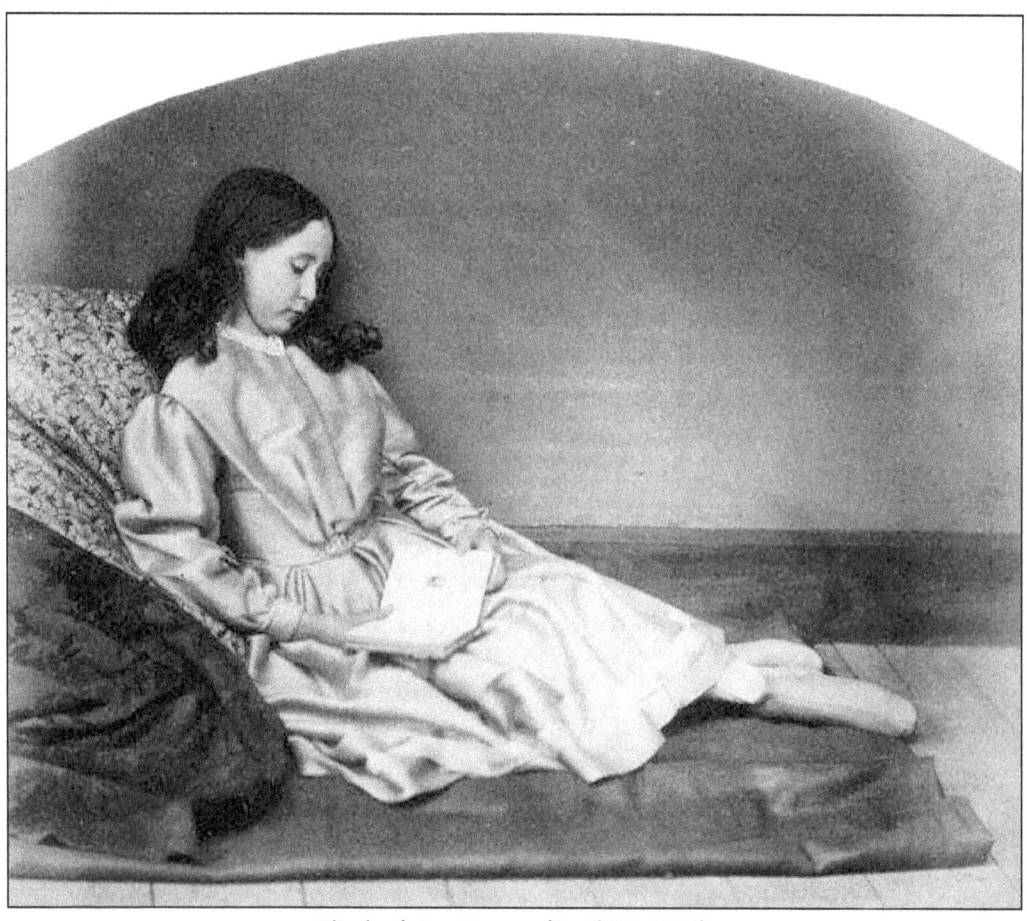

Elizabeth Ley Hussey (April 26, 1864)

Ella Chlora Faithful Monier-Williams

Ella Monier-Williams (May 24 or 29, 1866)

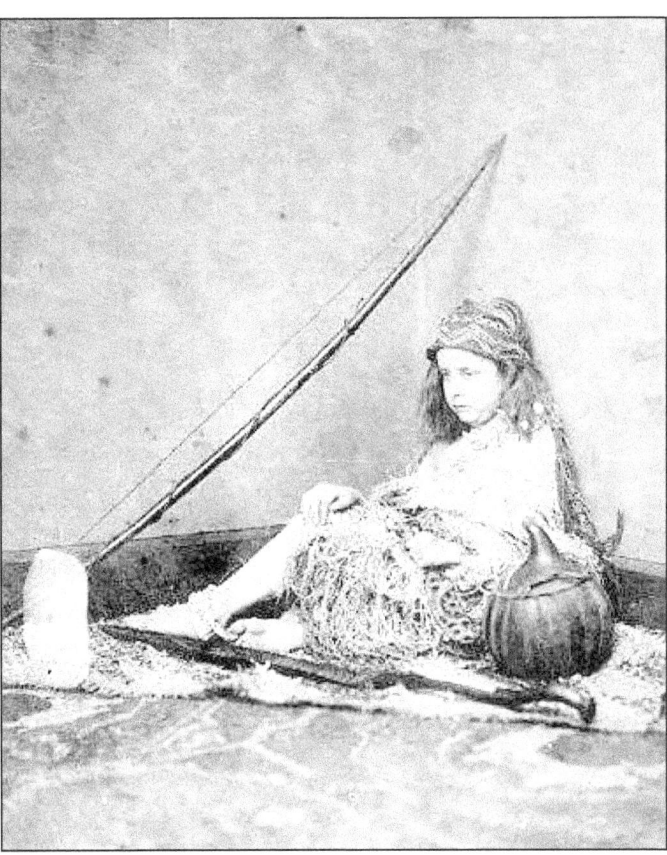

Ella Monier-Williams (July 9, 1866)

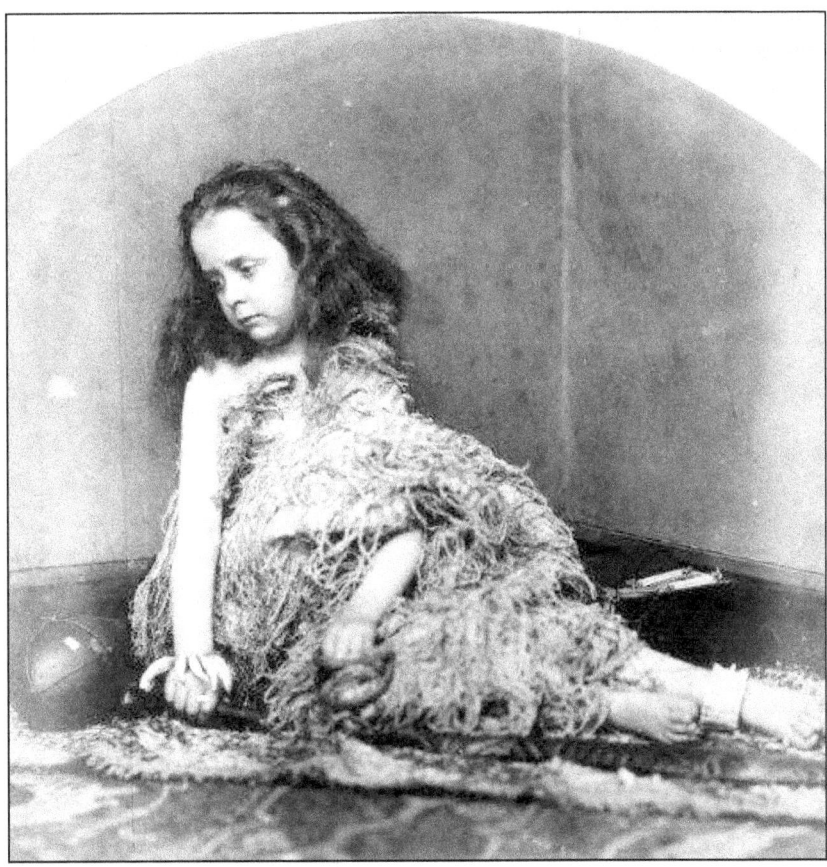

Ella Monier-Williams (July 9, 1866)

Ellis sisters (Bertha, Dymphna and Mary)

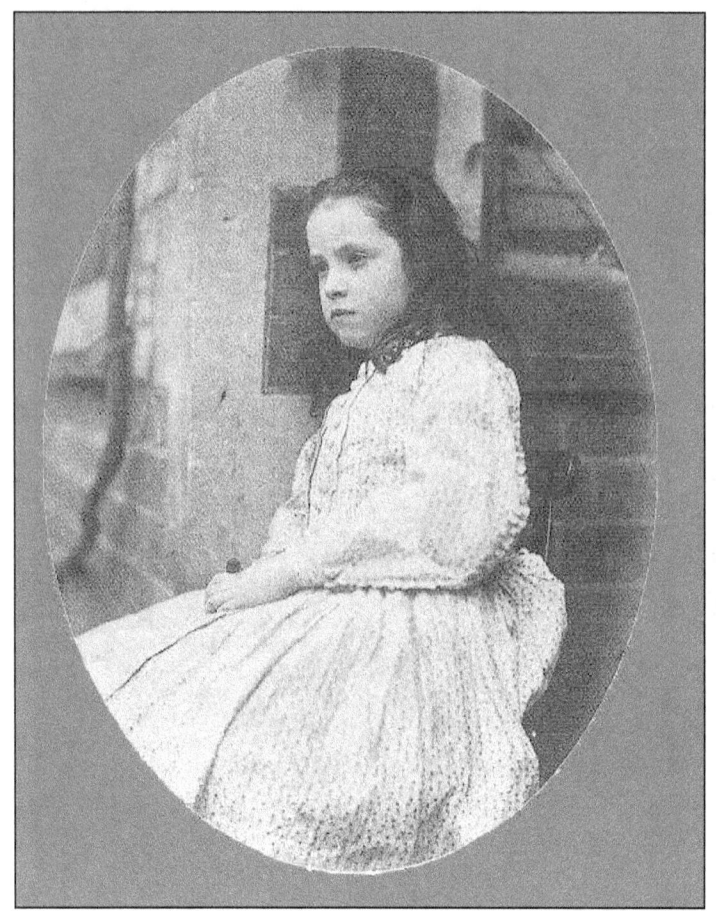

Bertha Ellis (July 26-27, 1865)

Dymphna Ellis (July 25, 1865)

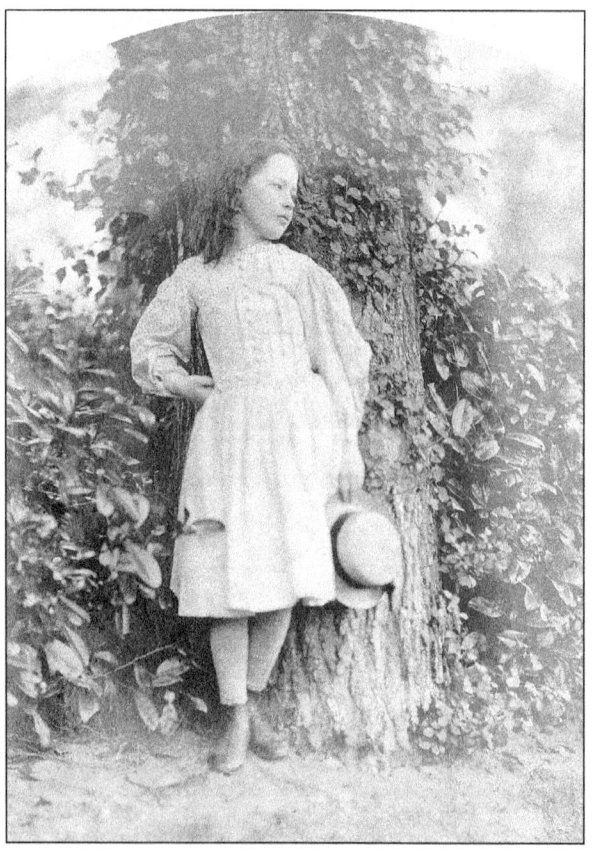

Mary Ellis
(July 26-27, 1865)

May, Dumphna and Bertha Ellis (July 26 Or 27, 1865)

Evelyn Dubourg with Kathleen O'Reilly

Evelyn Dubourg, Kathleen O'Reilly (July 10, 1875)

Evelyn Dubourg (August 13, 1873)

 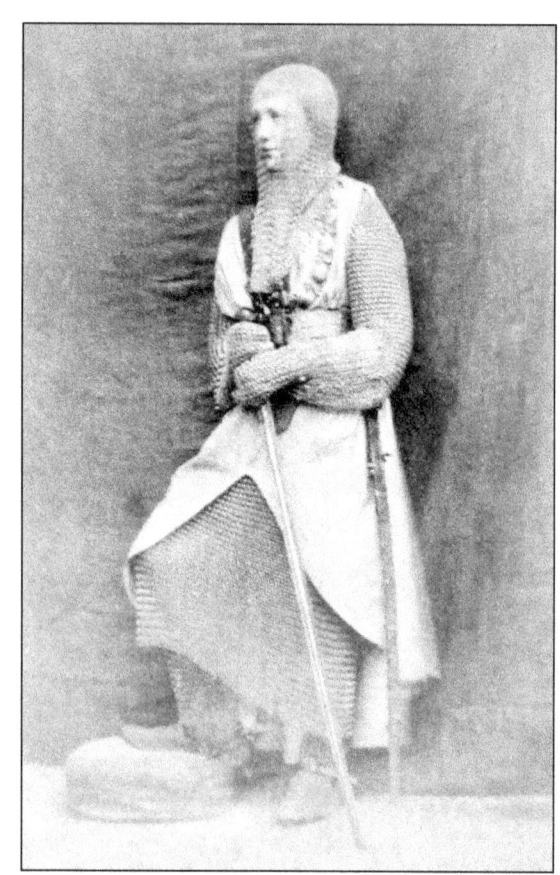

Evelyn Dubourg as "Joan of Arc" (July 12, 1875)

Frederica Harriette Morrell and Frederick, Crown Prince of Denmark

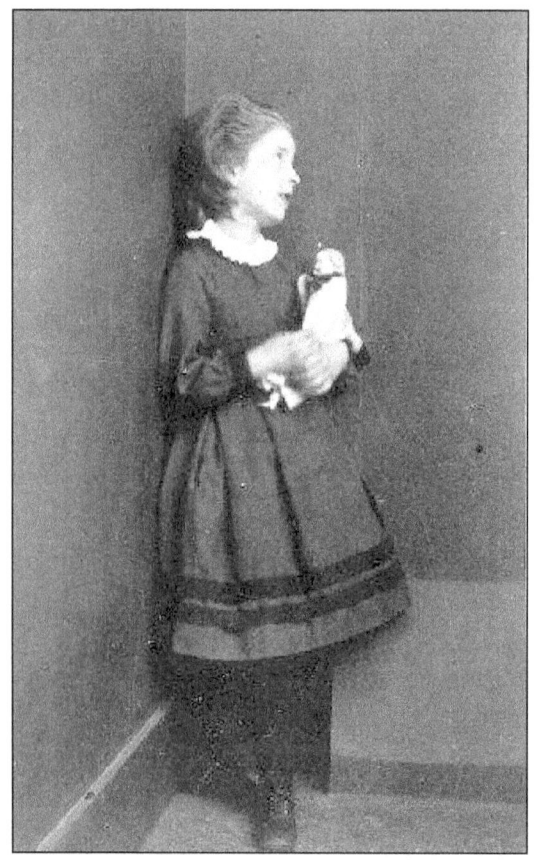 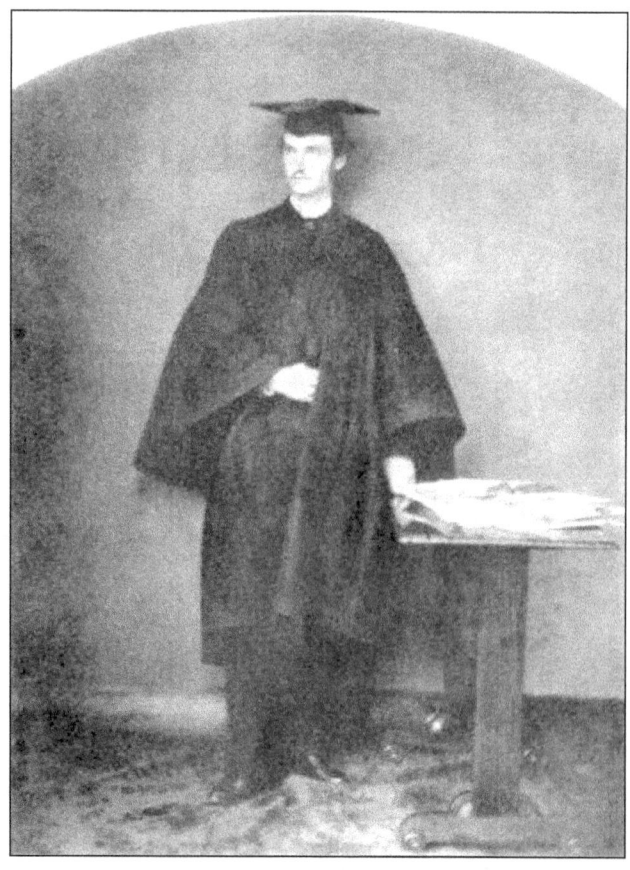

Frederica Harriette Morrell (July 11, 1873) Frederick, Crown Prince of Denmark (November 18, 1863)

Flora Rankin and Florence Hilda Bainbridge

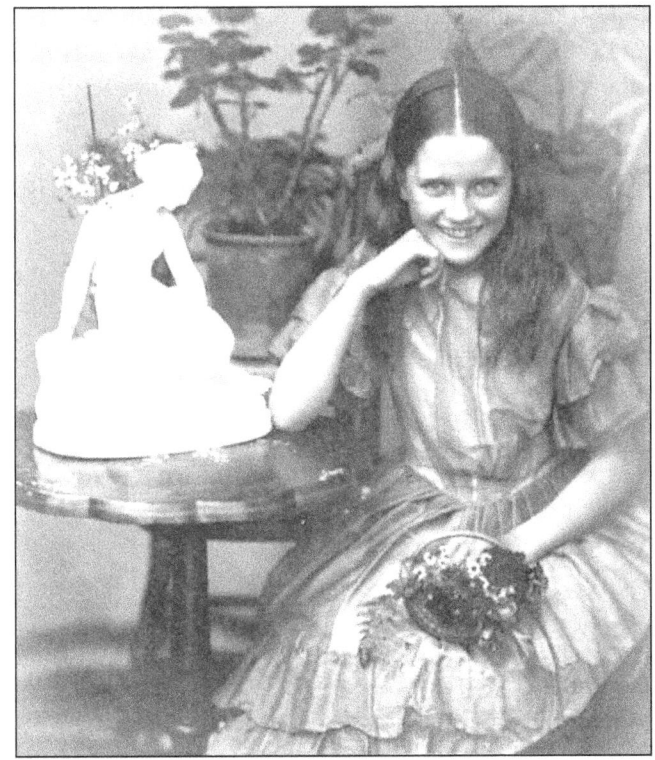

Flora Rankin (July 25-31, 1863) Florence Hilda Bainbridge (summer 1860)

Georgina "Gina" Mary Balfour

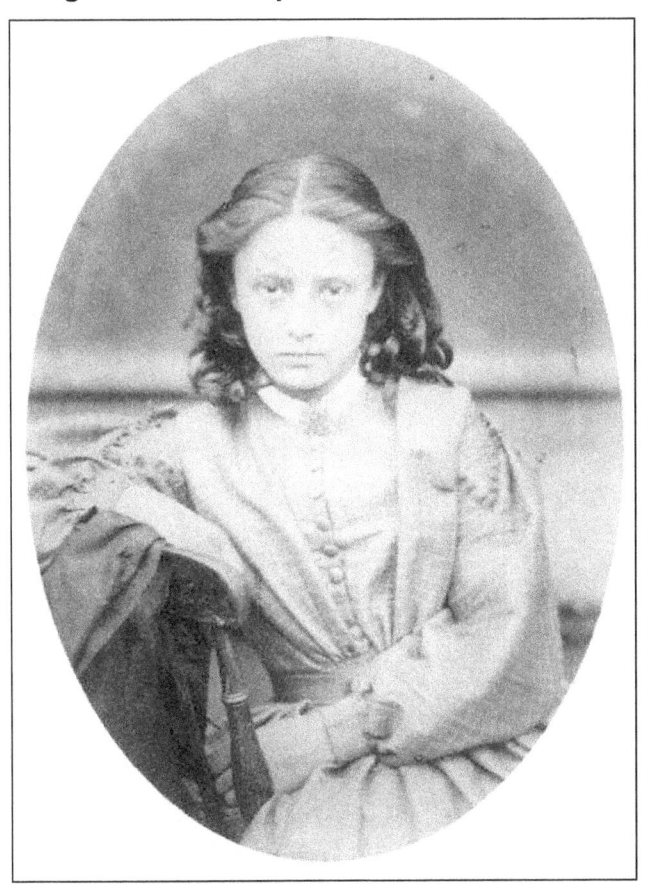
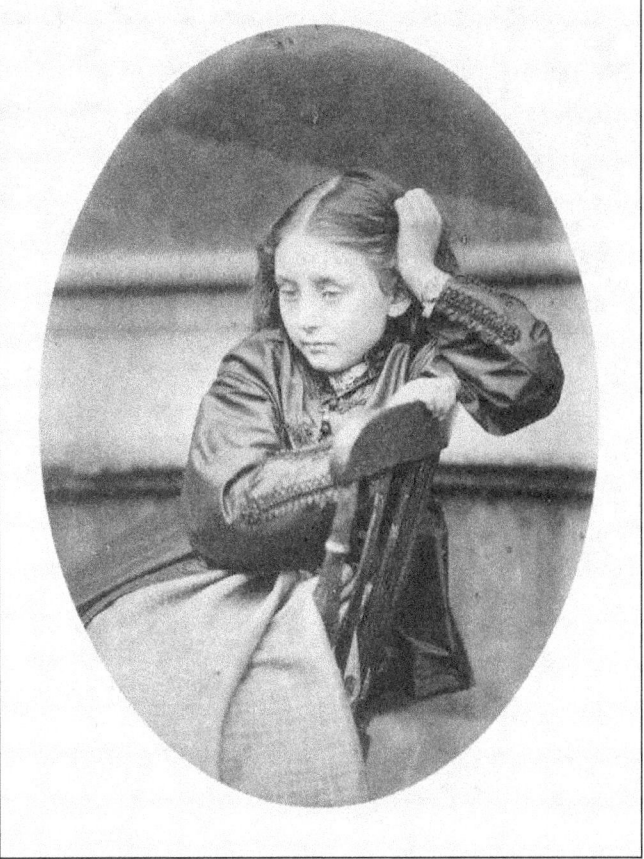

Georgina "Gina" Mary Balfour (July 5, 1864)

Gertrude Chataway

(Annie) Gertrude Chataway (1866-1951) was an important child-friend in the life of the author Lewis Carroll. Carroll's great nonsense mock-epic *The Hunting of the Snark* (1876), is dedicated to her and opens with a poem that uses her name as a double acrostic, i.e., both the first letter of each line and the first word in each stanza spell her name.

The opening page of the *Hunting of the Snark* reads -

Inscribed to a dear Child: in memory of golden summer hours and whispers of a summer sea.

Girt with a boyish garb for boyish task,
Eager she wields her spade: yet loves as well
Rest on a friendly knee, intent to ask
The tale he loves to tell.

Rude spirits of the seething outer strife,
Unmeet to read her pure and simple spright,
Deem, if you list, such hours a waste of life,
Empty of all delight!

Chat on, sweet Maid, and rescue from annoy
Hearts that by wiser talk are unbeguiled.
Ah, happy he who owns that tenderest joy,
The heart-love of a child!

Away, fond thoughts, and vex my soul no more!
Work claims my wakeful nights, my busy days—
Albeit bright memories of that sunlit shore
Yet haunt my dreaming gaze!

Carroll first became friends with Gertrude in 1875, when she was aged nine and he was forty-three, while on holiday at the English seaside resort of Sandown. He made a number of pen and ink sketches of Gertrude as a young girl. He continued to correspond with her, and to spend numerous seaside holidays with her, including several when she was in her late twenties.

Annie Gertrude Chataway October 26, 1876

Harington sisters (Alice and Beatrice) and Harry Ashworth Taylor

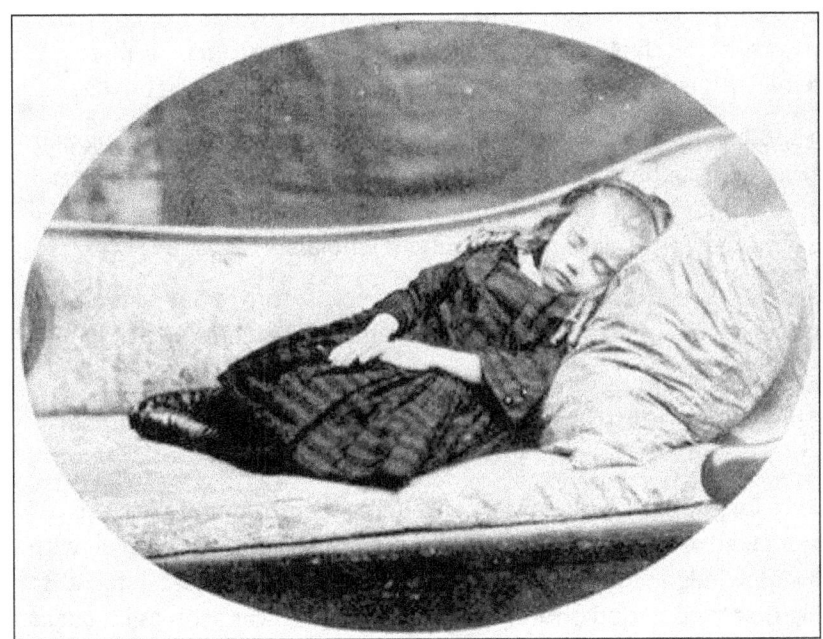

Alice Margaret Harington (March 26, 1858)

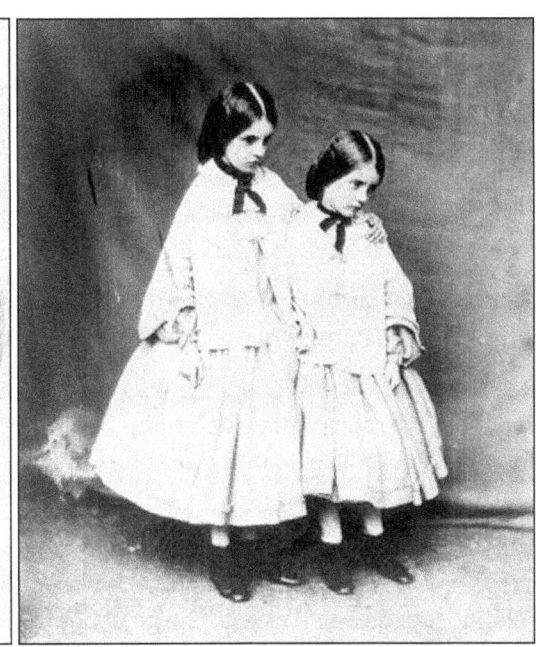

Beatrice Cecilia Harington
and Alice M. Harington (autumn 1860)

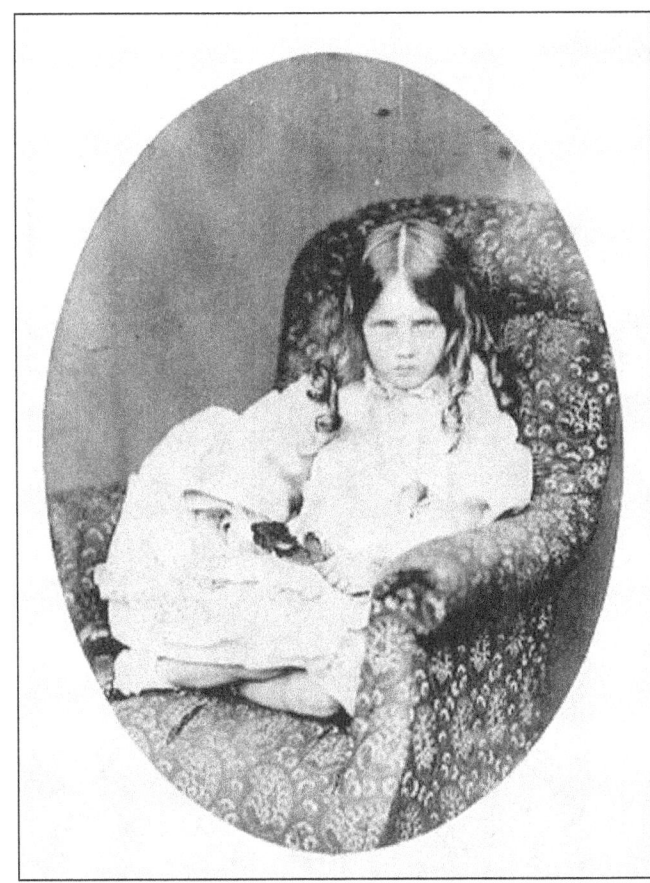

Alice Margaret Harington (spring 1860)

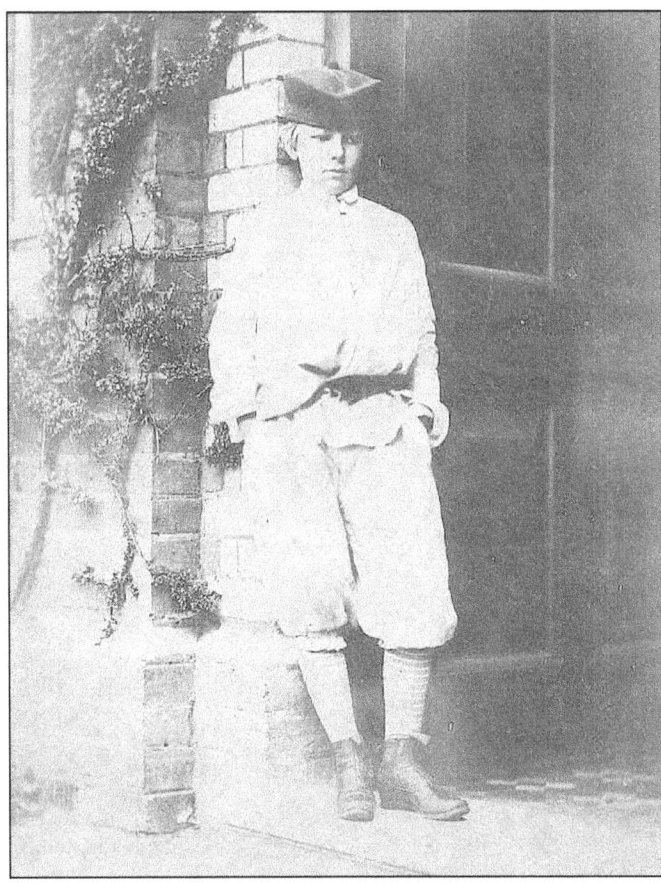

Harry Ashworth Taylor (September 5, 1862)

Hatch Siblings (Wilfred, Beatrice, Ethel and Evelyn)

Reverend Edwin Hatch, born in 1835, was a theologian; author; a vice-principal of St. Mary Hall, Oxford; and later a university reader in ecclesiastical history. In 1863 Edwin married Bessie Thomas with whom he had five children. The oldest children, the two boys, were Arthur Herbert Hatch (1864-1910) and Wilfred Stanley Hatch. Wilfred Stanley was born in September 1865 became a minister and died in September 1937.

The family lived in a Gothic-style house built in 1866 on Banbury Road in Norham Gardens, North Oxford, England. Neighborhood friends included Julia and Ethel Huxley, daughters of Thomas Henry Huxley and the mother and aunt respectively of Aldous and Julian Huxley. Other acquaintances in the neighborhood who visited the Hatch family included Bonamy Price, Mark Pattison, and Benjamin Jowett – all Oxford University scholars.

Beatrice Sheward Hatch was born in September 1867. She attended Oxford High School, Oxford, a day school for girls in Oxfordshire. While there, she acted in plays, as well as arranged texts for dramatic presentations.

Beatrice, along with her sisters, was introduced to Carroll through mutual acquaintances. Carroll cultivated "the friendship of many little girls", often photographing them. His friendships with these children focused on upper-middle-class families, making sure he did not seek very low-class children as friends.

After their introduction, Beatrice was said to be "a long term favorite of Carroll". Carroll referred to Beatrice as "Bee" sometimes and started photographing her naked around the age of 5. These sessions were undertaken with the permission from Mrs. Hatch, who was in full knowledge of the activities. Modern writers have speculated at the relationship Carroll had with the girls, but during that time period photographing young girls was seen as innocent and free from sexual connotations.

Hatch wrote her memories of Carroll when she was an adult, as did other "child friends" including Ethel Arnold and Ethel Rowell. She died on December 20, 1947.

Wilfred Stanley Hatch [1865-1956] (April 19-30, 1872)

Beatrice Hatch (March 24, 1874)

Beatrice Hatch (July 29, 1873)

Beatrice Hatch (July 7, 1873)

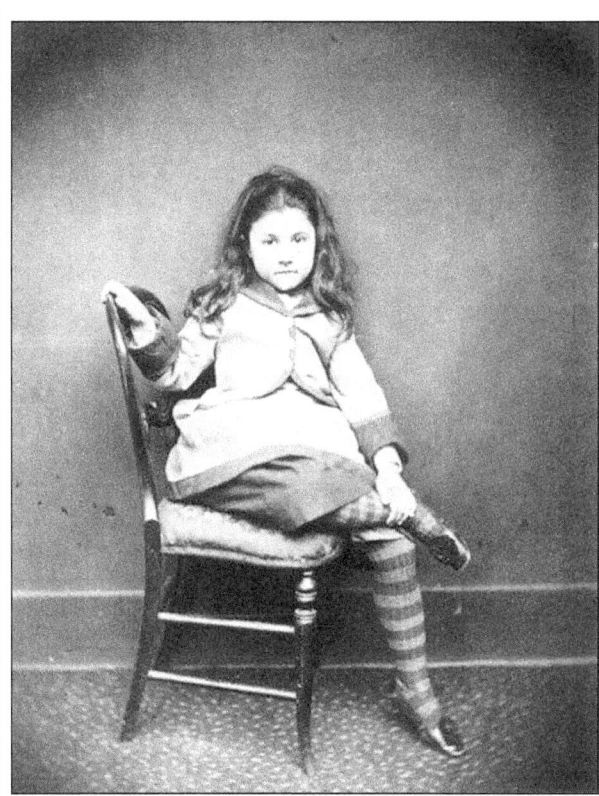

Beatrice Hatch (March 24, 1874)

Ethel Charlotte Chase Hatch was born on May 17, 1869. Ethel's mother gave permission to Carroll to photograph her three girls and Carroll was considered a family friend. Beatrice, rather than Ethel or Evelyn, was considered the "long term favorite of Carroll." Carroll's friendship with Ethel continued for a number of years, however. Along with clothed photo shoots, Carroll also photographed Ethel nude. She was considered one of Carroll's muses. The photos that Carroll took of nude prepubescent girls have been the cause of much discussion and speculation in contemporary times.

As an adult, Ethel was an artist who worked mostly with watercolors, and her paintings made the rounds at galleries for display. Christie's, the art business and a fine arts auction house, has auctioned off some of Ethel's work. She died in 1975, a month shy of her 106th birthday.

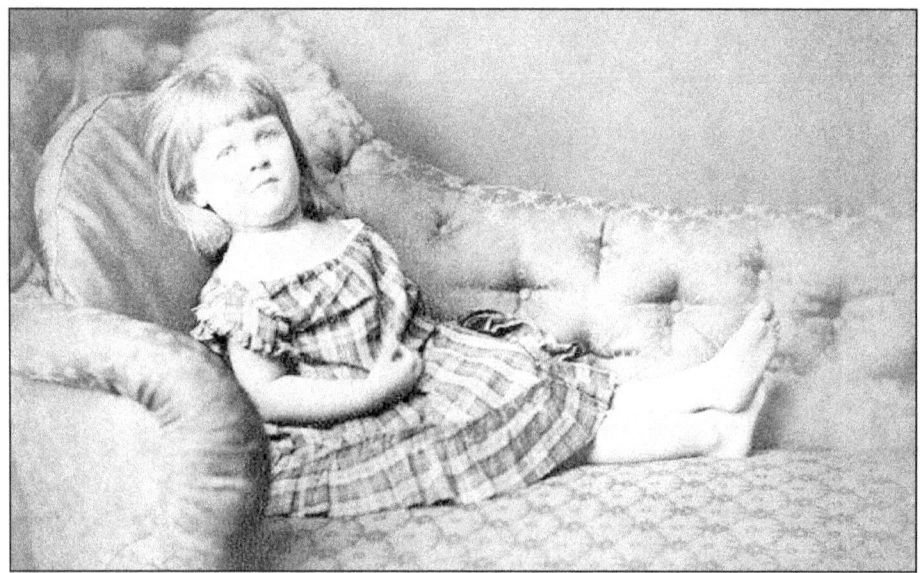

Ethel (April 30, 1872)

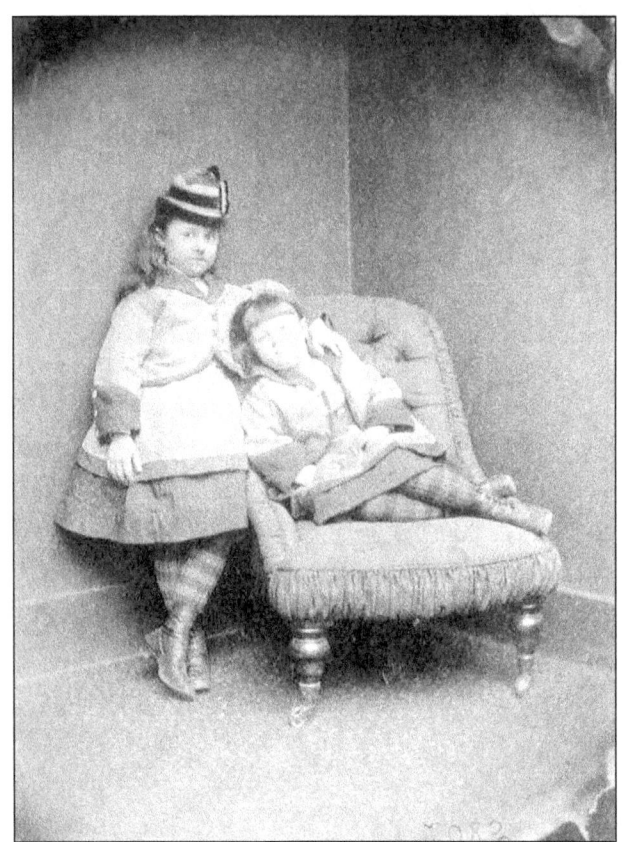

Beatrice and Ethel (March 24, 1874)

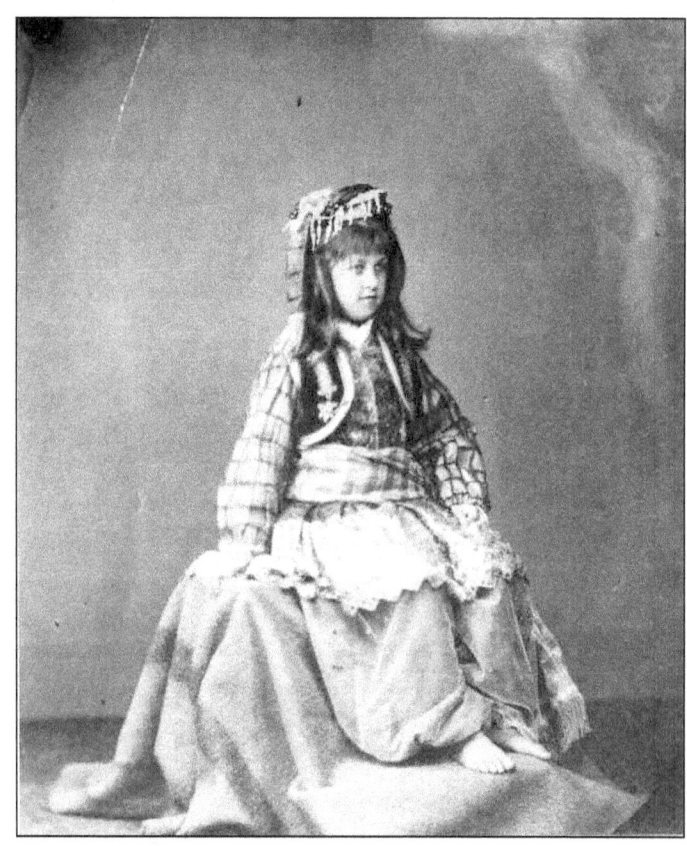

Ethel Hatch (June 16, 1877)

Evelyn Maud Hatch was born in 1871 to Edwin and Bessie Hatch. Carroll's friendship with Evelyn continued for a number of years, lasting until his death when Evelyn was in adulthood. In 1897, Evelyn acted as a bridesmaid to Dorothy Maud Mary Kitchin, daughter of the Rev. George Kitchin and sister of Alexandra Kitchin, another of Carroll's youthful subjects. In1927, Evelyn released a book she had written titled *Burgundy: Past and Present*, a historical tour of the Burgundy region of France. After Carroll's death and in her adulthood, Evelyn edited a book of Carroll's letters called *A Selection from the Letters of Lewis Carroll to his Child-Friends*.. Evelyn died in 1951.

Evelyn Hatch (July 29, 1879)

Evelyn Hatch (June 15, 1880)[4]

Henderson sisters (Annie and Frances)

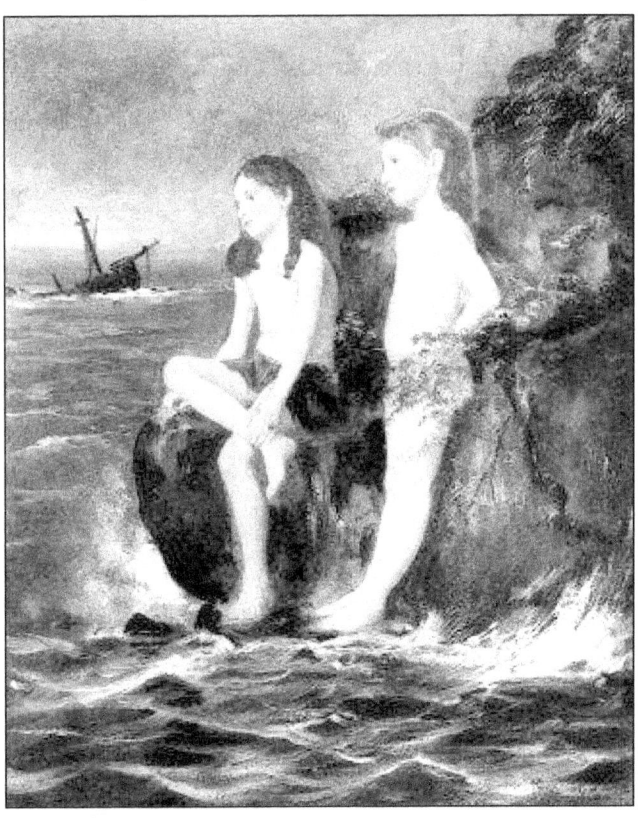

Annie Gray Wright and Hamilton Frances Henderson

(July 15, 1879)

[4] Last photographic entry in Lewis Carroll's diary for which a print is known to exist.

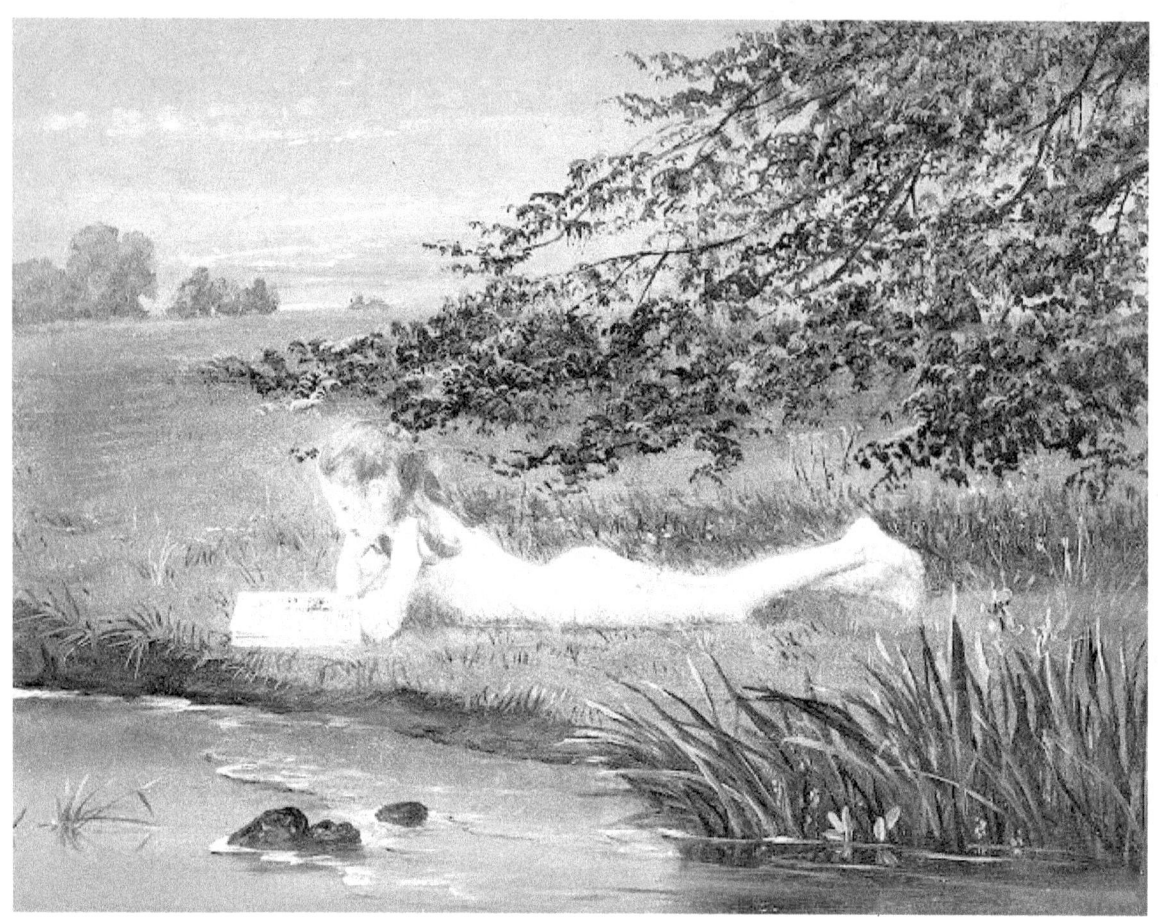

Annie Henderson (July 18, 1879)
From the Governing Body of Christ Church, Oxford; shelf mark Carroll-Annie Henderson

Hughes family (Tryphena and her children Arthur, Amy, and Agnes)

Tryphena and her children Arthur, Amy, and Agnes (July 19, 1864)

Amy (October 12, 1863)

Hughes, Arthur and Isabella (Ella) Maude Drury

The Hughes' father was the pre-Raphaelite painter Arthur Hughes. Carroll owned his painting Lady with the Lilacs.

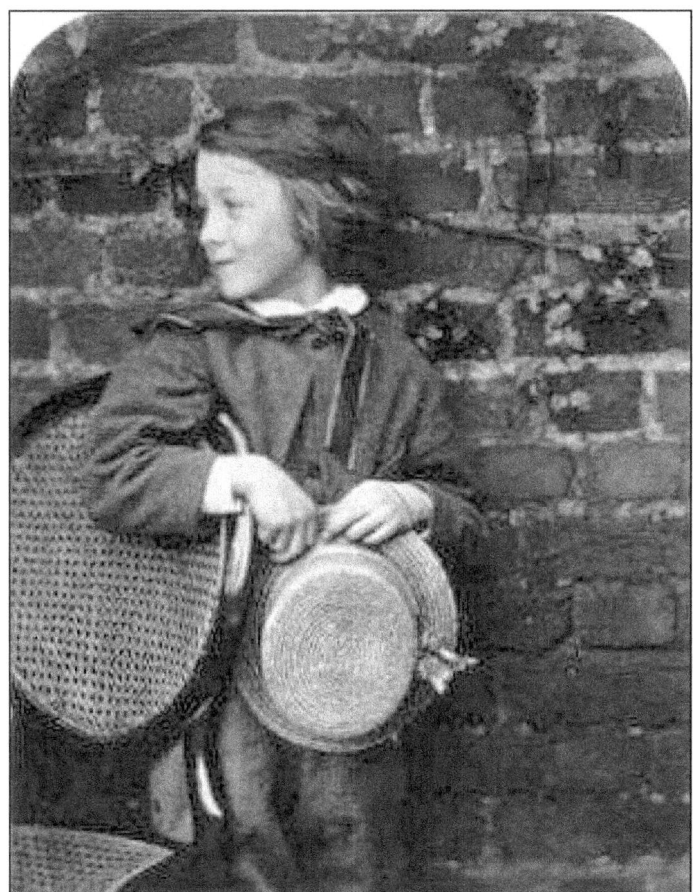

Arthur Hughes (October 12, 1863) Isabella (Ella) Maude Drury (September 4-17, 1869)

Ivo Bligh and Joa Pollock

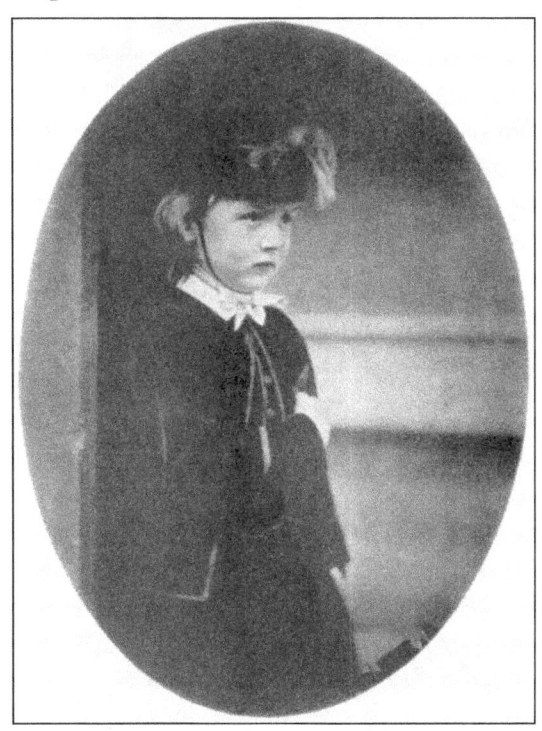
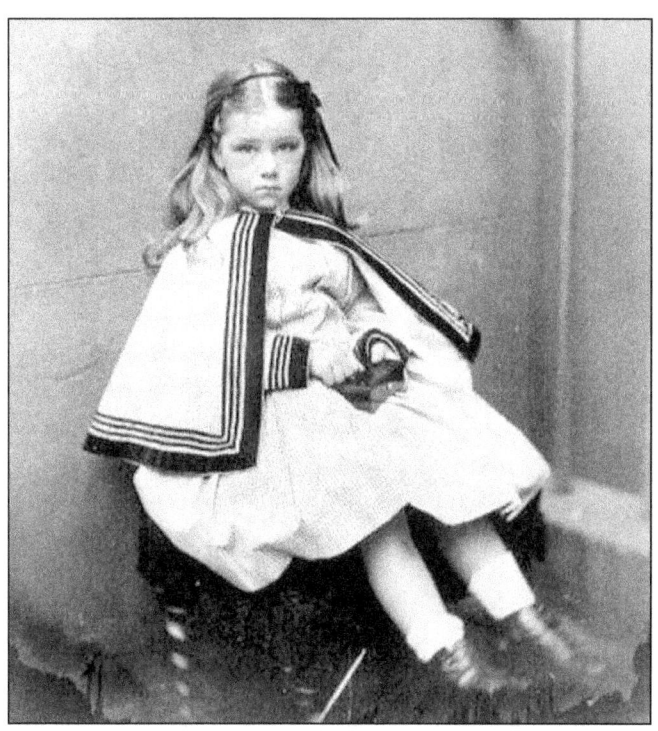

Ivo Bligh (July 7, 1864) Joa Pollock (July 30, 1866)

John (Johnnie) Henry Joshua Ellison, John Wycliffe Taylor

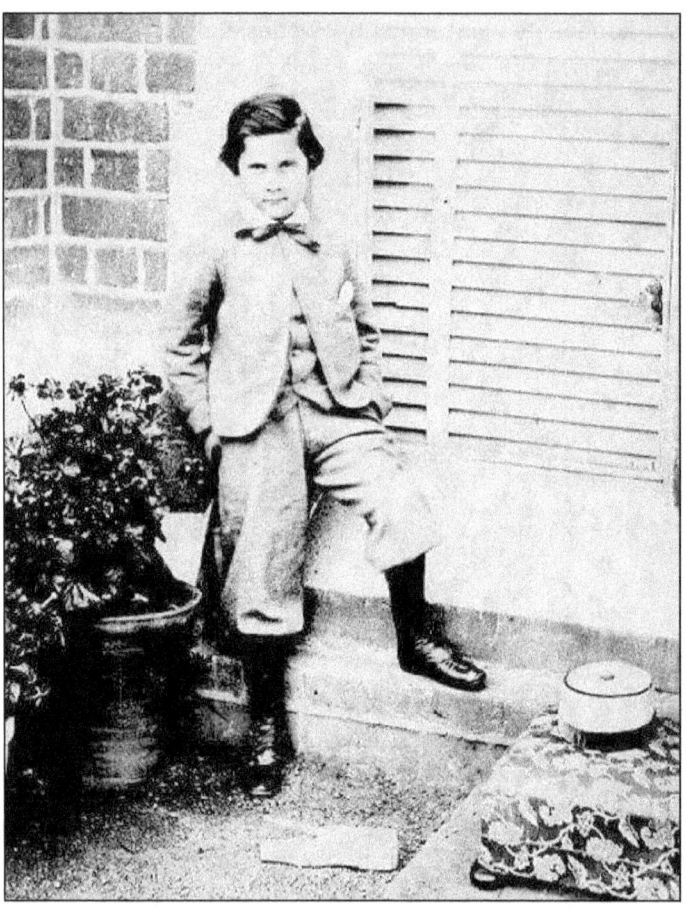

John (Johnnie) Henry Joshua Ellison (August 18-22, 1862)

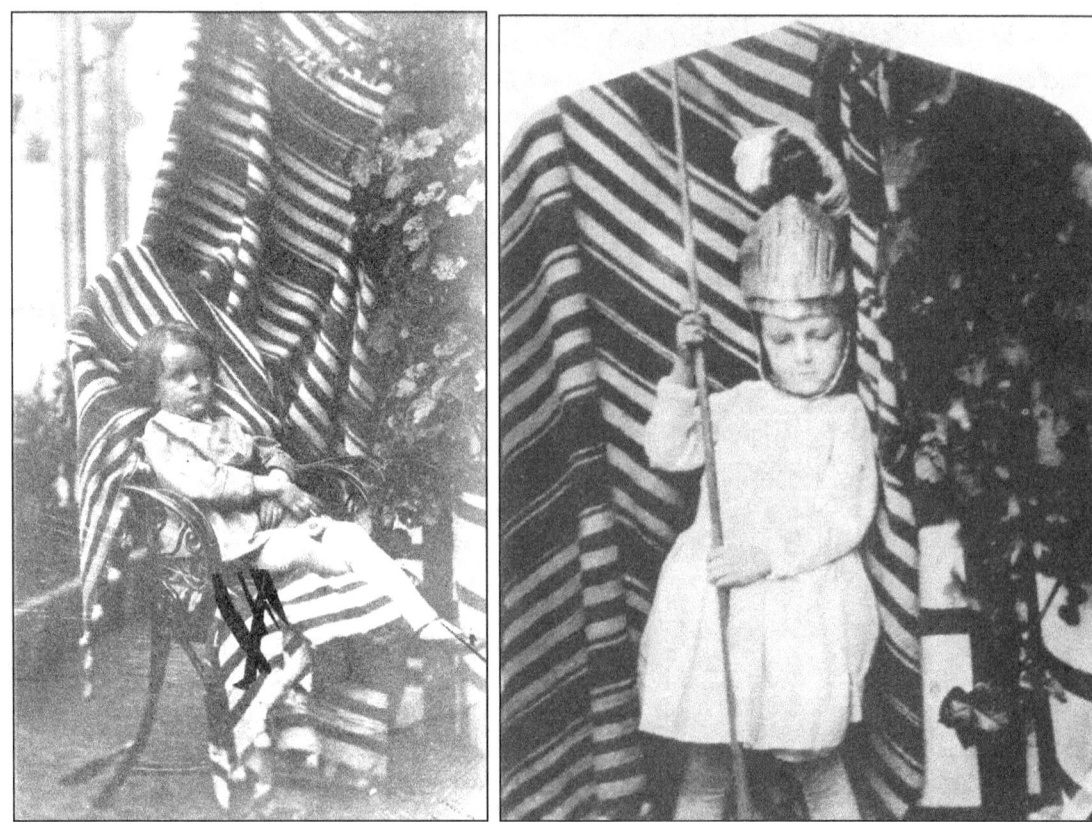

John Wycliffe Taylor (October 3, 1863)

Kathleen Tidy and Katie Brine

Kathleen Tidy (March/April 1858

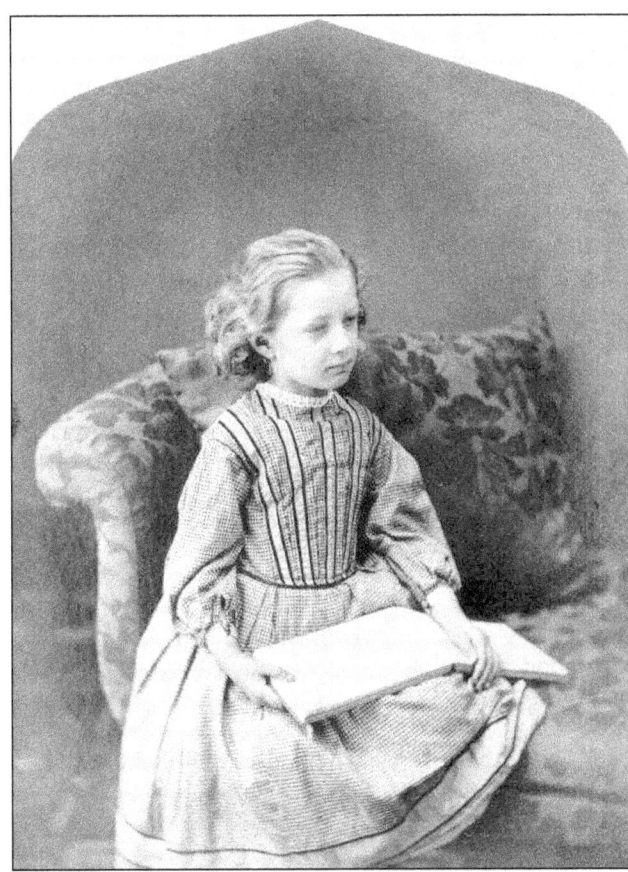
Katie Brine (June 16, 1866)

Kitchin (Alexandra [Xie] Kitchin, Brock Taylor Kitchin, Hugh Bridges Kitchin, George Herbert Kitchin)

Alexandra "Xie" Rhoda Kitchin, who was born on September 29 1864, was a notable 'child-friend' and favorite photographic subject of Carroll.

Xie Kitchin with her mother, Alice Maud Kitchin

(July 12, 1869)

Xie was the daughter of Rev. George William Kitchin (1827-1912), who was Carroll's colleague at Christ Church, Oxford, and later became Dean of Winchester and Dean of Durham, and his wife, Alice Maud Taylor, second daughter of Bridges Taylor, the British consul in Denmark at the time. Her godmother was Alexandra, Queen of Denmark, and then Princess of Wales, who had been a childhood friend of her mother. Xie had three younger brothers: George Herbert, Hugh Bridges, and Brook Taylor, and a younger sister, Dorothy Maud Mary. All were featured in Carroll's photographs.

Quoting from Carroll's friend Henry Holiday's autobiography *Reminscences Of My Life*: "The girl was called Alexandra, after her godmother, Queen Alexandra, but as this name was long she was called in her family X, or rather Xie (pronounced 'Ecksy'). She was a perfect sitter, and Dodgson asked me if I knew how to obtain excellence in a photograph. I gave it up. 'Take a lens and put Xie before it.'(Xie-lens) ". When Carroll met Rev. Kitchin for the first time he told him the same pun. This pun also appeared in a letter from Brook Kitchin (one of Xie's younger brothers) to Beatrice Hatch and in a letter Carroll sent to Xie on June 16, 1880?. In it he wrote ... "Here is a riddle- 'What is the best way to secure excellence in a photograph?' Answer: 'First you take a "lence," and then put "ecce" before it.'" He is punning on "ecce," the Latin word for "behold."

Carroll took at least 50 photos of Xie, from 1869, when she was four, until 1880, just before her sixteenth birthday, when he gave up photography.

She married Arthur Cardew, a civil servant and gifted amateur musician, on April 17, 1890. They had six children: Penelope (1891-1969), Christopher (1894-?), Richard (1898-1918), Michael (1901-1983), Philip (1903-1960) and Arthur (1906-1985). The family resided at 4 North View, Wimbledon Common, London, until Xie's death on April 6, 1925; they also had a country home at Saunton. She is buried at Putney Vale Cemetery.

Unlike Alice Liddell, Isa Bowman and other Carroll 'child-friends', Xie never published reminiscences of him.

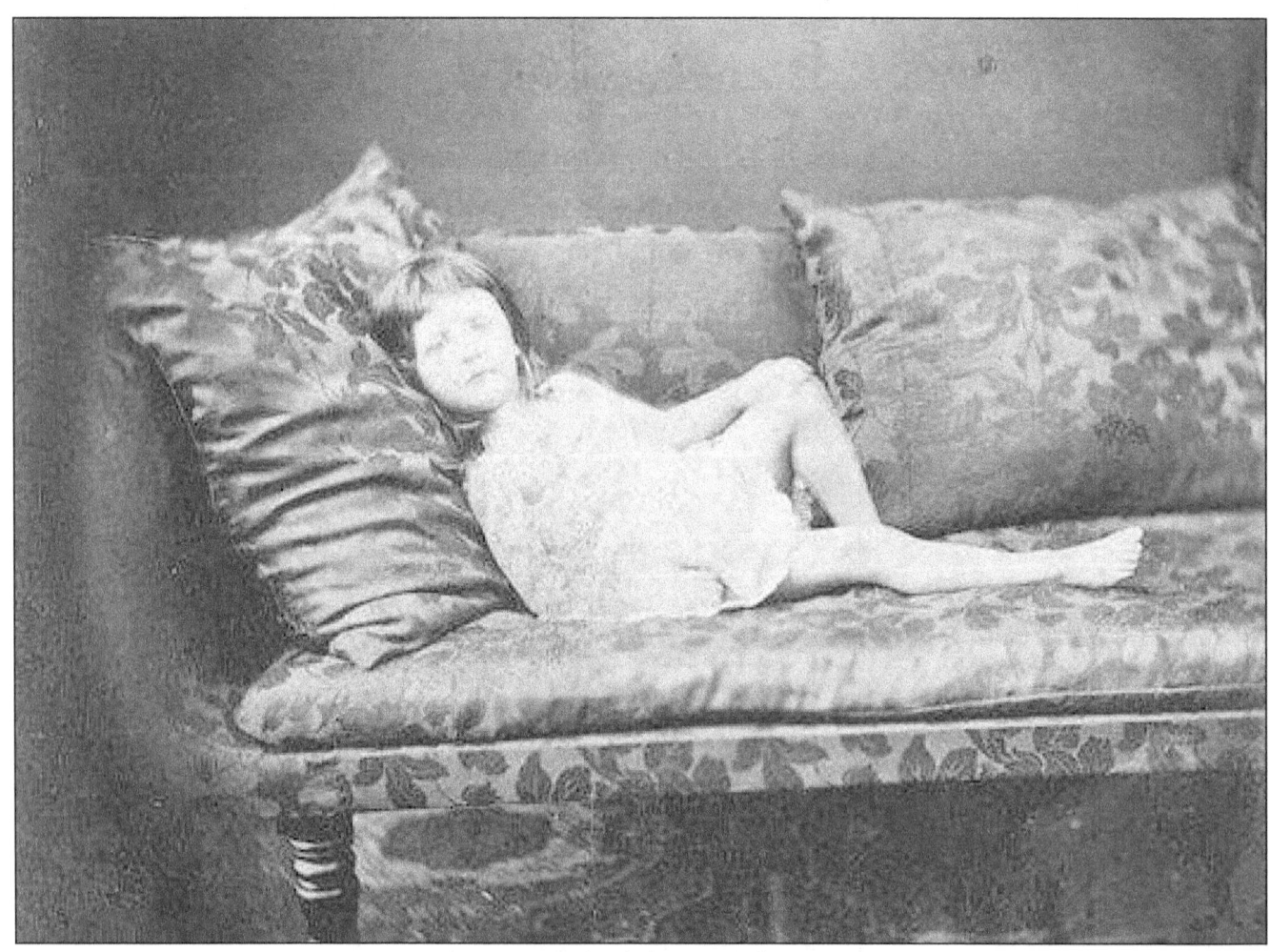

Xie Kitchin (July 12, 1869)

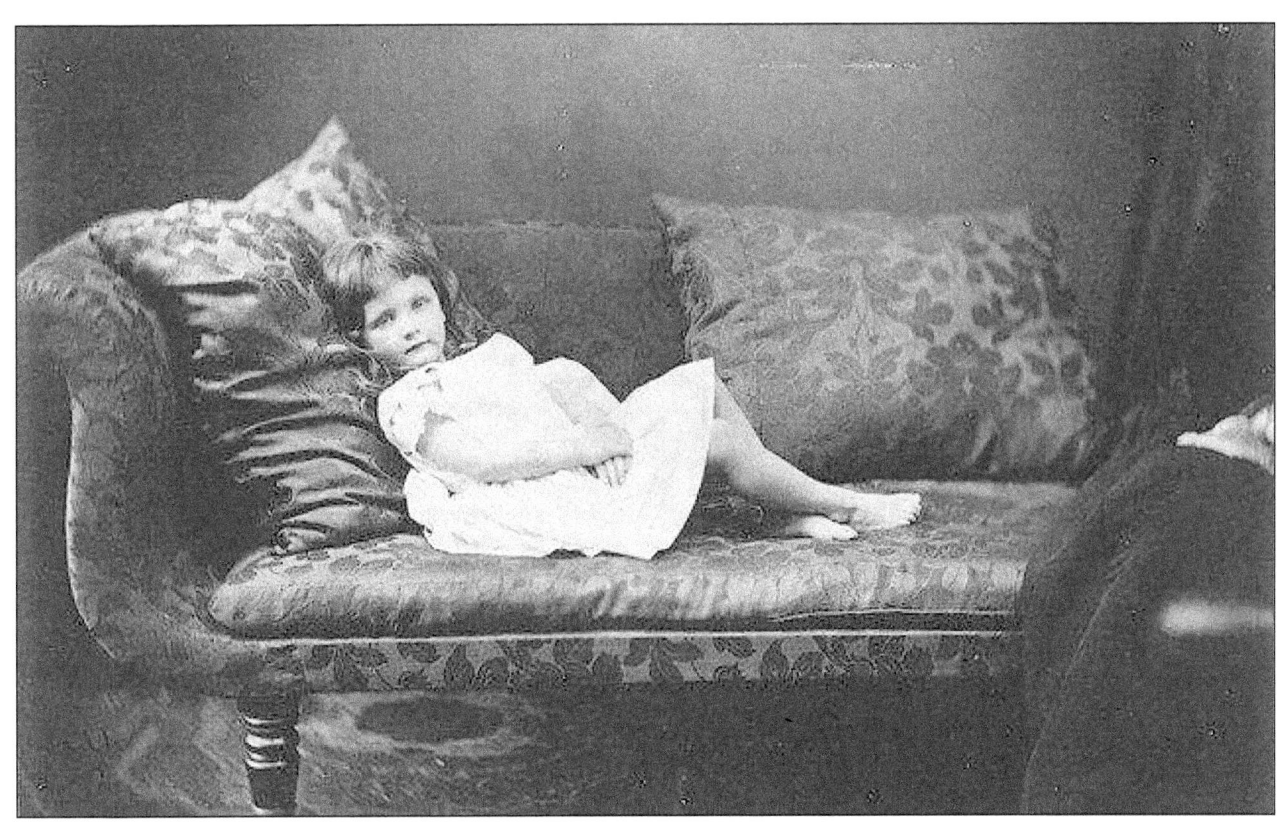

Xie Kitchin (July 12, 1869)

Xie Kitchin (July 15, 1873)

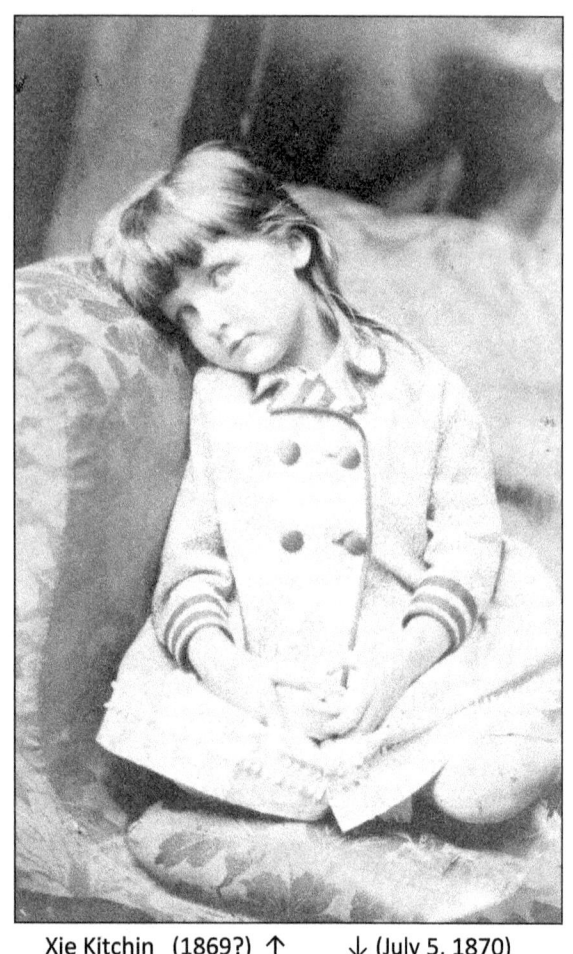
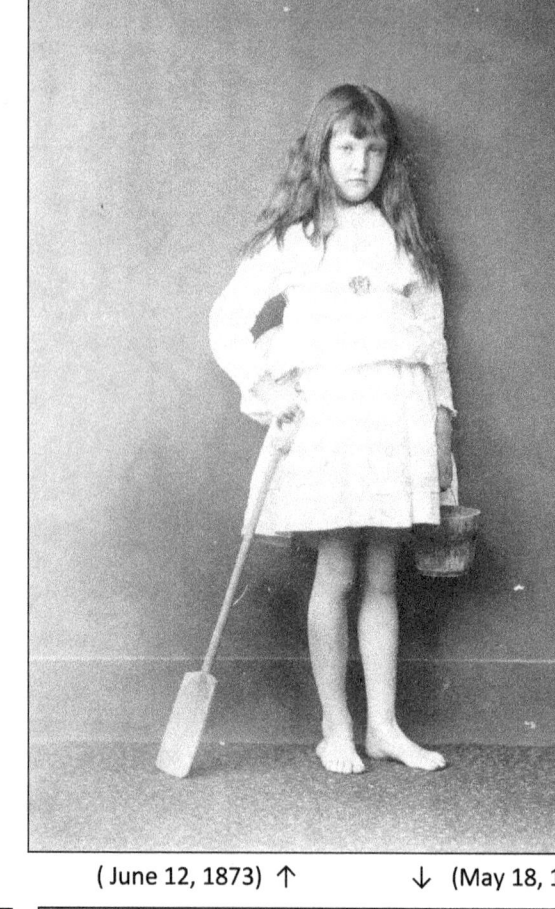

Xie Kitchin (1869?) ↑ ↓ (July 5, 1870) (June 12, 1873) ↑ ↓ (May 18, 1874)

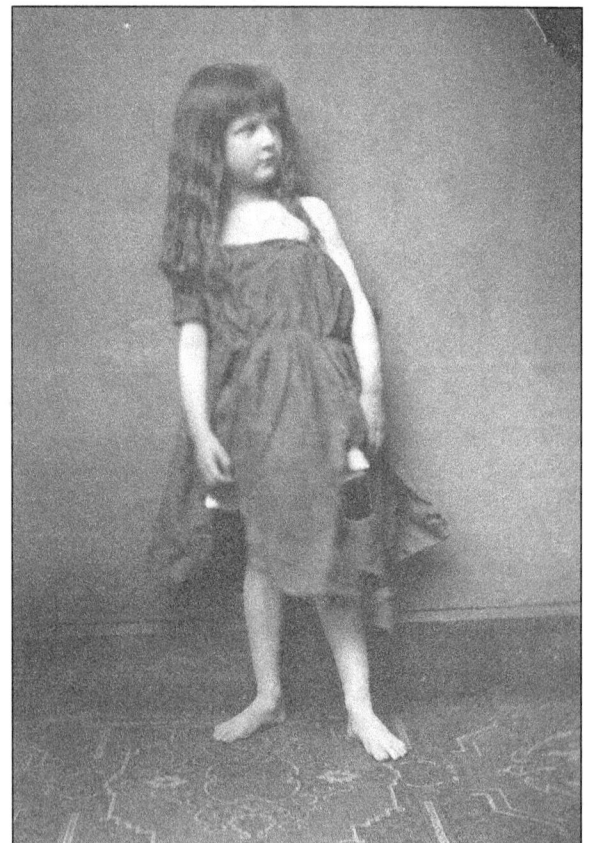
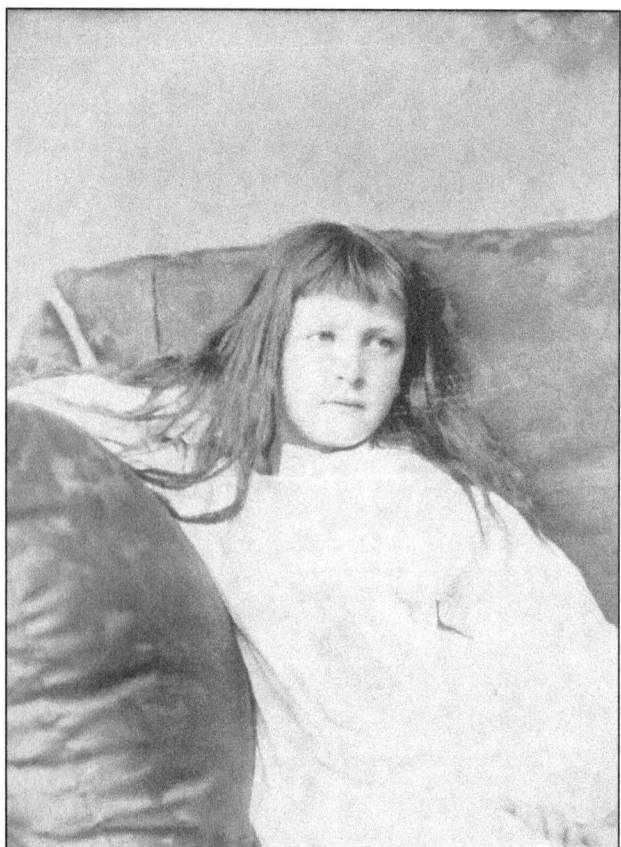

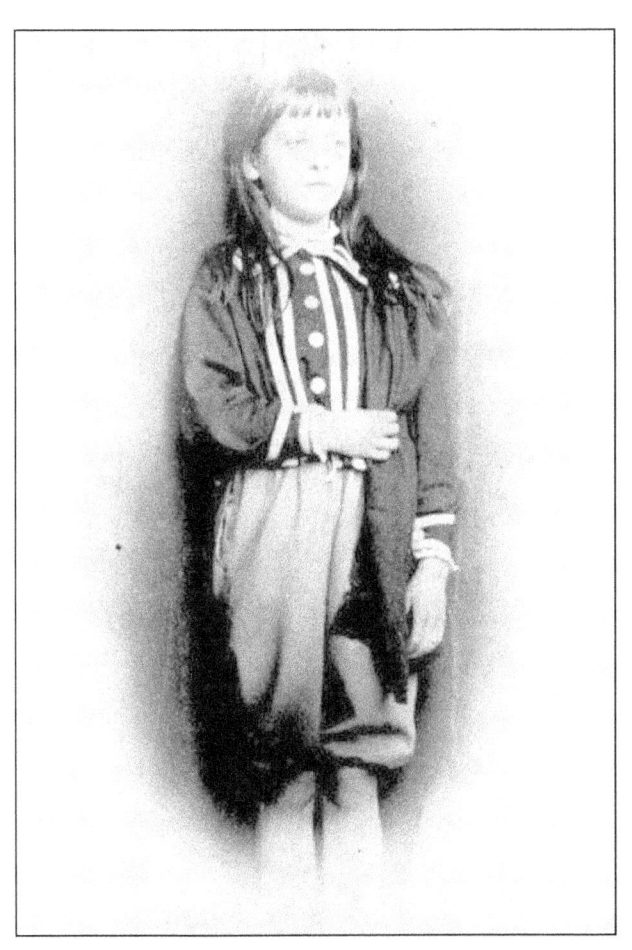 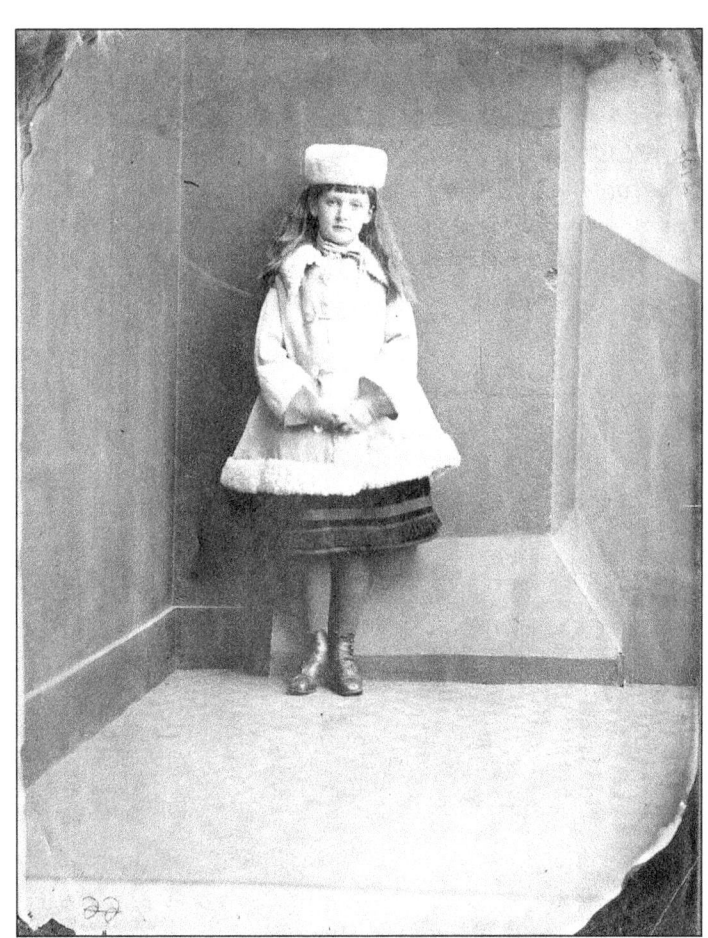

Xie Kitchin (March 23, 1874) ↑ ↓ (June 12, 1873) (May 14, 1873) ↑ ↓ (June 20, 1877)

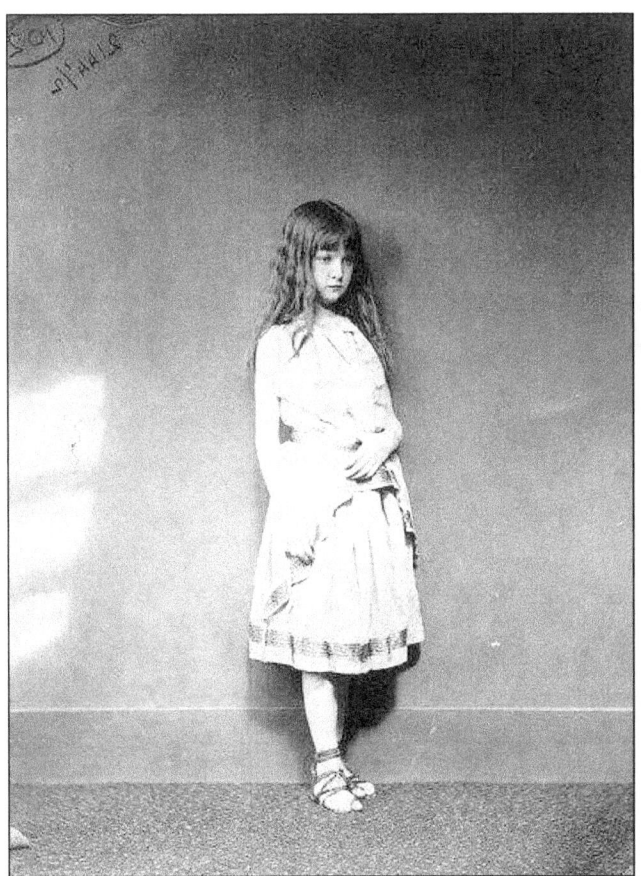 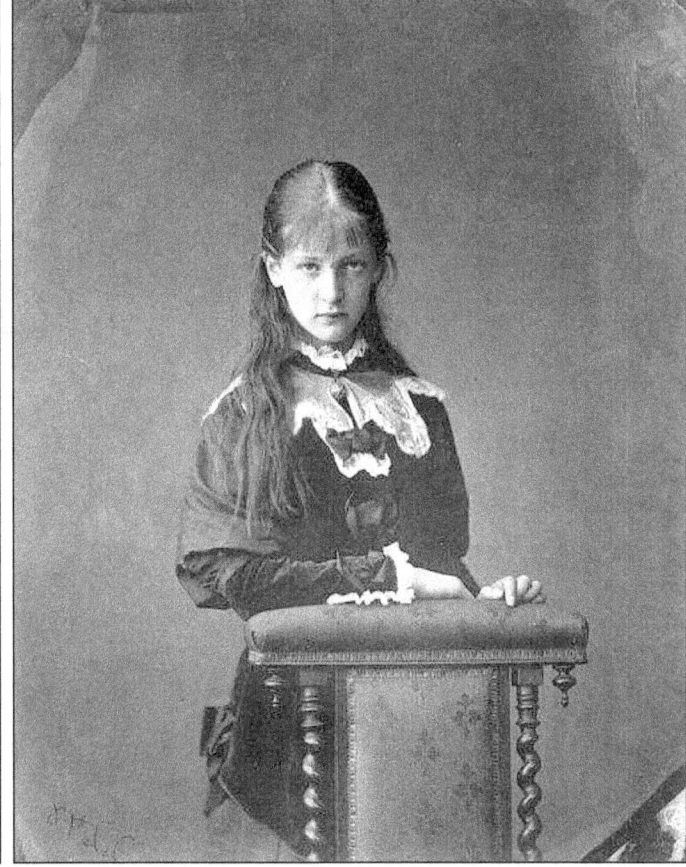

Carroll's first, or "seated," portrait of the costumed Xie is directly influenced by one of the greatest child portraits of the Georgian Era, Sir Joshua Reynolds's painting of Penelope Boothby (1785–1791). Penelope, the only child and heir of Sir Brooke Boothby, the seventh baronet, and his wife, Susanna, was painted at the age of three in Reynolds's London studio in July 1788. By all accounts, Reynolds enjoyed the company of small children as much as Dodgson and had a fine relationship with the young Penelope throughout their sessions.

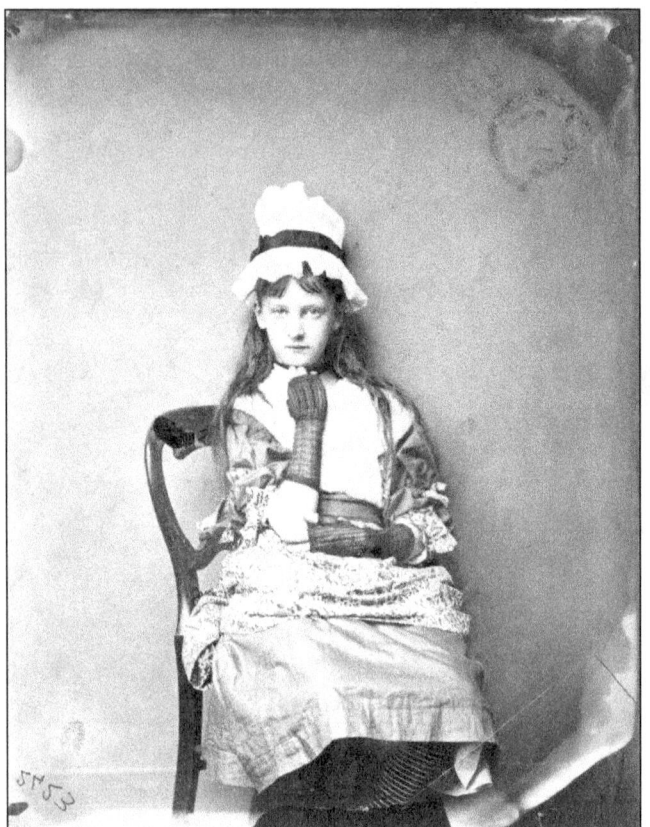
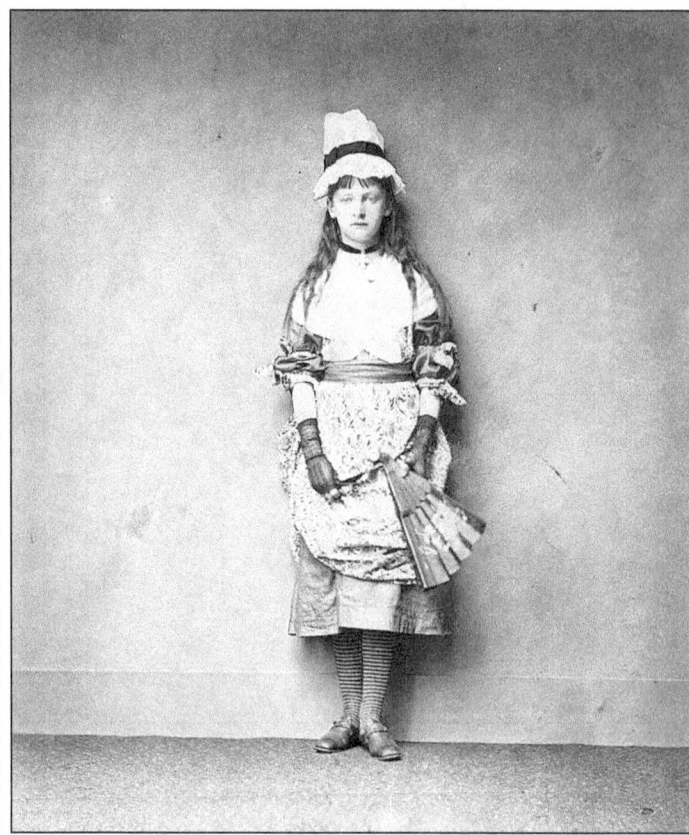

Xie as Penelope Boothby (July 1, 1876)

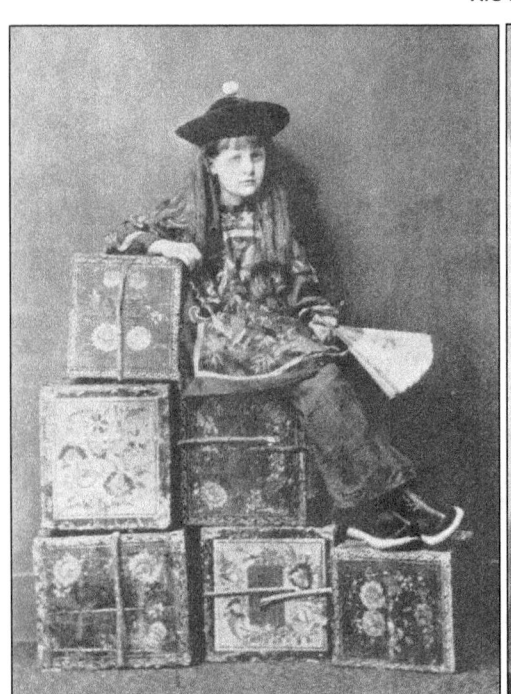

Xie as a tea merchant (July 14, 1873)

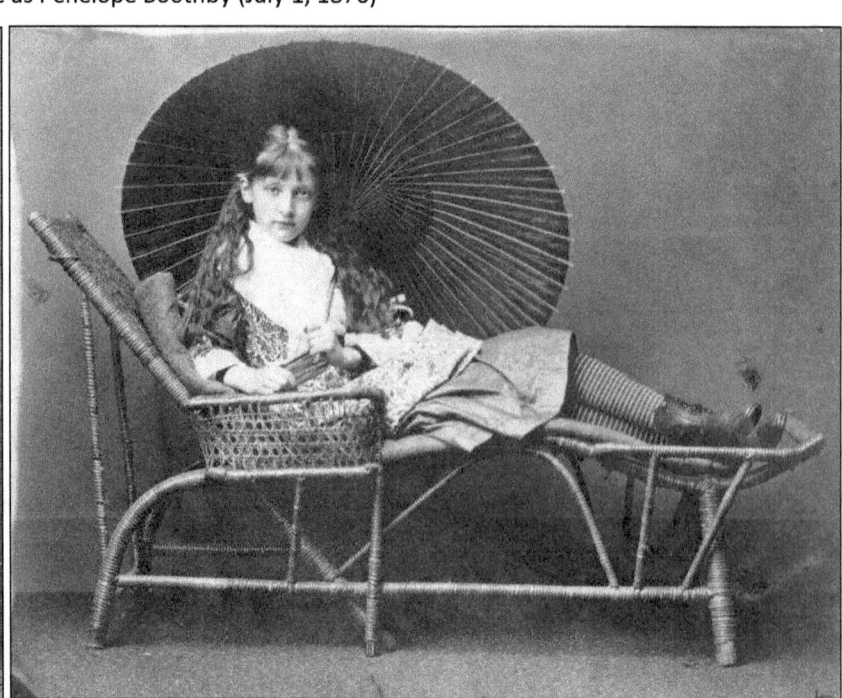

Xie Kitchin (July 1, 1876)

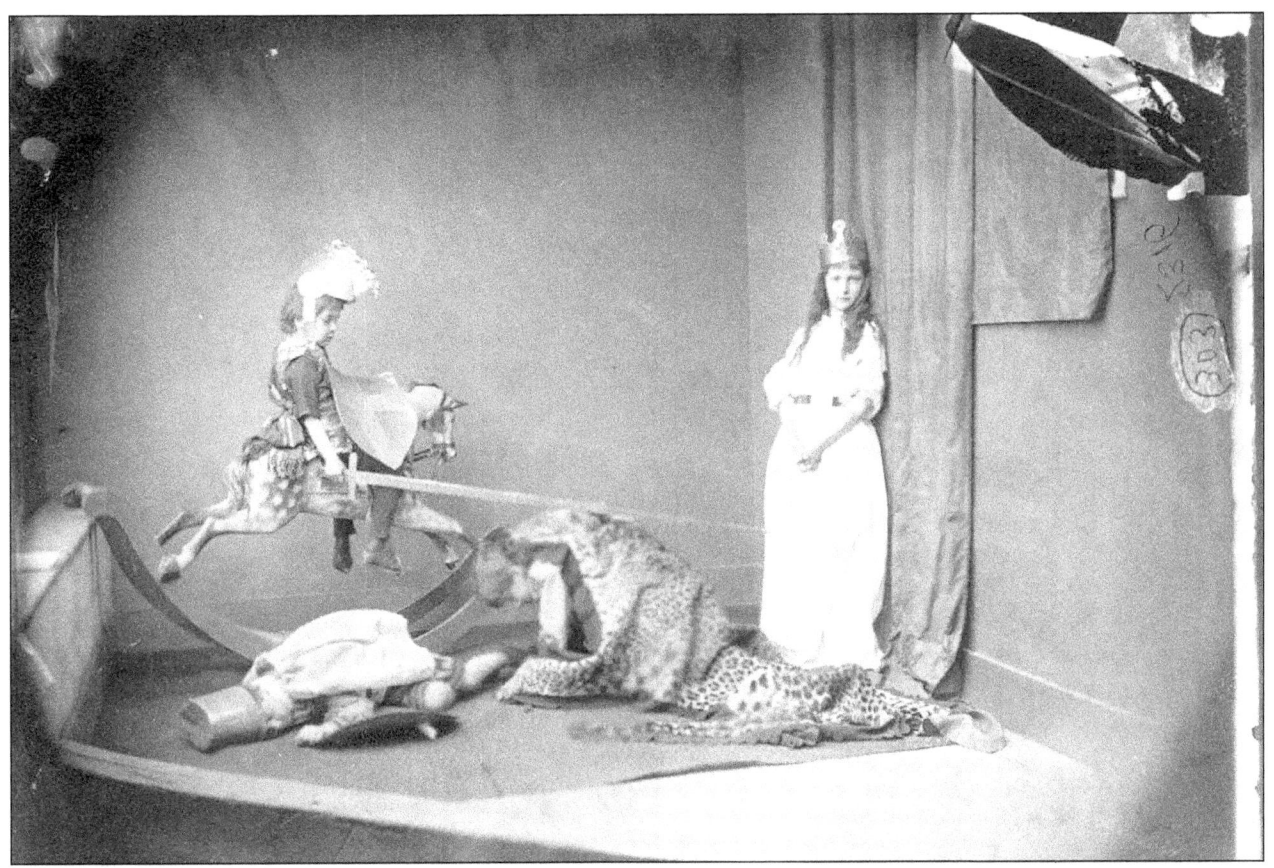

Xie Kitchin as a princess, her brothers Brook Taylor Kitchin as Saint George, George Herbert Kitchin as the slain soldier and Hugh Bridges Kitchin wrapped in the leopard skin rug in St. George and Dragon (June 26, 1875)

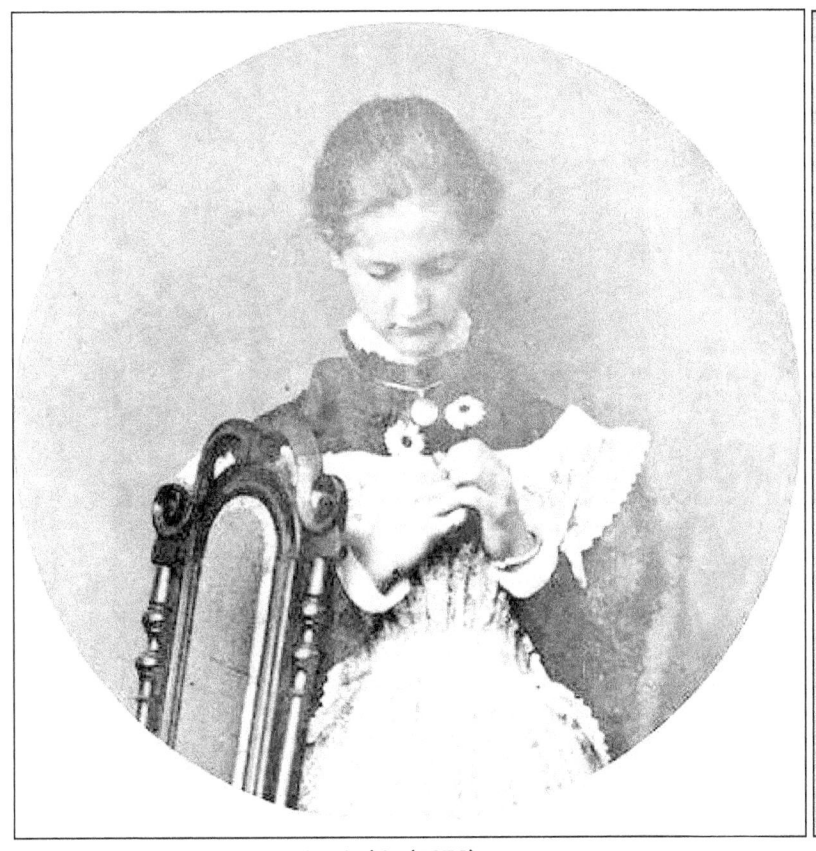

Xie Kitchin (1876)

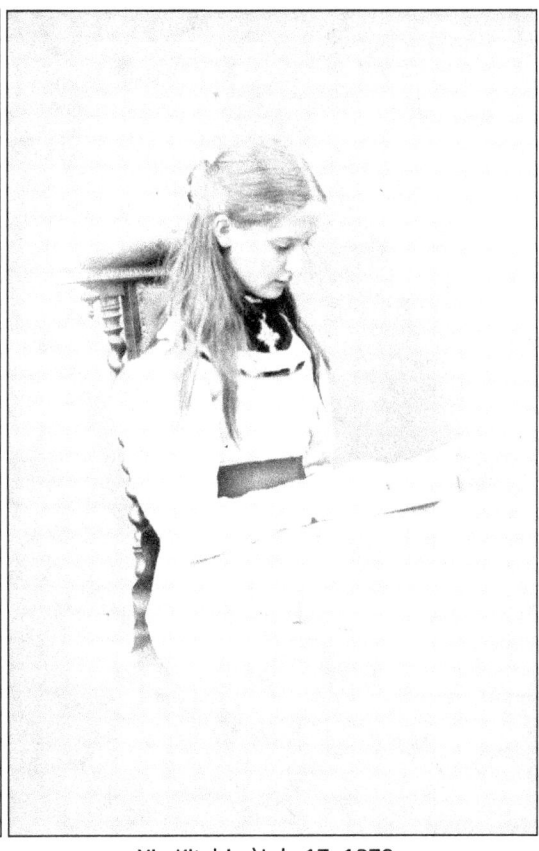

Xie Kitchin)July 17, 1878

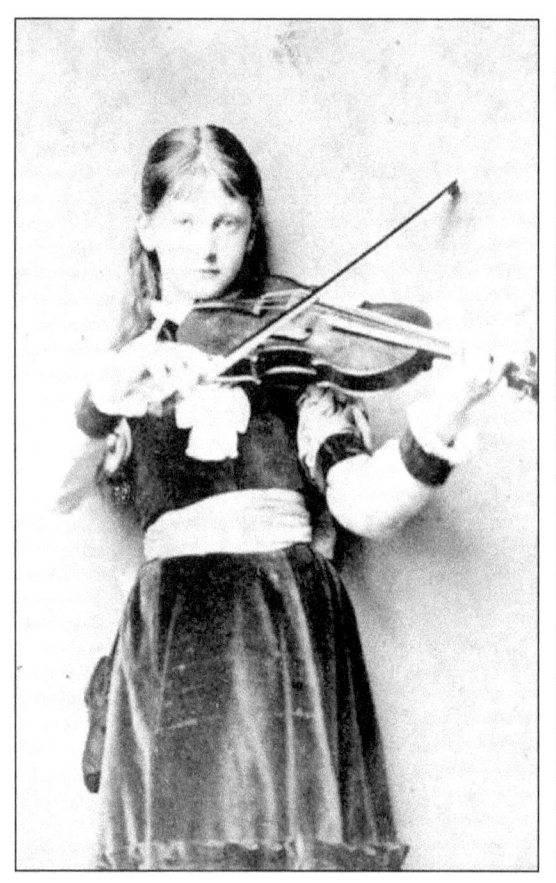 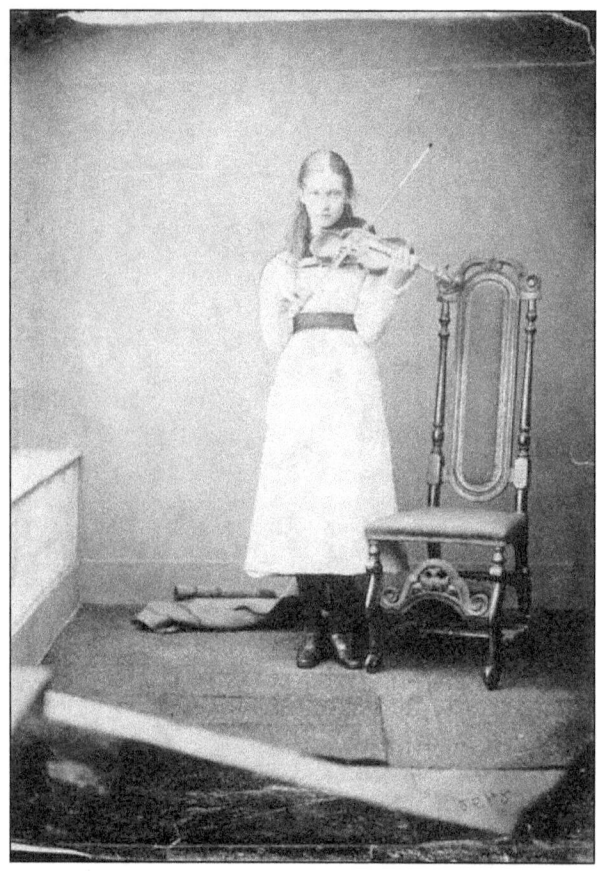

Xie Kitchin: (July 1, 1876) ↑ ↓ (July17, 1878) ↑ (July 17, 1878) ↓ (1923 – unk photographer)

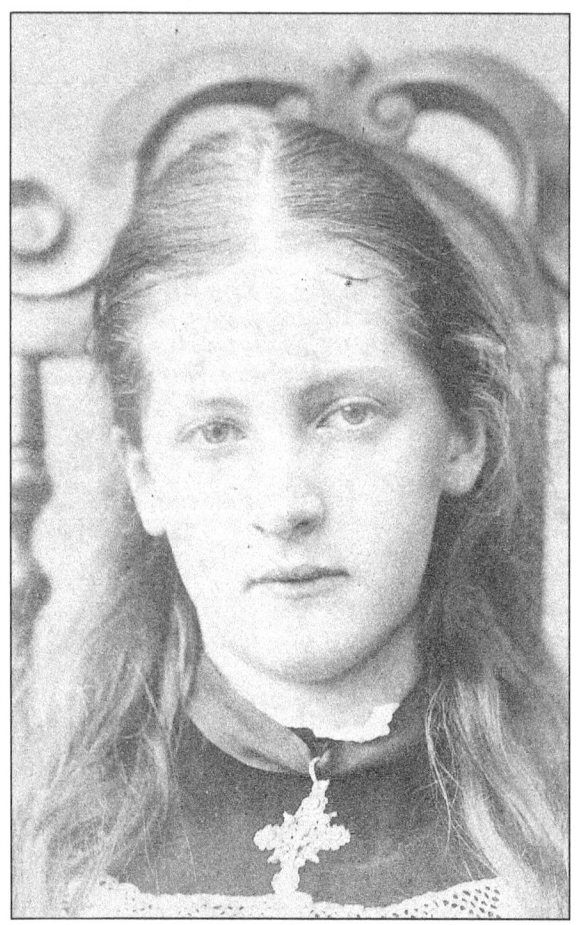 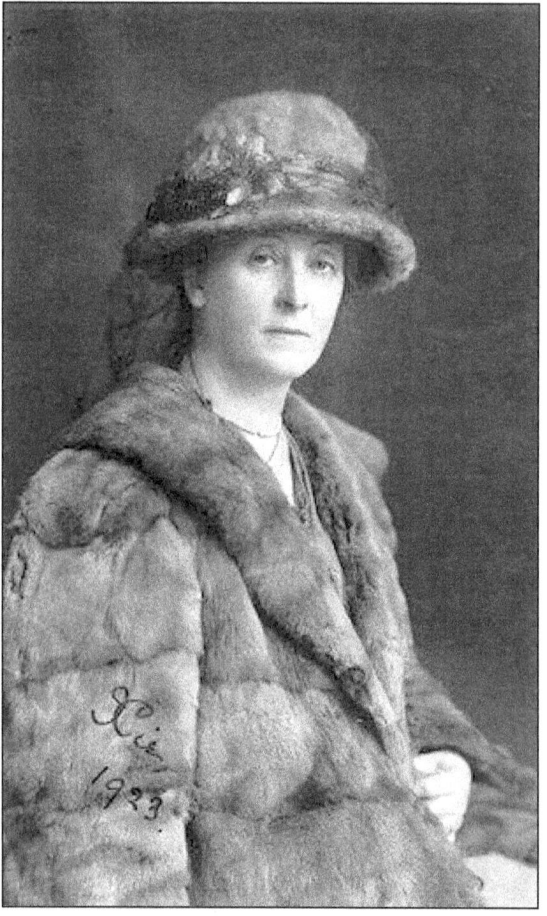

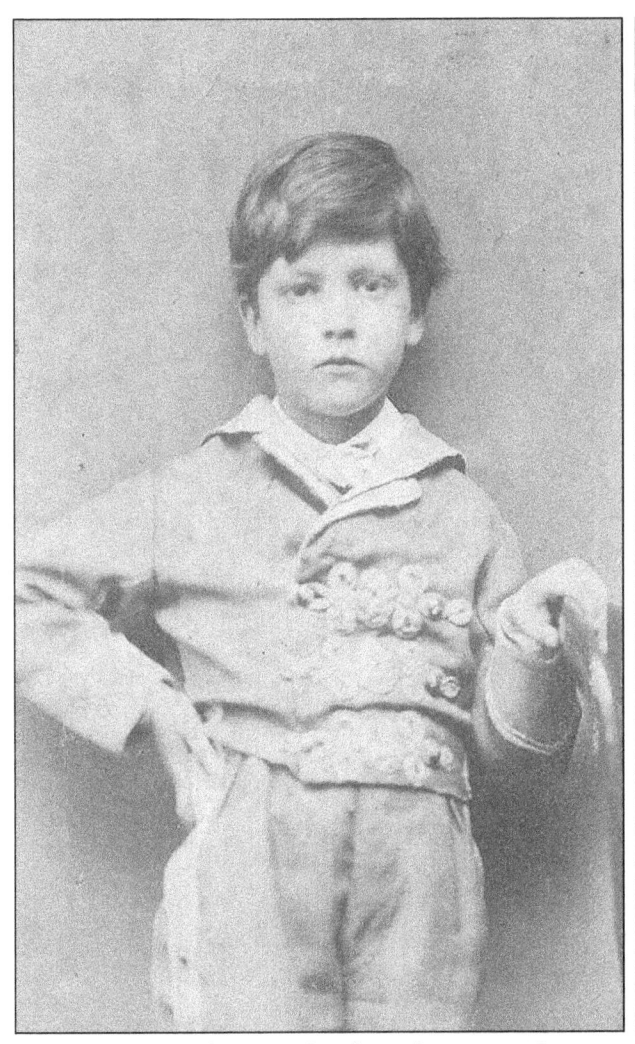
George Herbert Kitchin (May/June 1873)

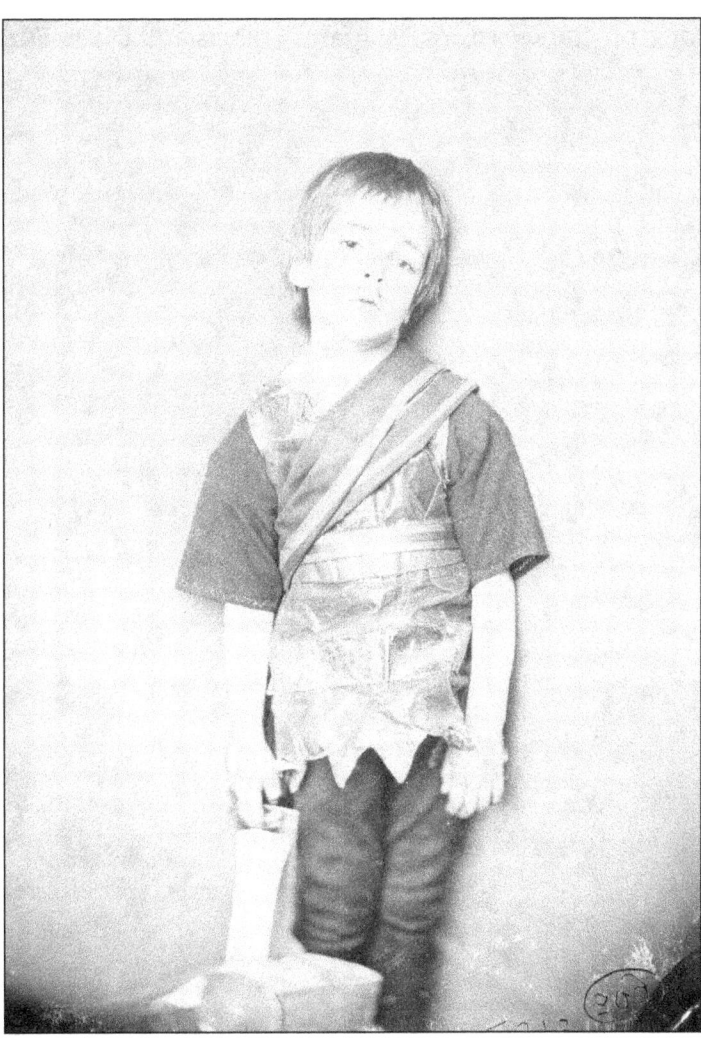
Brook Taylor Kitchin (June 26, 1875)

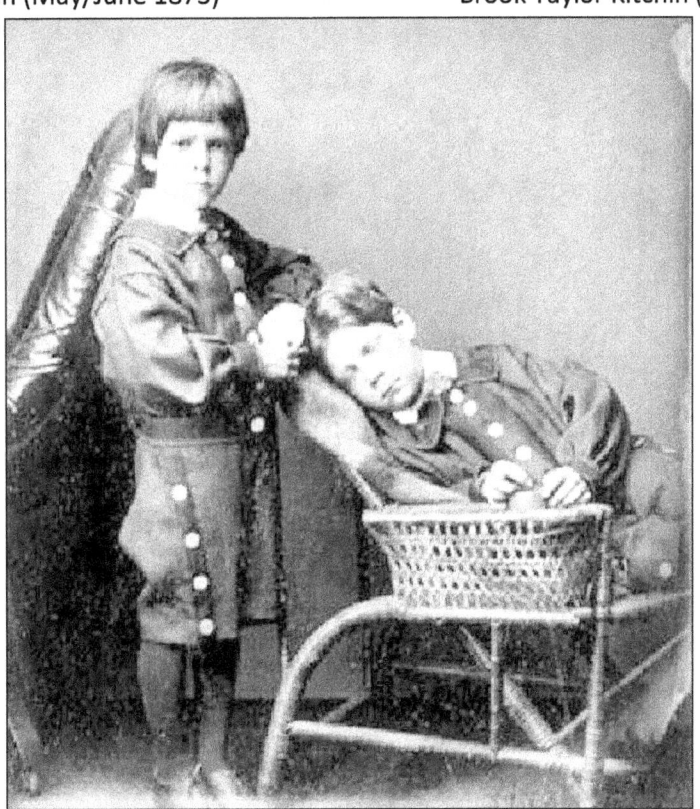
Hugh Bridges Kitchin and Brook Taylor Kitchin (July 5, 1876)

Langton Clarke sisters (Margaret Francis and Diane Elizabeth)

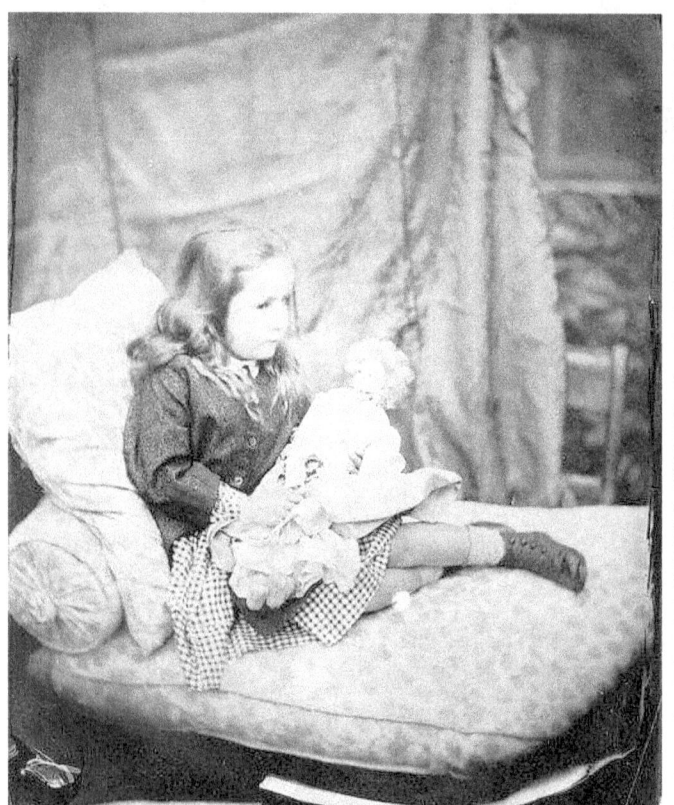
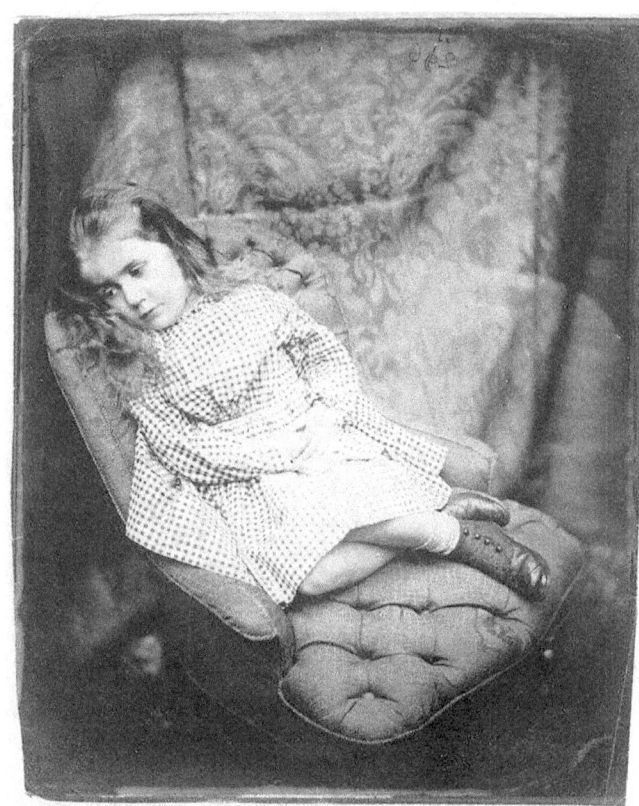

Margaret Frances Langton Clarke (September 19-29, 1864)

Diane Elizabeth Langton Clarke (September 19-29, 1864)

Leila Campbell Taylor and Lisa Wood

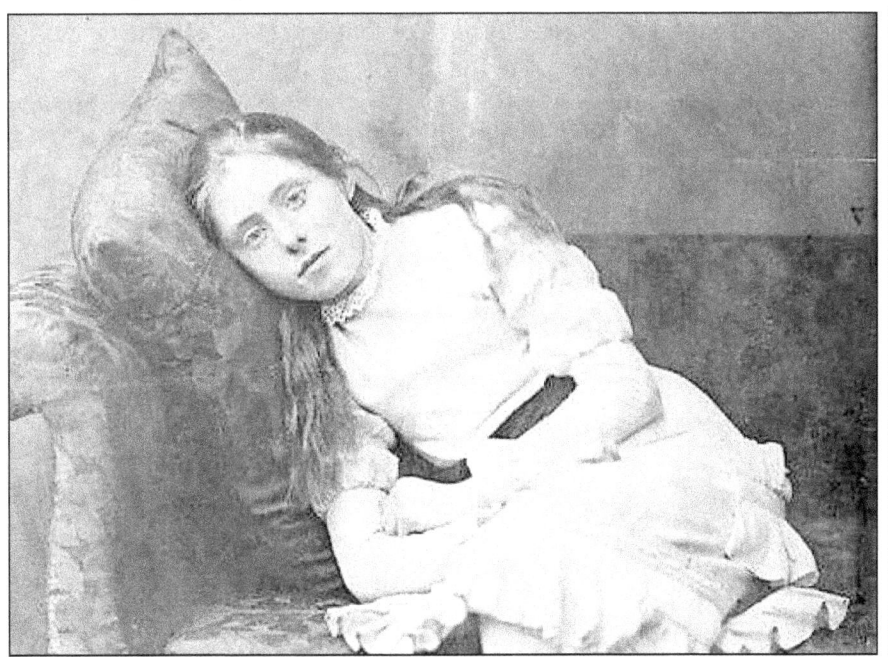

Leila Campbell Taylor (July 19, 1879) Lisa Wood (August 1857)

Longley sisters (Caroline and Rosamund) and Lucy Tate

The sisters' father was Charles Thomas Longley, Bishop of Ripon and later Archbishop of Canterbury.

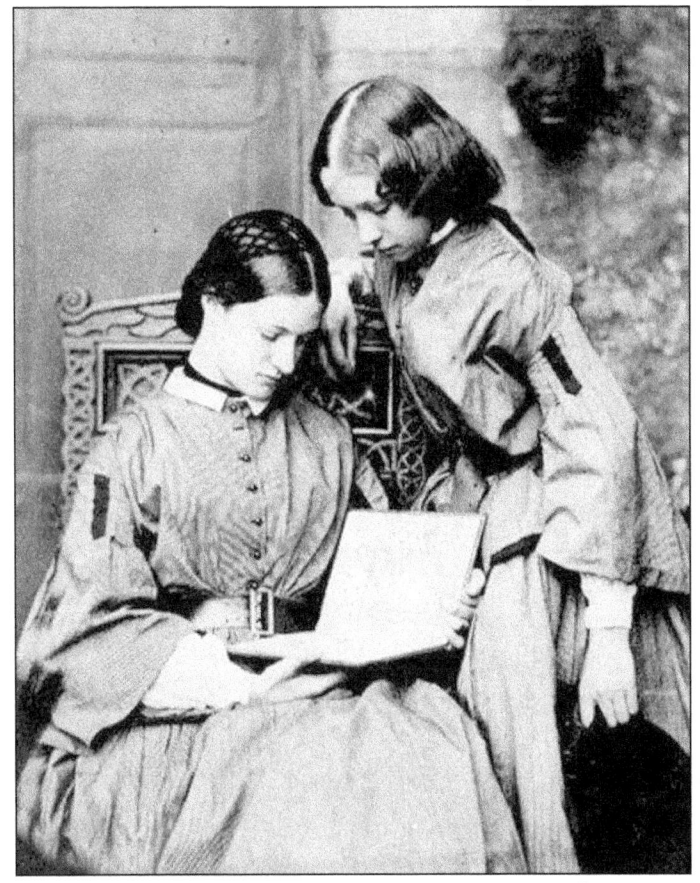
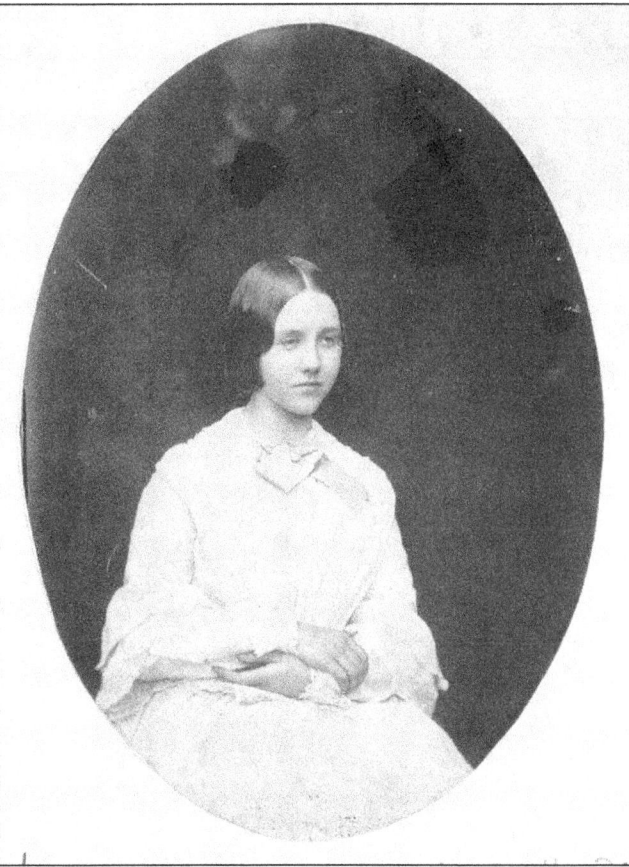

Caroline and Rosamond Longley (summer 1859) Lucy Tate (11 July 1856)

MacDonald Family

The family father was George MacDonald a novelist, poet and minister. He was a pioneering figure in the field of modern fantasy literature and the mentor of fellow writer Lewis Carroll.

Louisa MacDonald with four MacDonald children and Lewis Carroll (July 14-16, 1870)

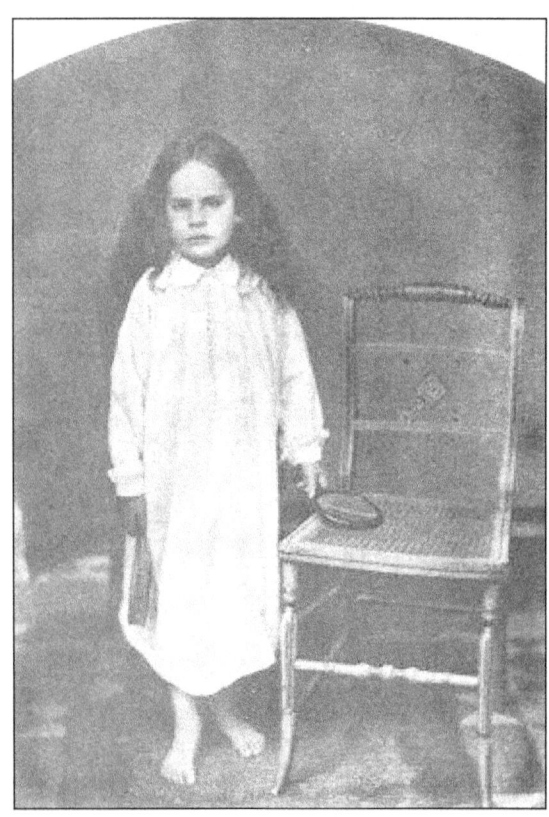

Irene McDonald (1863)

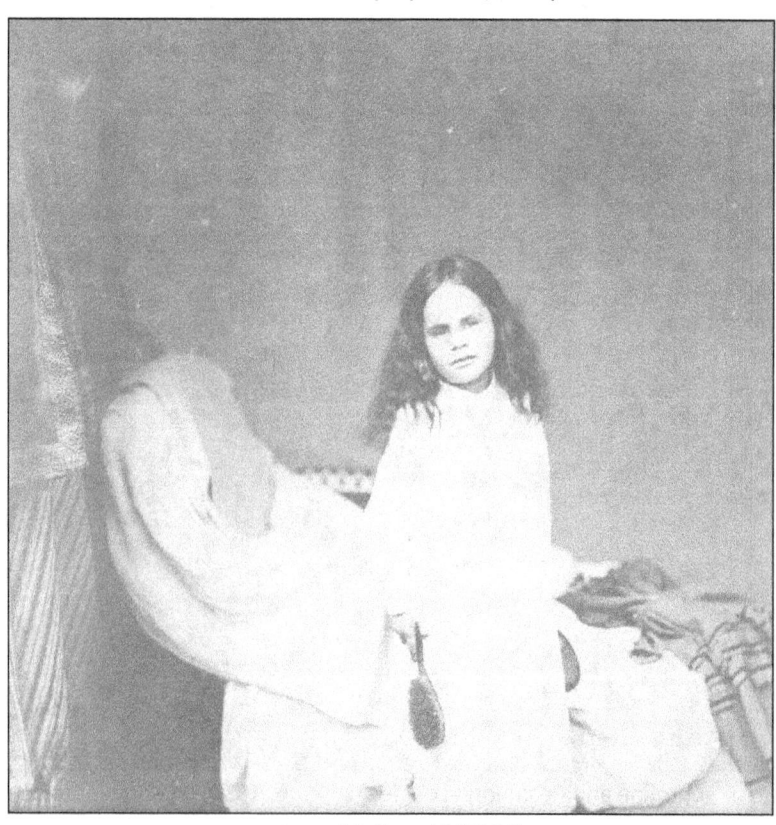

Irene McDonald (1864)

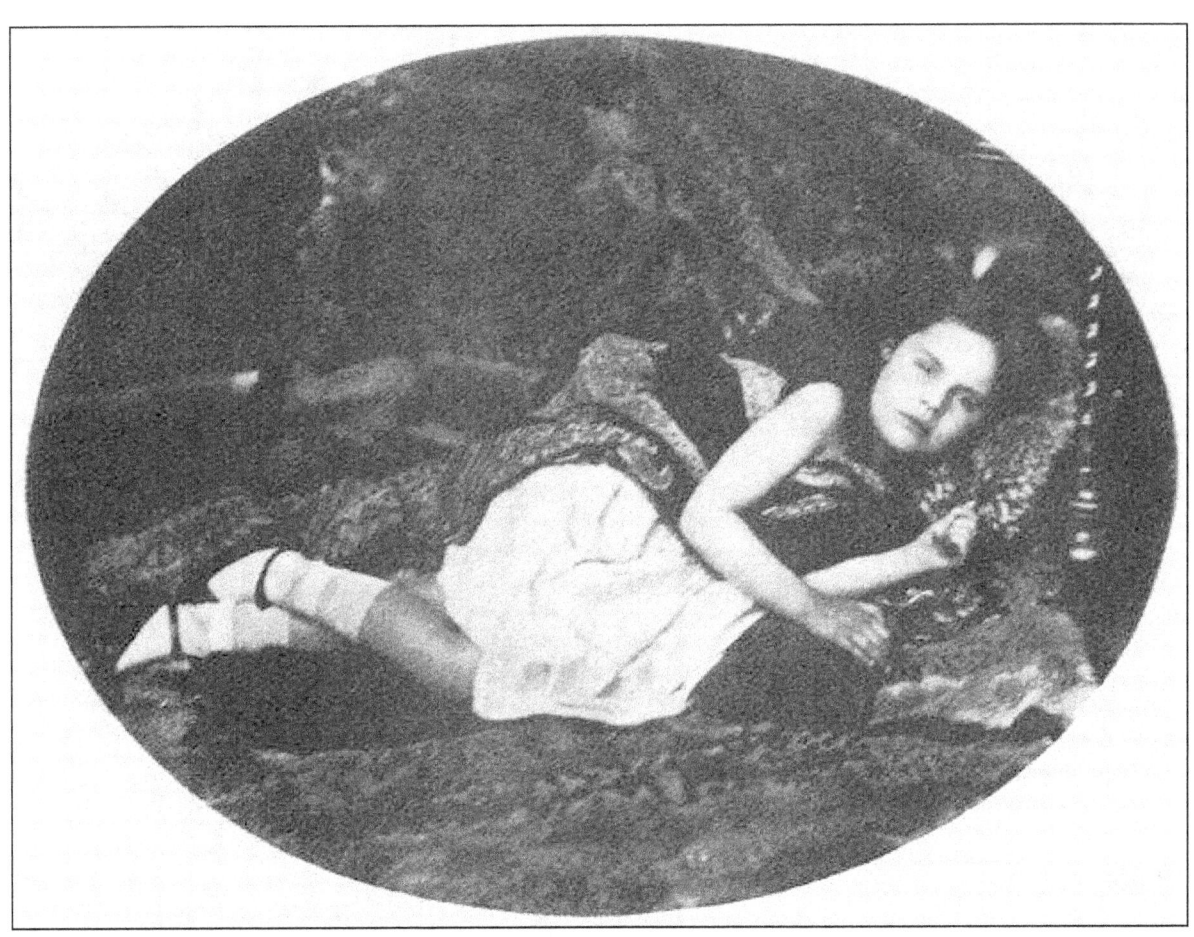
Irene McDonald (1863)

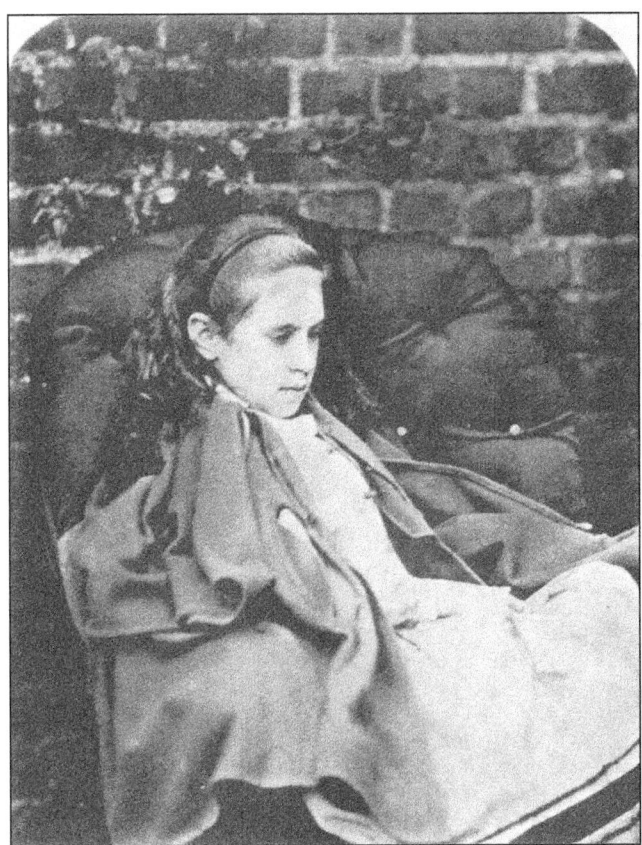
Mary Josephine MacDonald (October 10, 1863)

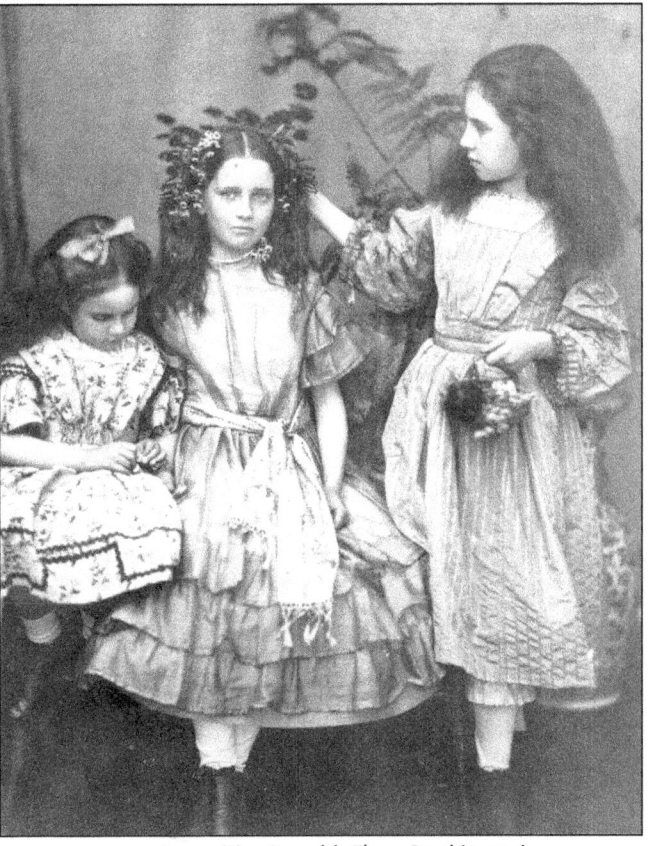
Irene MacDonald, Flora Rankin and
Mary Josephine MacDonald (July 25-31, 1863)

Mary J. MacDonald dreaming of her father George MacDonald and brother Ronald (July 25-31, 1863)

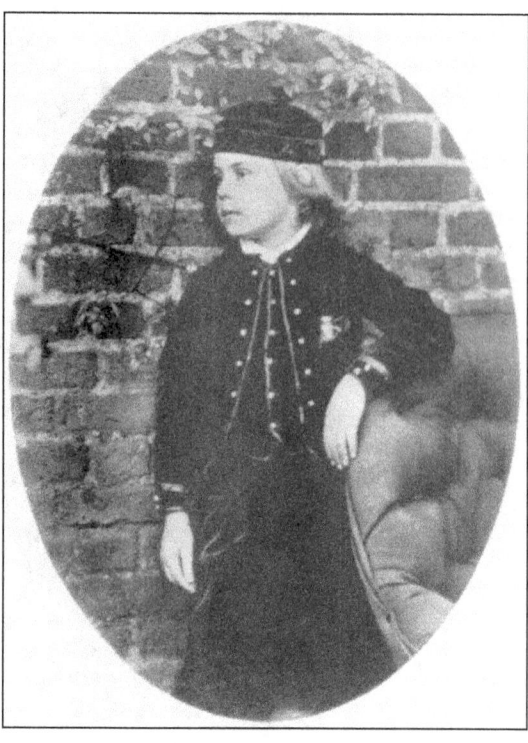

Greville MacDonald (October 10, 1863)

Maria White

Maria was the niece of the porter at Lambeth Palace, the London residence of the Archbishop of Canterbury.

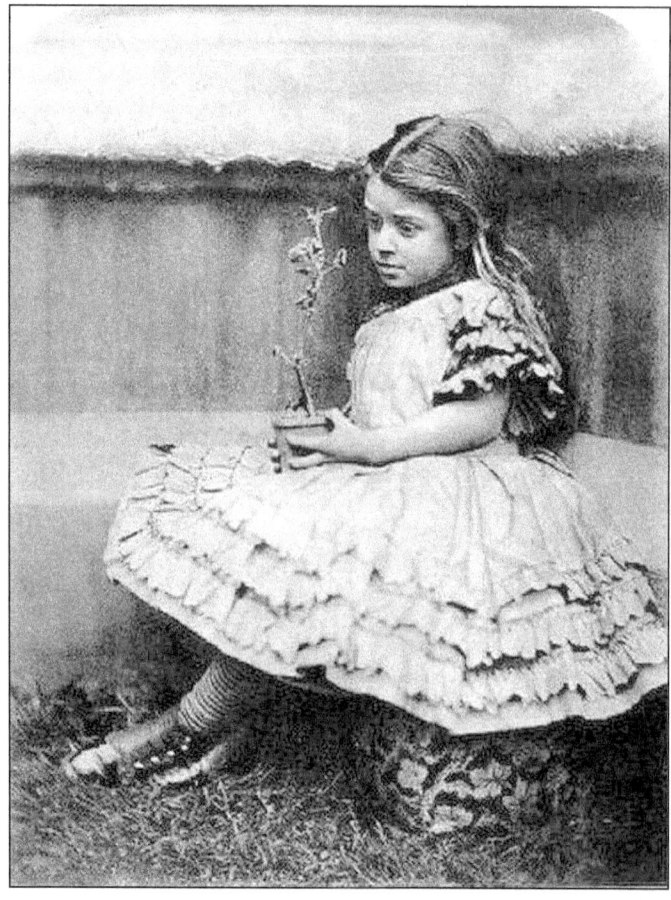

Maria White (July 11, 1864)

Mary L. Jackson and Mary Elizabeth Lott

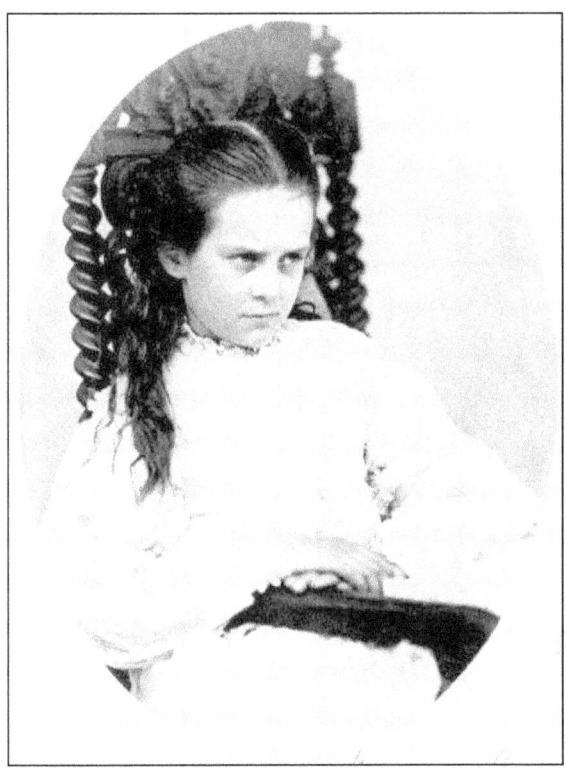

Mary L. Jackson (July 3, 1863)

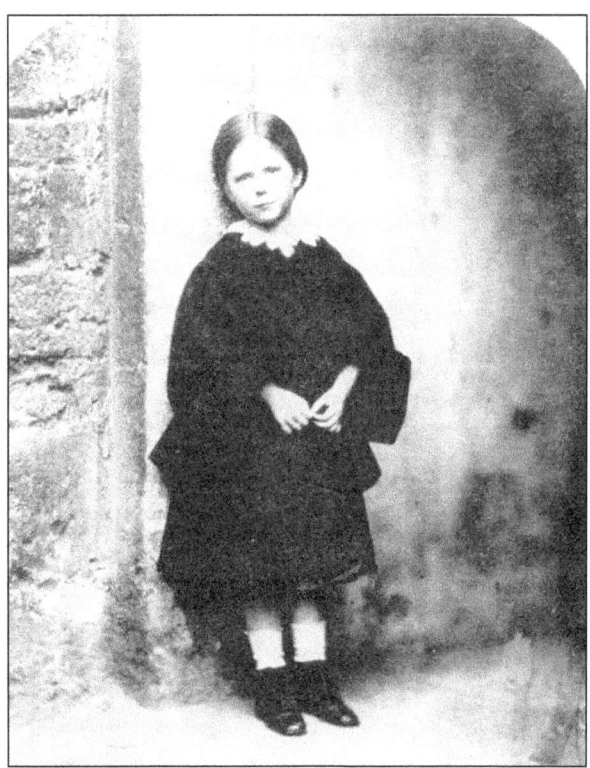

Mary Lott (spring 1857)

Marcus Keane and the Millais Family (Effie Gray, John Everett, Effie and Mary)

The Millais family father, John Everett Millais, was a prominent pre-Raphaelite painter.

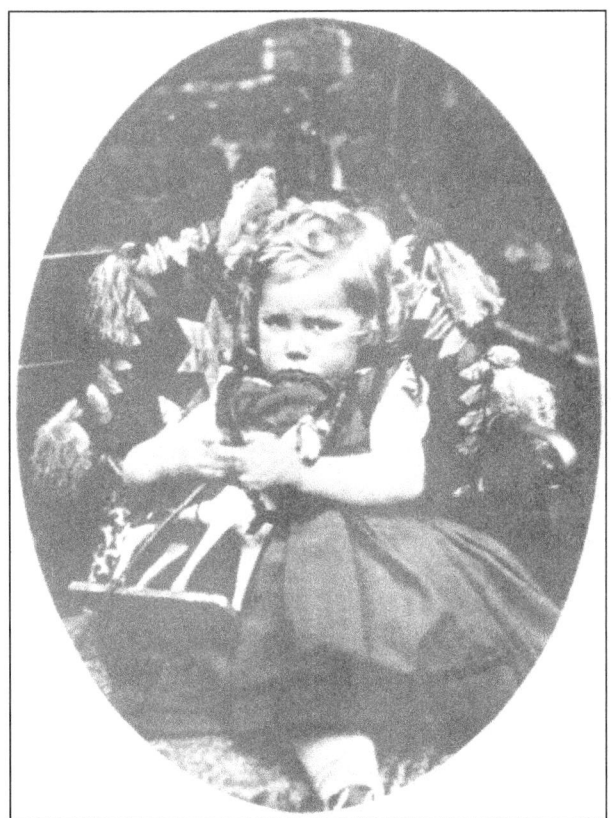

Marcus Keane (August 26-29, 1863)

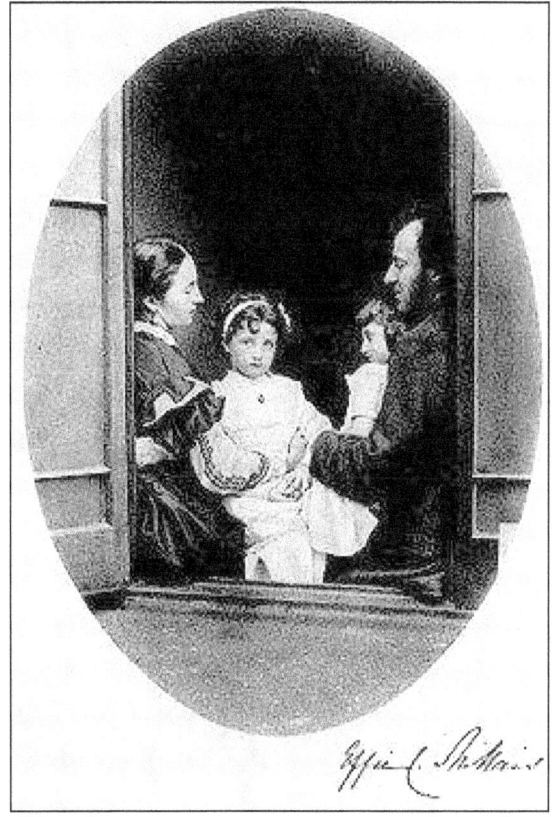

Effie Gray Millais, John Everett Millais, and their daughters Effie and Mary (July 21, 1865)

Effie Millais (July 21, 1865)

Mary Millais (July 21, 1865)

Nelly MacDonald

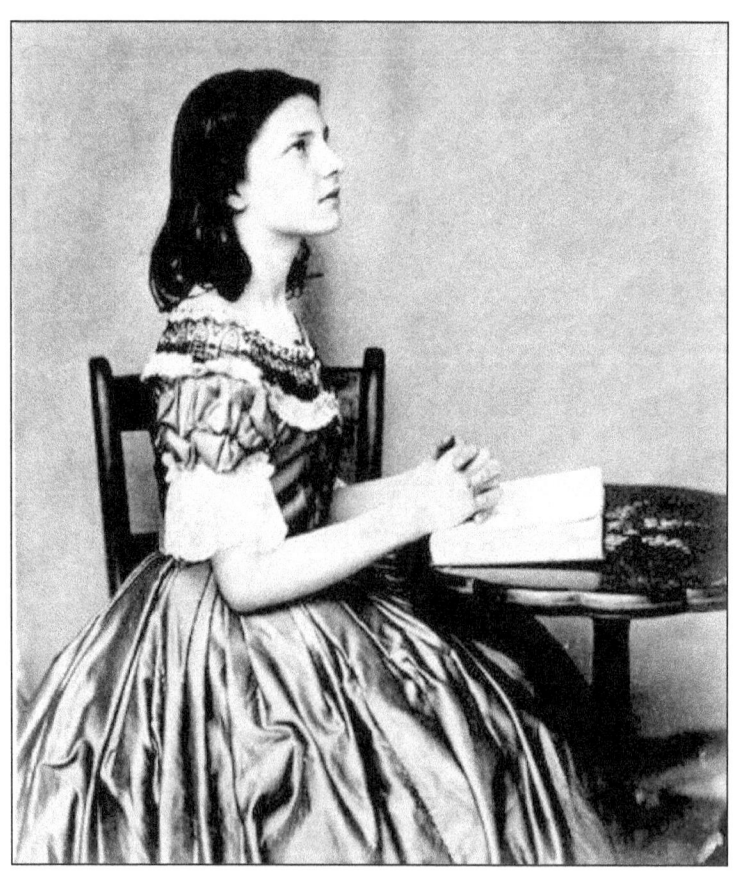
Nelly MacDonald (July 25-31, 1863)

Owen Siblings (Lucy, Henrietta, Sidney, Isobel, Margaret and Edward)

Eight of the photographs of the Owen siblings have not been previously published. These photographs were provided by the Governing Body of Christ Church, Oxford, are from shelf mark Carroll-Owen 1-8 and follow on pages 79, 80 and 81 as well as an image of Sidney Owen on the upper right of page 82. These photographs of the children of Sidney James Owen (1827-1912) and Mary Ellen Owen (née Sewell) include portraits of six of their eight children; Lucy, Henrietta, Sidney, Isobel, Margaret and Edward Owen. The siblings were often photographed either singly or in pairs by Dodgson. Some of the photographs were taken at Badcock's Yard. The later photographs were taken in Dodgson's photographic studio on the roof above his rooms in Tom Quad (Tom7:6). Dodgson's diary reference for 27 June 1863 records: "Photographed the young Owens in the morning..."

Sidney George Owen (1858-1940). From 1882 until 1890 he was Assistant Lecturer in Classics at Owens College, and Lecturer in Classics at the Victoria University, Manchester. In the summer term of 1890 Owen returned to Oxford, having been appointed Classical Lecturer at Christ Church, Oxford the previous December.

Lucy Owen. In September, 1888 she was appointed Assistant Classical Teacher at the Ladies College, Cheltenham, and in 1890 she became Head Classical Teacher. She held this position until 1896 when ill health forced her to resign. In the spring of 1902 she settled in Manchester with her brother Montague.

Henrietta Owen. From 1885 to the time of her marriage in 1892 she had a preparatory school for boys which she ran with the help of her three younger sisters in her father's house in Oxford.

Edward Cunliffe Owen. In 1892, he became Assistant-Master at the Manchester Grammar School and in 1893 Assistant-Master at King Edward VI School, Bromsgrove and was Chaplain there from 1895. He was ordained Deacon in 1895 and Priest in 1896. He became Head Master of St. Peter's School, York in 1900.

I have estimated the year each photograph was taken using a table in Edward Wakeling's book *The Photographs of Lewis Carroll: A Catalogue Raisonné* which correlates Carroll's image numbers with each year he was active as a photographer.

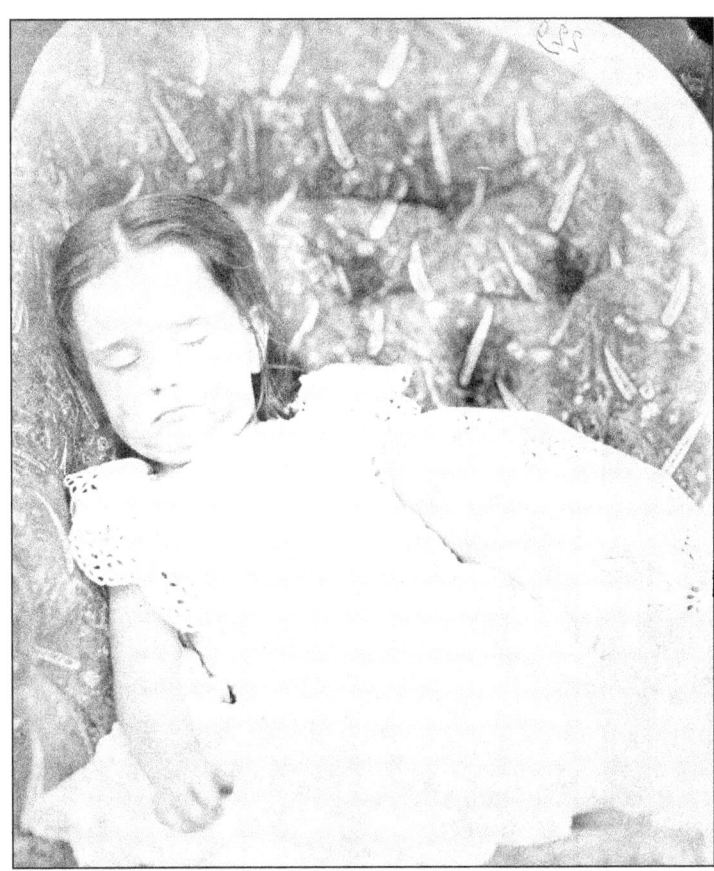

Lucy Owen, born - November 11, 1860 (1863)

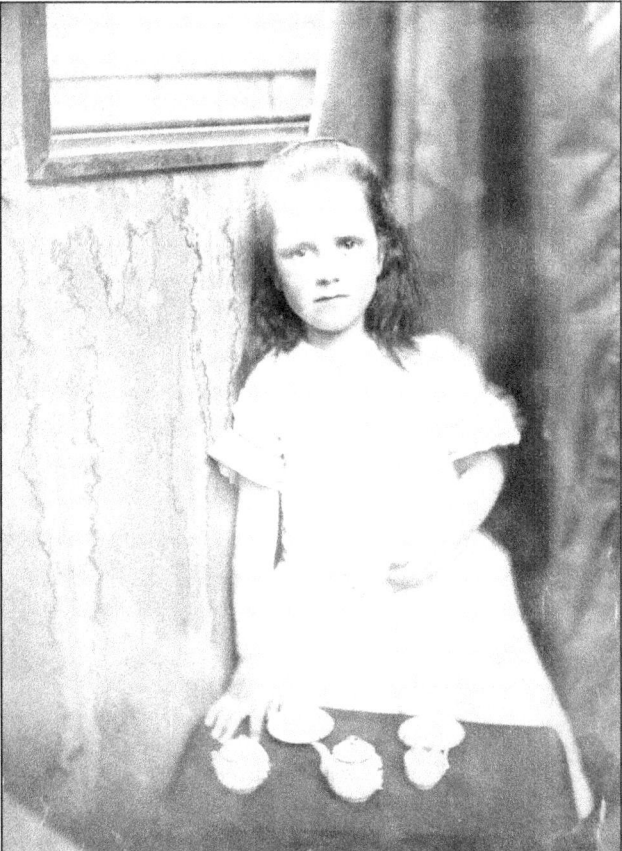

Lucy Owen (1868)

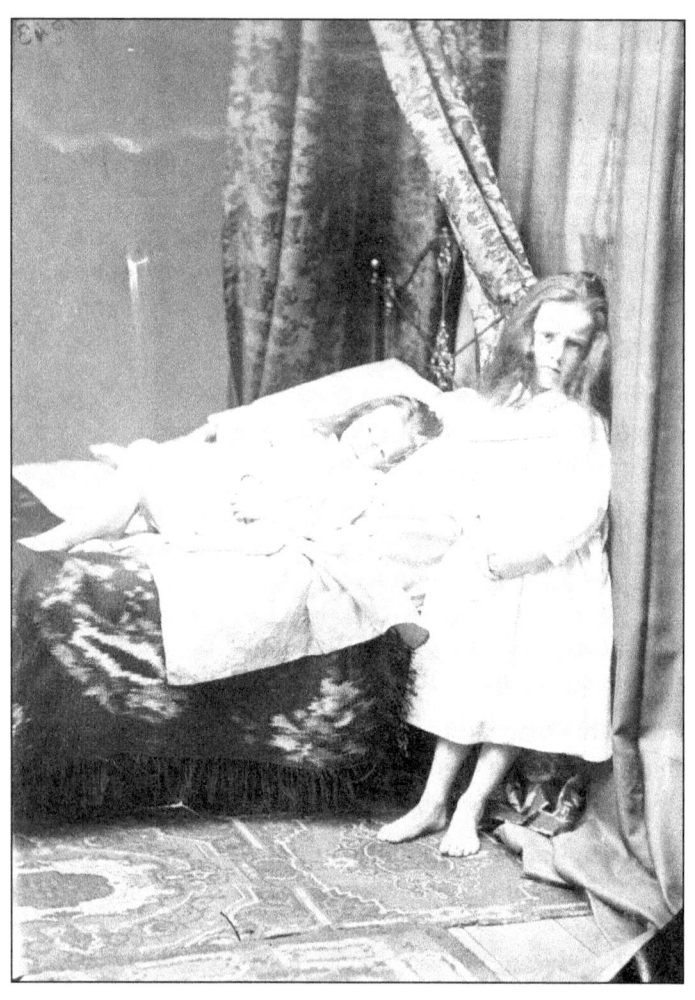
Lucy & Henrietta Owen, born - December 3, 1862 (1868)

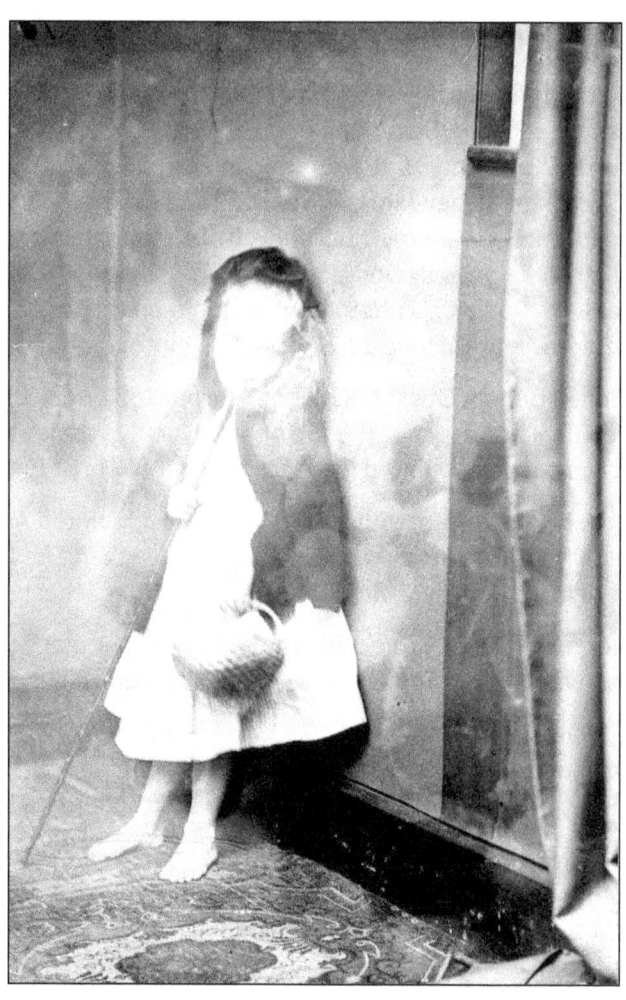
Henrietta Owen as "Little Red Riding Hood (1868)

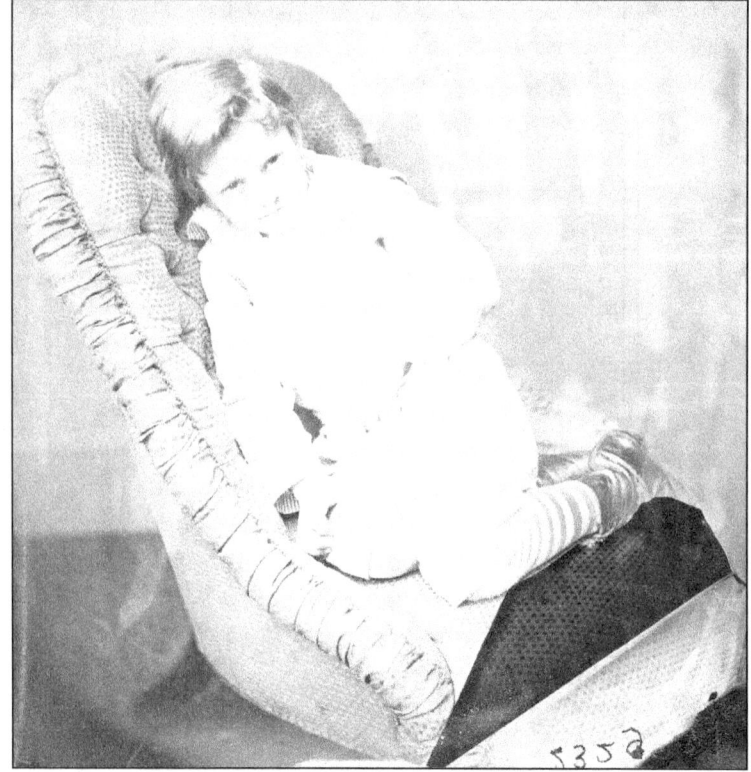
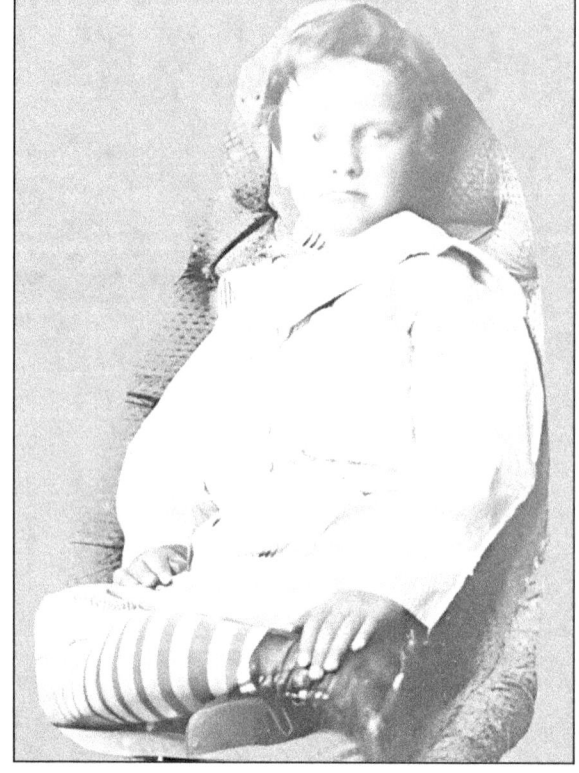
Edward Cunliffe Owen, born - February 5, 1869 (1875)

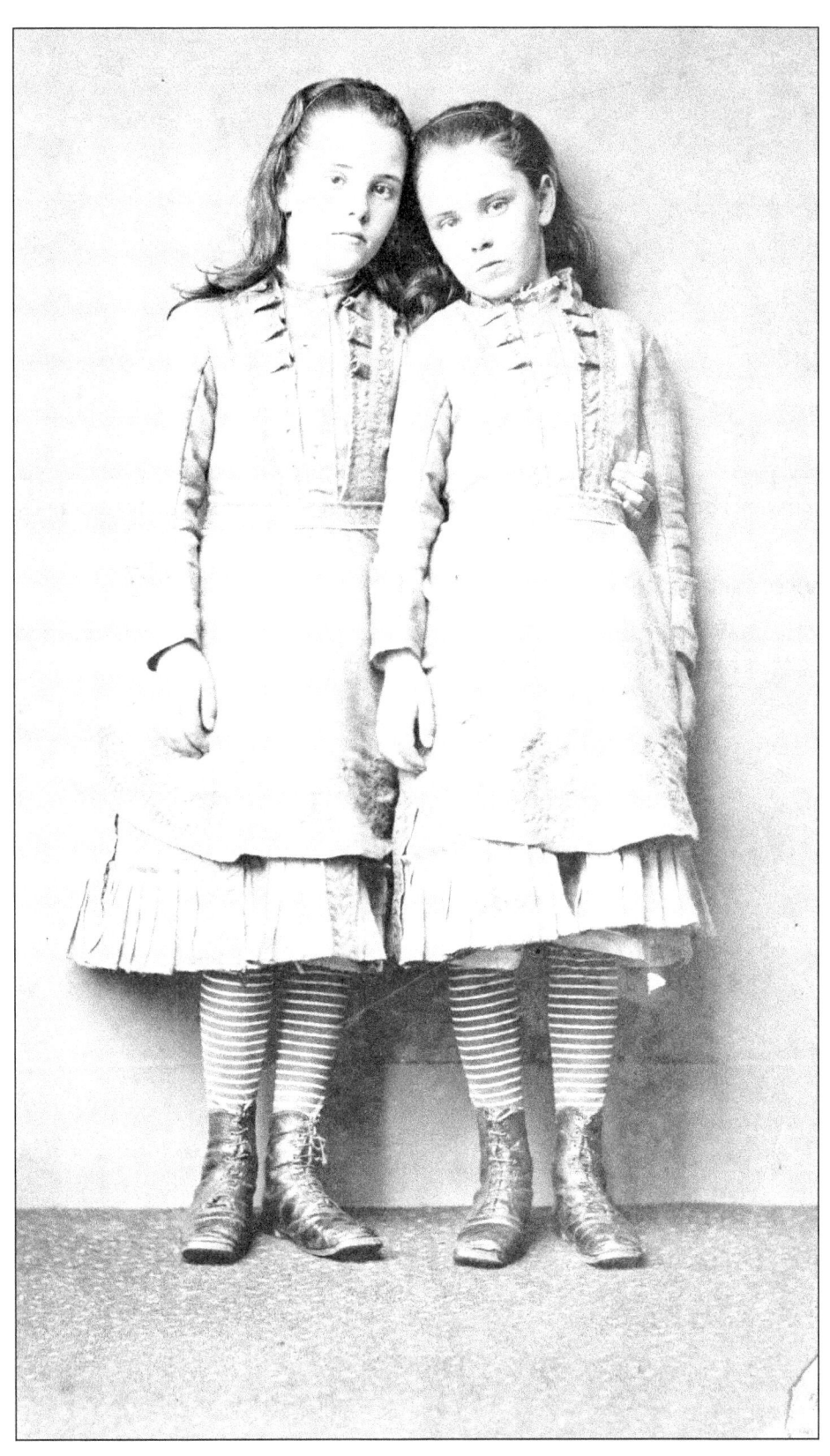

Isobel and Margaret Owen, twins born - August 2, 1866 (1873)

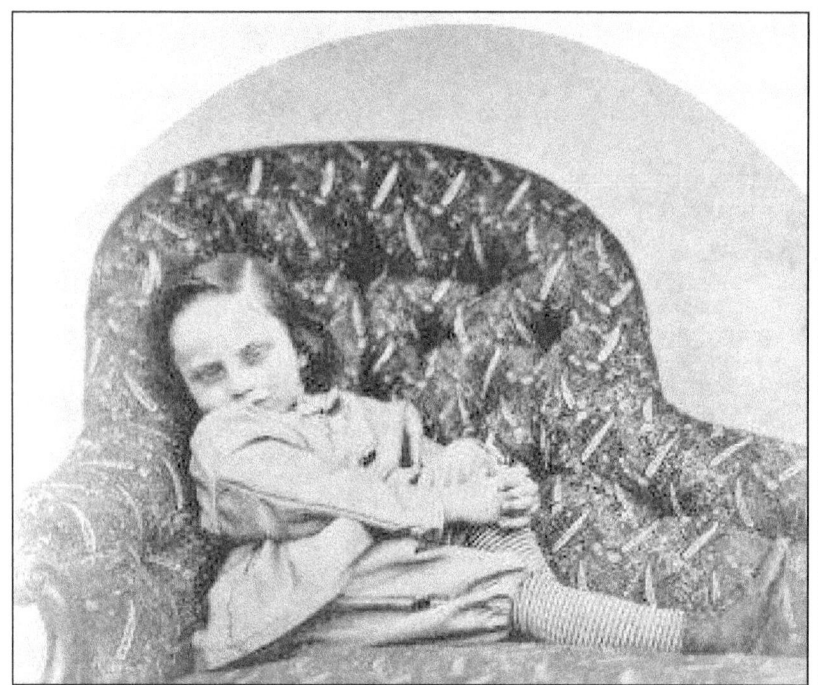
Sidney George Owen, born November 2, 1858 (June 27, 1863)

Sidney George Owen, (1868)

Parnell Siblings (Victor and Madeleine)

Their father was Sir Henry William Parnell, 3rd Baron Congleton who was a cousin of Irish politician Charles Parnell.

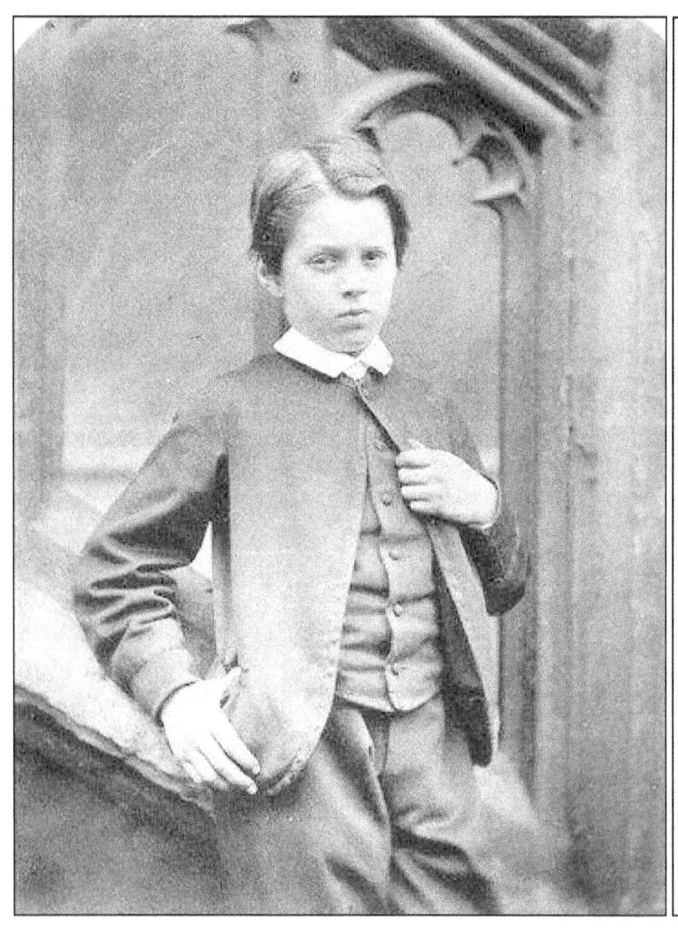
Victor Alexander Lionel Dawson Parnell (July 7, 1864)

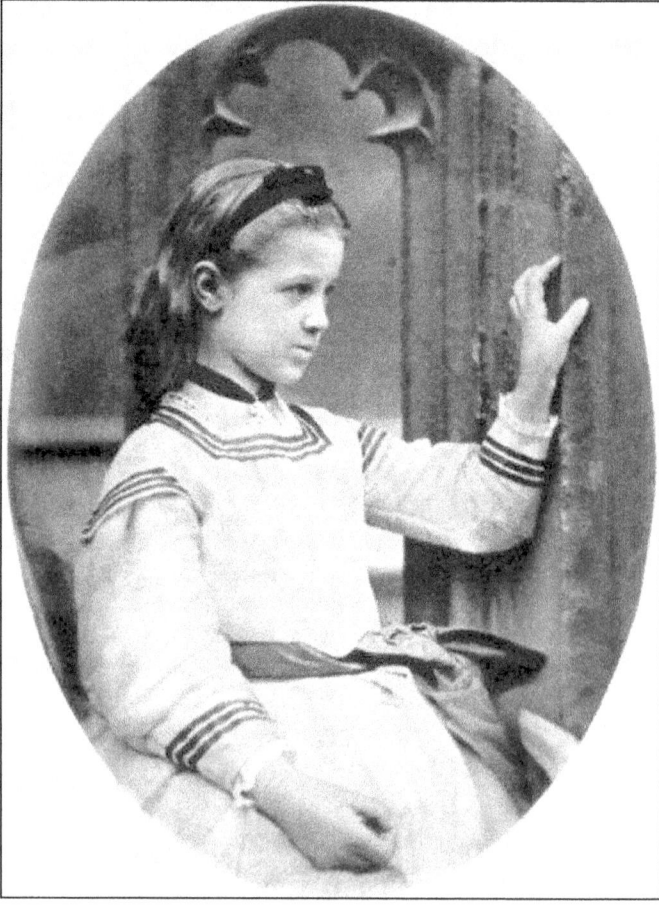
Madeline Parnell (July 7, 1864)

Quintin Twiss

Quintin William Francis Twiss (March 13, 1835 – August 7, 1900) was an English first-class cricketer and actor.

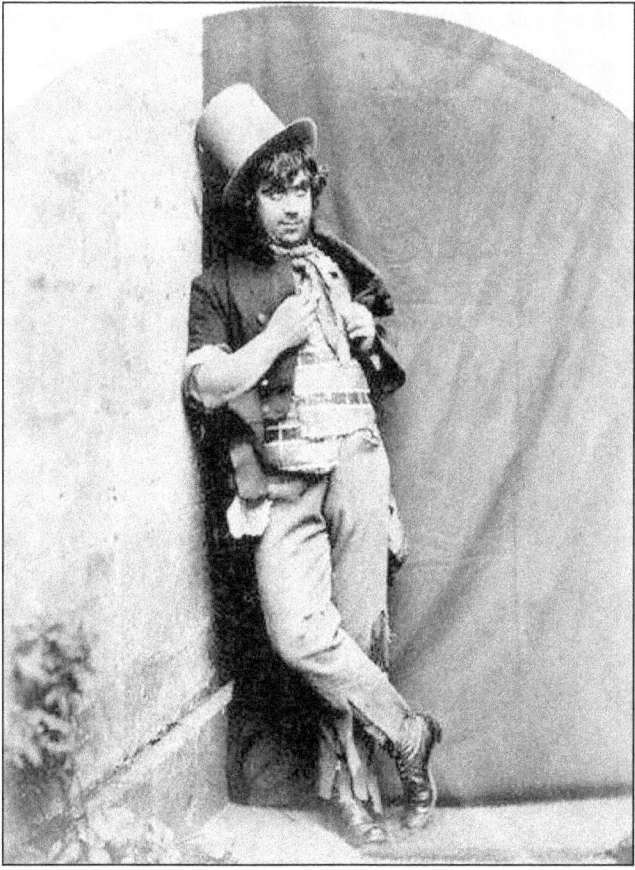

Quintin Twiss as
the Artful Dodger
(May 1858)

Rogers Family (Annie and Henry)

Their father was Thorold Rogers, an economist, historian, and a member of the House of Commons for 6 years.

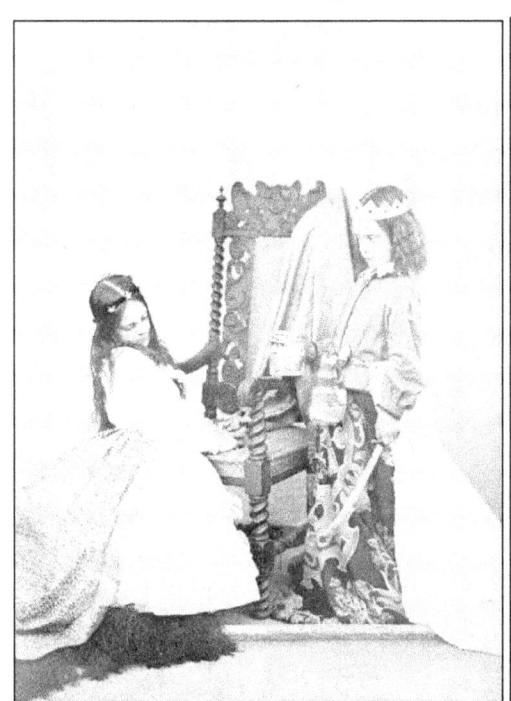

Annie Rogers and Mary Jackson in
"Fair Rosamund" (July 3, 1863)

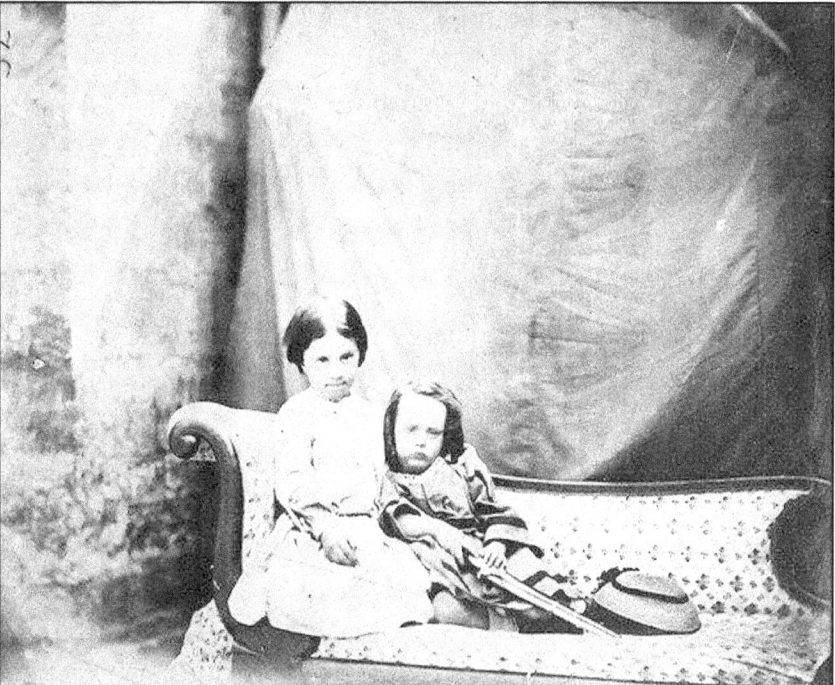

Henry and Annie Rogers (1863)

Rose Lawrie and Rose Wood (Eliza Rose Fawcett [née Wood])

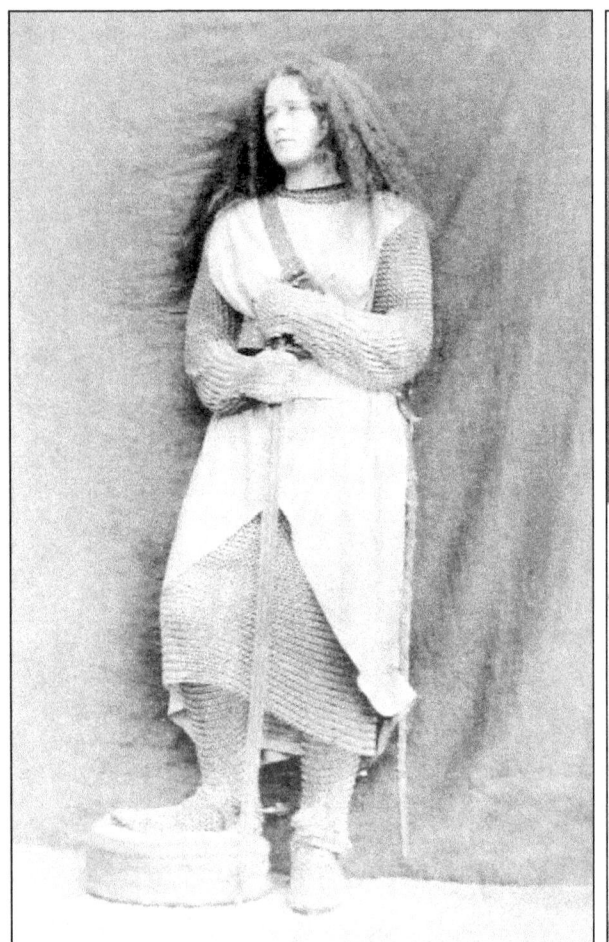
Rose Lawrie in "Waiting for the Trumpet" (July 7, 1875)

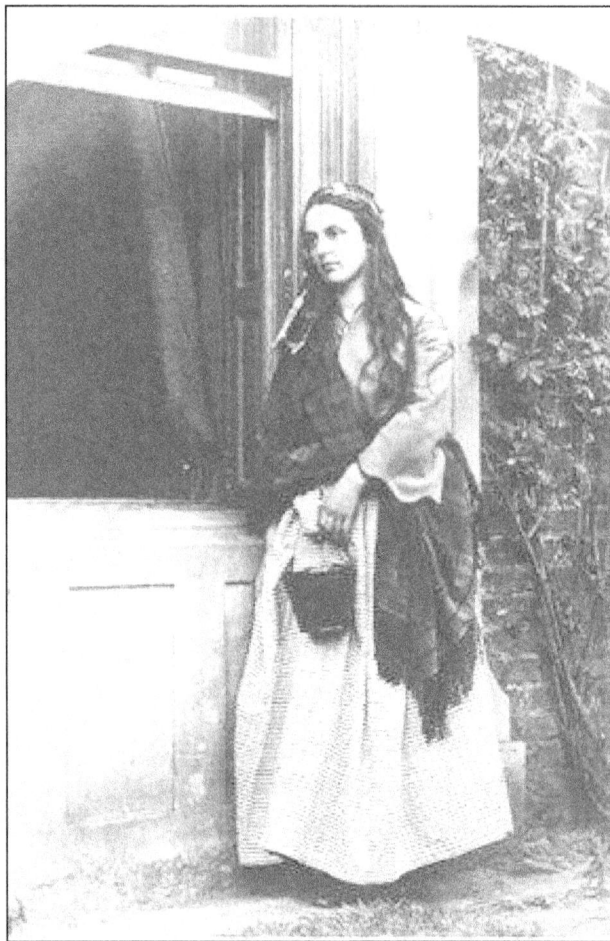
Rose Wood (September 1865)

Smith sisters (Anne, Maria, Joanna and Fanny)

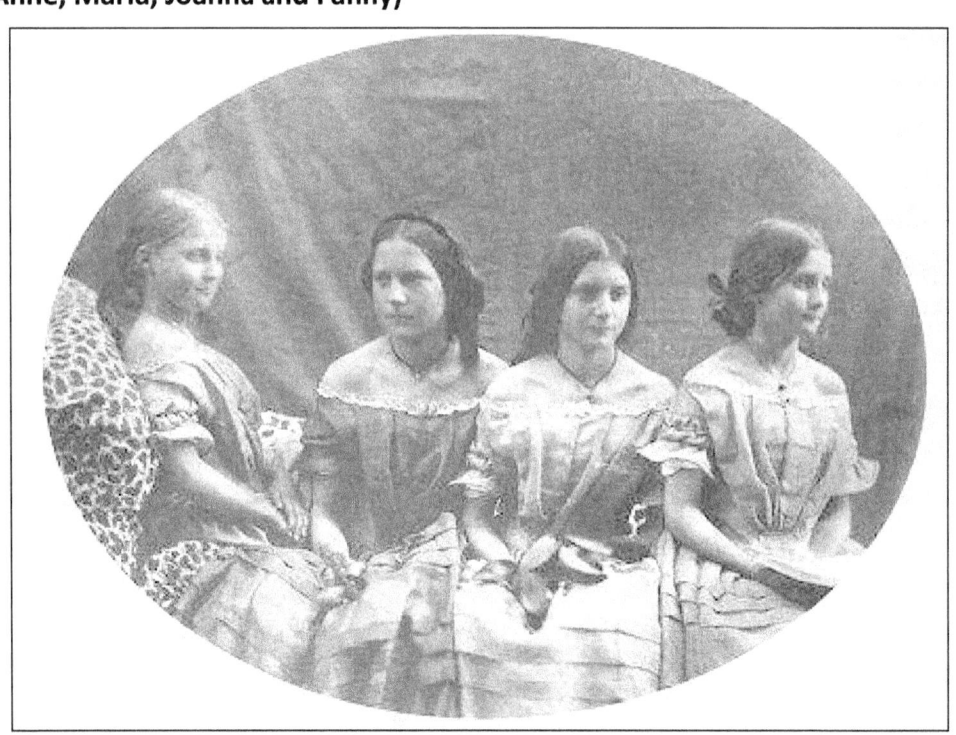
Anne, Maria, Joanna and Fanny Smith (August 4, 1857)

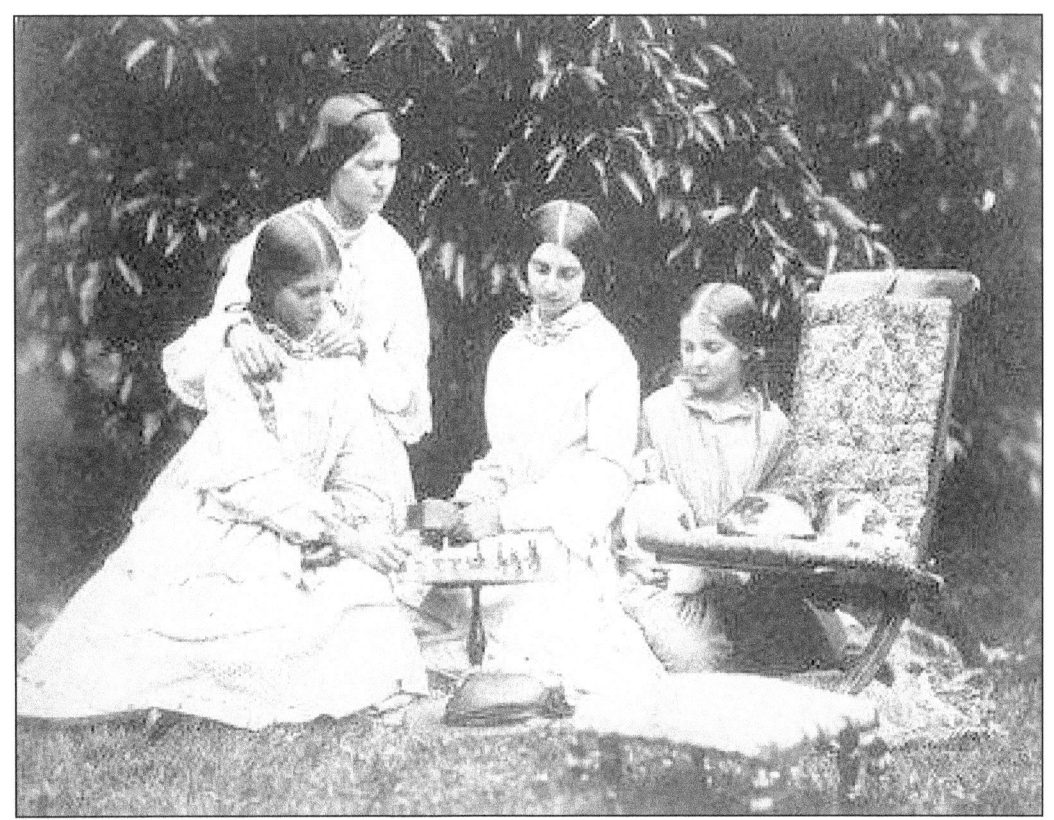
Fanny, Maria, Joanna and Anne Smith playing chess (summer 1859)

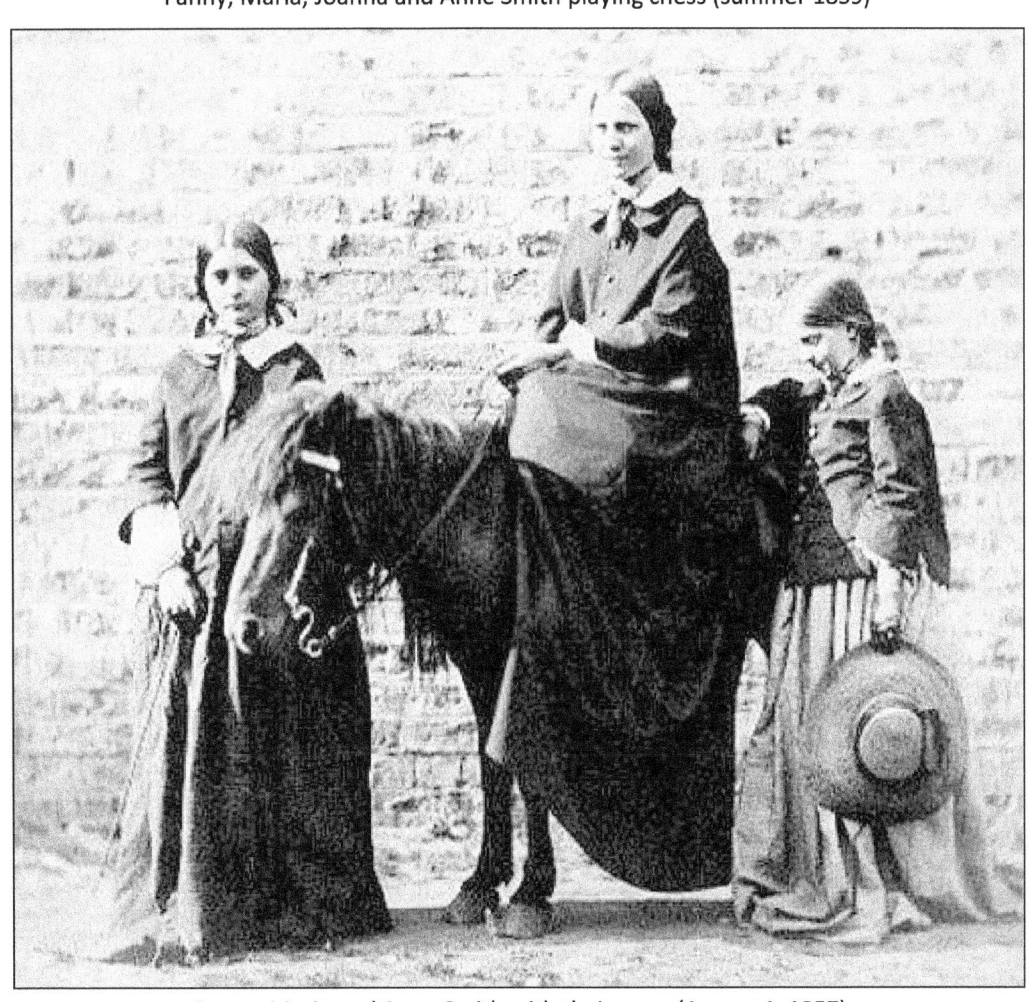
Fanny, Maria and Anne Smith with their pony (August 4, 1857)

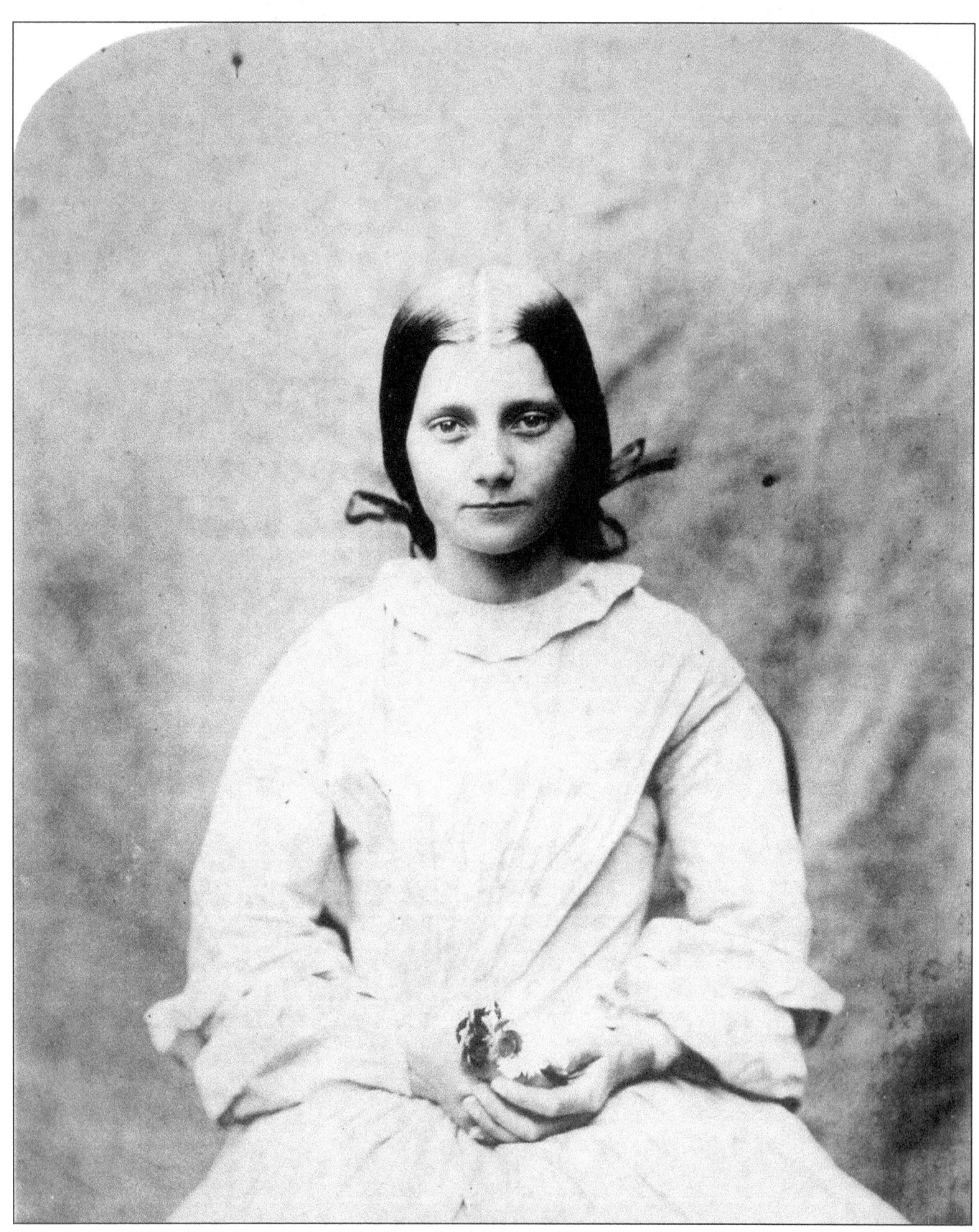
Fanny Smith (summer 1859)

Tennyson (Lionel and Hallam) and Julia Marsh

Hallam (1852-1928) and Lionel (1854-1886) were the only two children of Alfred, Lord Tennyson and Emily Sarah (Sellwood) Tennyson. Lord Tennyson was the Poet Laureate of England after William Wordsworth. Hallam served as Governor of South Australia from 1899 until May 1902 when he was appointed Governor-General of Australia, served a one year term and then returned to England. Lionel died of malaria at sea returning from a hunting trip to India.

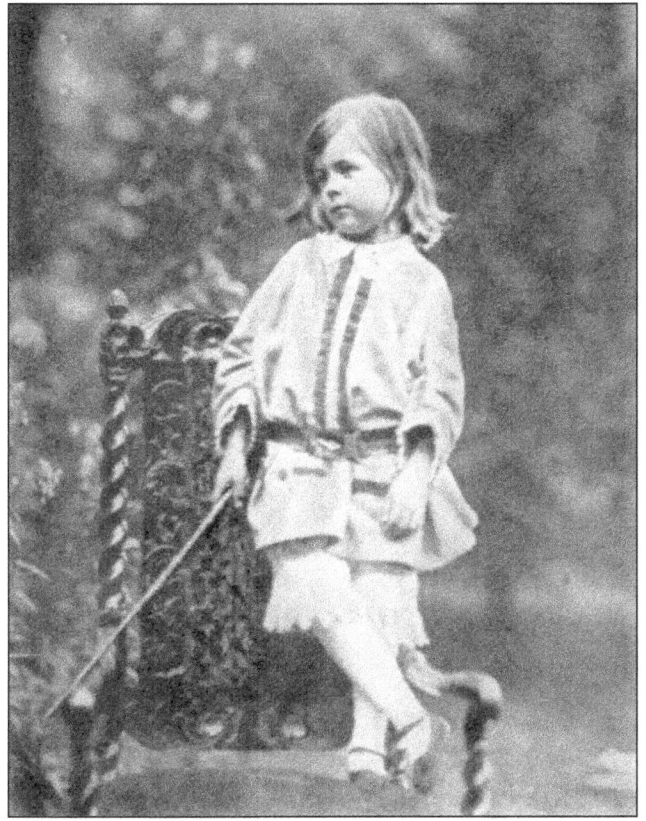
Hallam Tennyson (October 28, 1857)

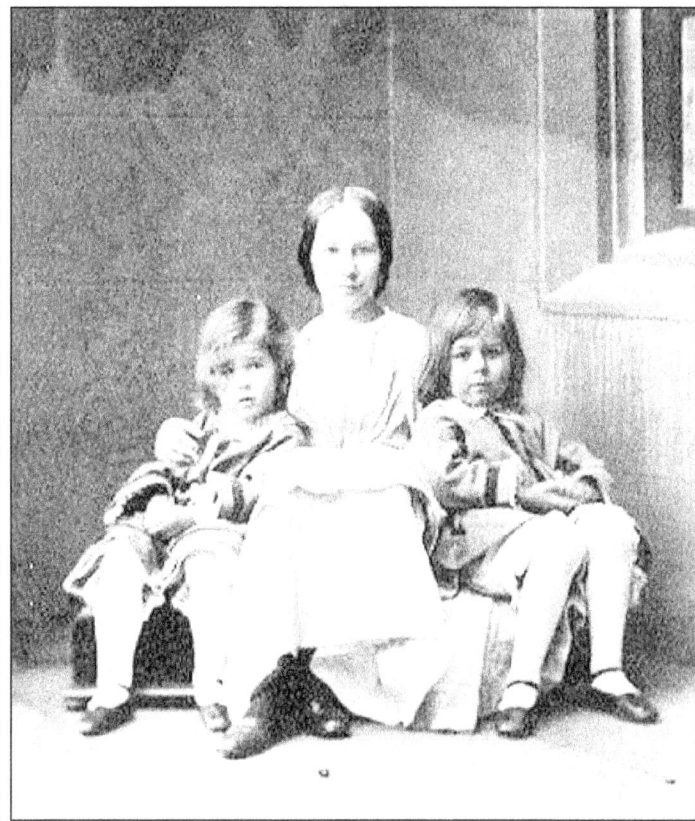
Lionel Tennyson, Julia Marsh, Hallam Tennson (August, 28 1857)

Terry Family (Kate, Ellen, Marion, Flo and Charles)

The Terry family is a British theatrical dynasty, begun in late 19th century, founded by the actor Benjamin Terry and his wife, Sarah. The family includes not only those members with the surname Terry, but also Neilsons, Craigs and Gielguds, to whom the Terrys were linked by marriage or blood ties. The couple had 11 children two of whom died in infancy.

Kate Terry (21 April 1844 – 6 January 1924) was an English actress. The elder sister of the actress Ellen Terry, she made her debut when still a child, became a leading lady in her own right, and left the stage in 1867 to marry. In retirement she commented that she was 20 years on the stage, yet left it when she was only 23. Her grandson was John Gielgud.

Ellen Terry, (27 February 1847 – 21 July 1928) was a leading English actress whose career on stage and screen lasted from 1856 to 1922. She was the third born of the 9 surviving Terry siblings.

Marion Bessie Terry [born Mary Ann Bessy Terry] (October 13, 1853– August 21, 1930) was the fifth born of the 9 surviving Terry siblings. In a career spanning half a century, she played leading roles in more than 125 plays and achieved considerable success in the plays of W. S. Gilbert, Oscar Wilde, Henry James and others. Terry died at her home and was buried at St Albans cemetery. She was the last of the first generation of Terry sisters. She never married and had no children. And since she was intensely private offstage nothing is known of her romantic life.

Florence Maud Terry (August 16, 1856– March 15, 1896) like her eldest sister Kate, acted until her marriage and then left the stage. She was the sixth born surviving sibling. She married a solicitor, William Morris. Of their four children, Olive and Jack Morris went on the stage.

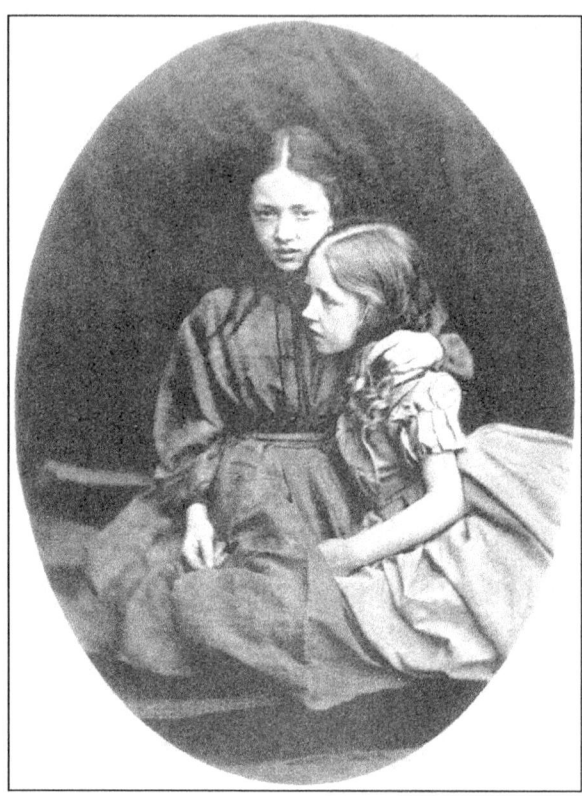

(July 13, 1865) Marion Terry [Polly] and Florence Maud Terry [Flo] (July 14, 1865)

Marion Terry as "Fitz-James" (July 12, 1875) Ellen Watts [née Ellen Terry] (July 13, 1865)

Flo Terry (July 17, 1865)

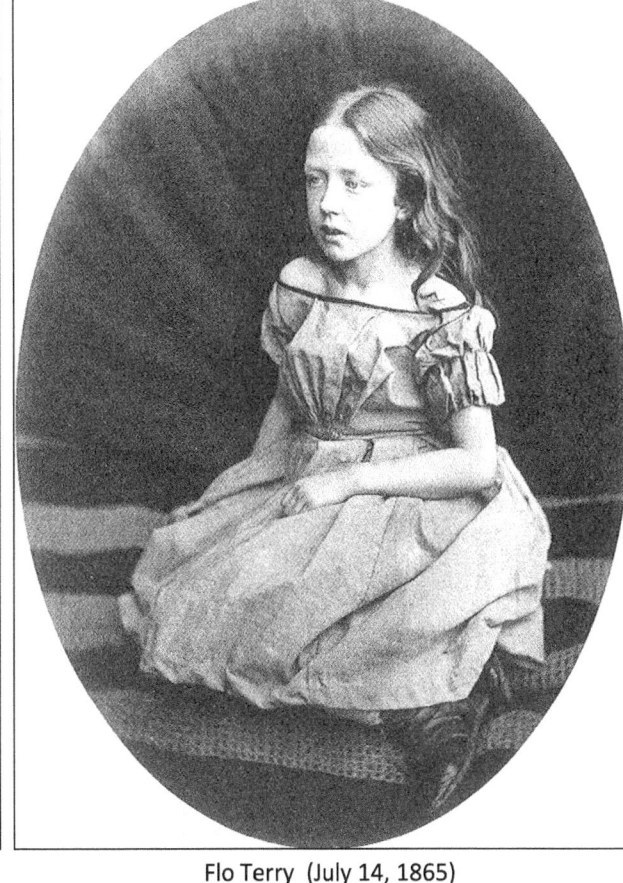
Flo Terry (July 14, 1865)

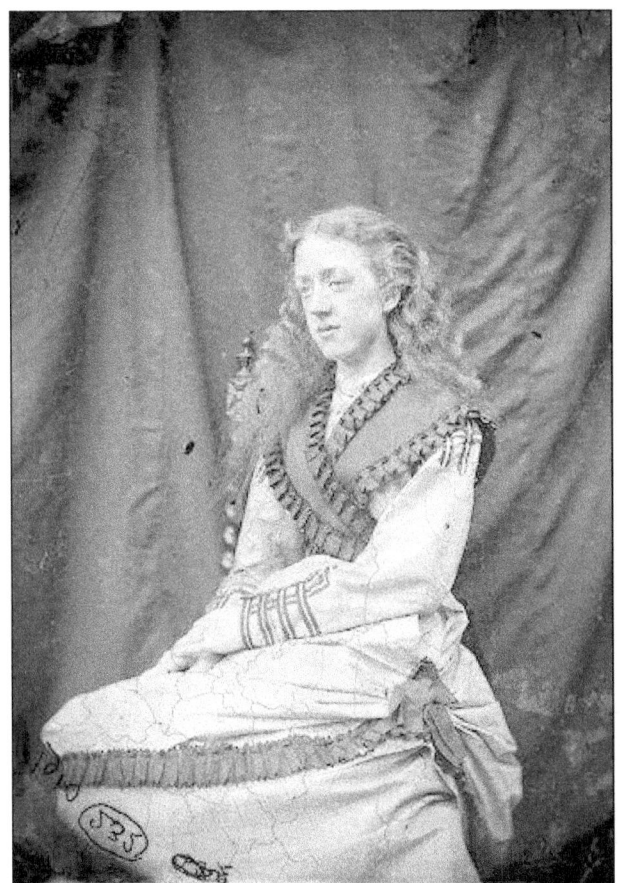
Flo Terry (July 8-11, 1870)

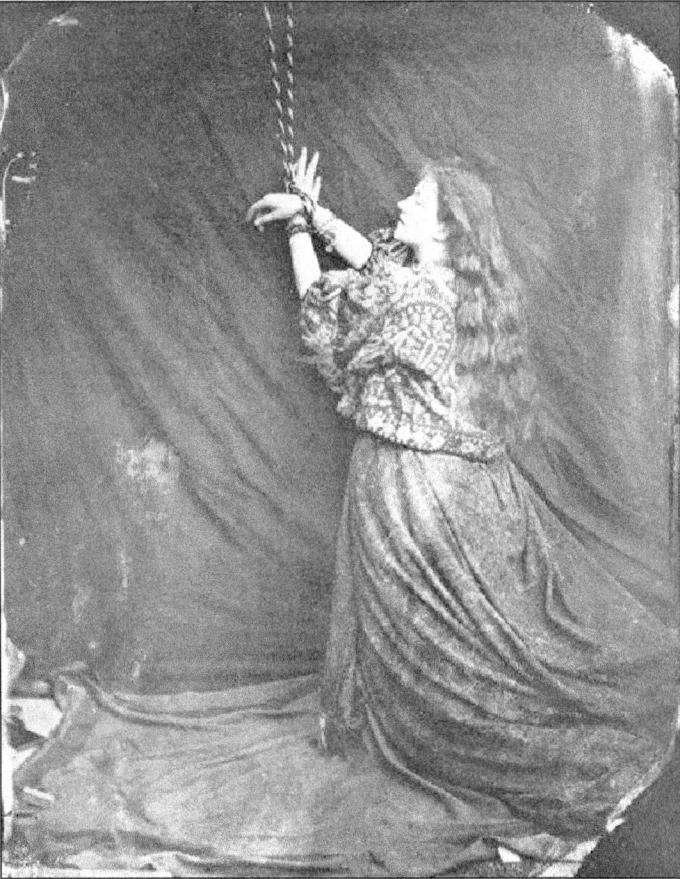
Kate Terry as "Andromeda chained" (July 15, 1865)

Charles Terry (1858–1933) was a theatre and stage manager. He worked successfully in the Bordeaux wine trade before moving into theatre management. After working as business manager for Michael Gunn at the Theatre Royal, Dublin, he joined the Compton Comedy Company, with whom he tried acting, without success. The rest of his career was spent in management. He was box-office manager at the Lyceum Theatre under Irving. He and his wife Margaret Pratt had three children, Minnie, Horace and Beatrice, all of whom followed a theatrical career.

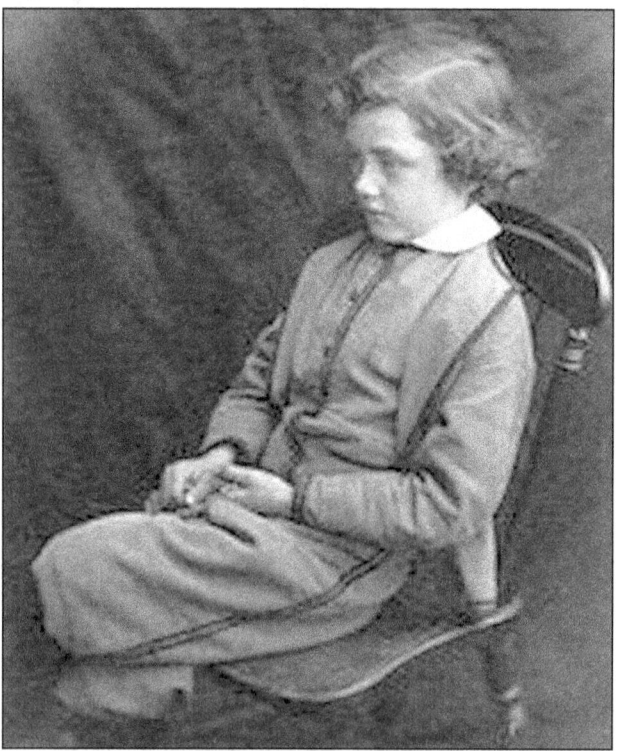

Charles Terry (July 14, 1865)

Twyford School

James Hume Dodgson (Carroll's cousin), Frederick George Richardson, A. Gordon, Edwin Dodgson, Charles Fosbery, John St. John Frederick, and Albert Heathcote (summer 1858)

Twyfod School (summer 1858) ↕

Unidentified girl holding a basket

(July 5, 1876)

Wilson-Todd Sisters (Aileen and Evelyn)

Aileen Wilson-Todd (September 4, 1865)

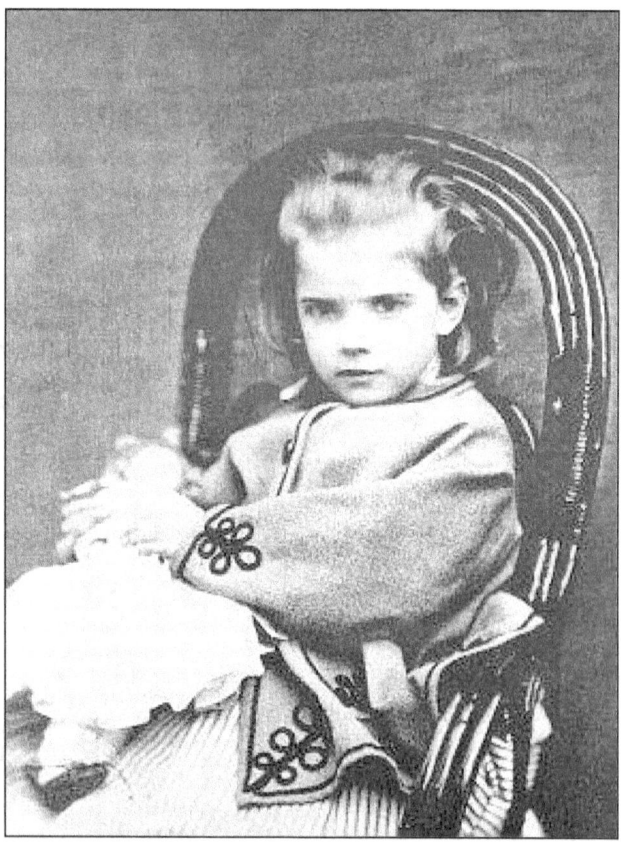

Evelyn Wilson-Todd (September 4, 1865)

Webster sisters (Margaret and Charlotte) and Margaret Gatey

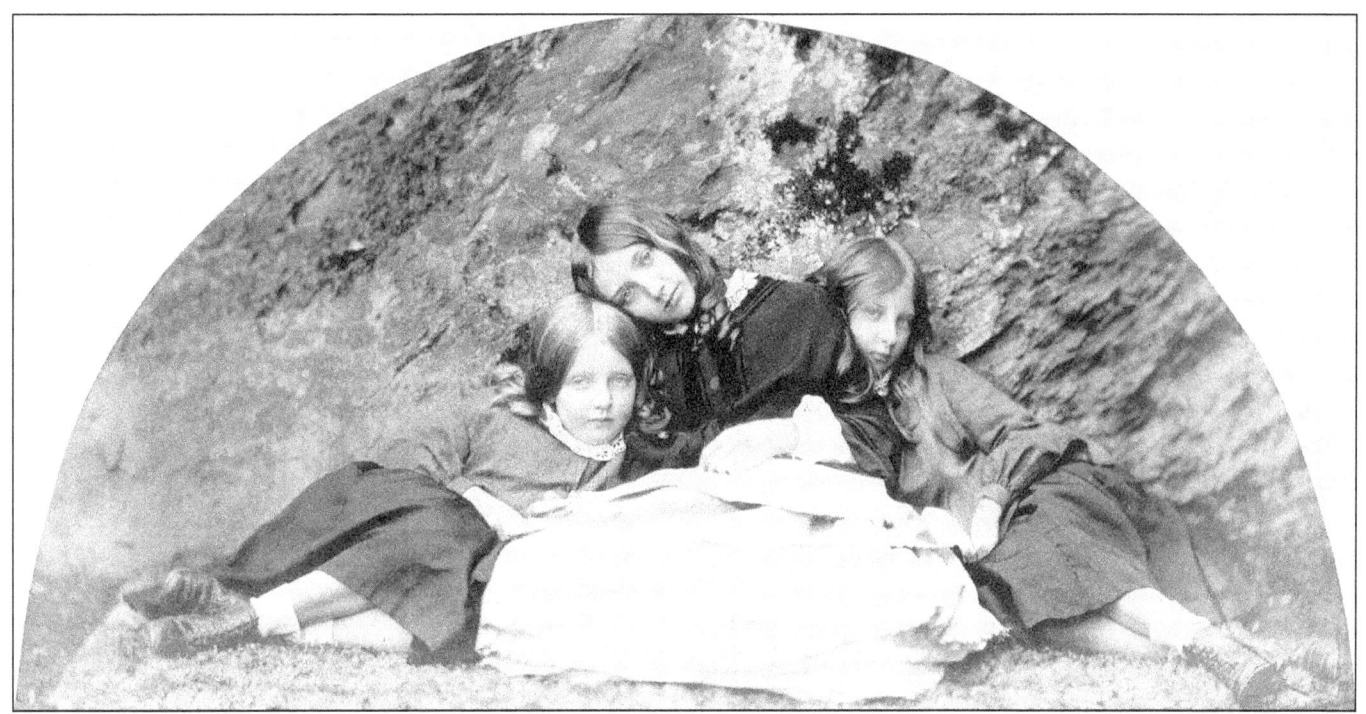

Mary and Charlotte Webster with Margaret Gatey (September 25, 1857)

Winifred Holiday with Daisy Whiteside and Zoe Strong

Winifred Raven Holiday (1866-1949) was a noted violinist, violin teacher and suffragette. She and her immediate family were involved in the women's suffragette movement. Henry Holiday, the painter and the illustrator of *The Hunting of the Snark*, was her father and often organised local suffragette meetings in the Lake District. She became involved with the New Constitutional Society for Women's Suffrage (NCSWS) and in 1913 enlisted George Bernard Shaw to speak against the force feeding of suffragettes during their imprisonment. In 1914, she wrote a pamphlet for the NCSWS entitled *Women under a Liberal Government, 1906-1914*.

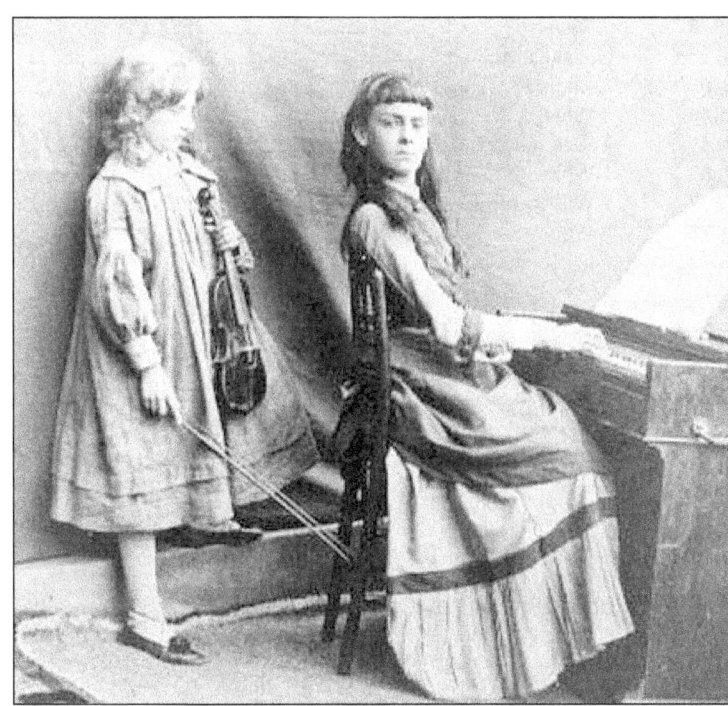
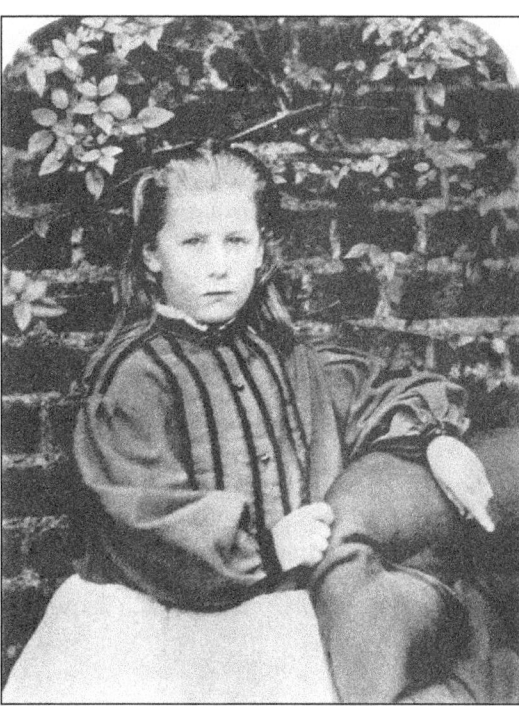

Winifried Holiday and Daisy Whiteside, "The lost chord" (July 10, 1875) Zoe Strong (October 10, 1863)

Index of Surnames of Sitters and of other Significant Individuals

Arnold ... 37, 38, 56
Bainbridge ... 53
Balfour ... 53, 94
Barry ... 39, 40
Bickersteth ... 40
Bligh ... 61
Brine ... 63
Brodie ... 41
Brooke ... 41, 68
Cameron ... 9, 13, 19
Carroll . 1, 2, 6, 7, 8, 9, 11, 12, 13, 14, 16, 17, 18, 19, 20, 21, 23, 24, 25, 43, 44, 54, 56, 57, 58, 63, 64, 68, 74
Chataway ... 7, 54
Coates ... 37
Cole ... 41
Denham ... 42
Dodgson 1, 2, 3, 4, 5, 6, 7, 8, 9, 12, 13, 14, 15, 16, 19, 20, 21, 23, 24, 25, 42, 43, 44, 68, 79, 90
Donkin ... 44
Douglas ... 36
Drury ... 61
du Maurier ... 8
Dubourg ... 51, 52
Dykes ... 45
Ellis ... 50, 51
Ellison ... 47, 48, 62
Fosbery ... 90
Frederick ... 19, 90
Gatey ... 92
Harington ... 55
Hatch ... 56, 57, 58, 59
Heathcote ... 90
Henderson ... 59, 60
Henley ... 38
Hobson ... 46
Holiday ... 8, 64, 93
Hughes ... 6, 60
Hulme ... 46
Hussey ... 48
Jackson ... 77, 83
Keane ... 77
Kitchin ... 58, 63, 64, 65, 66, 67, 68, 69, 70, 71
Langton Clarke ... 72
Lawrie ... 84
Liddell 1, 5, 7, 8, 9, 11, 12, 13, 14, 16, 19, 20, 23, 24, 25, 26, 27, 28, 29, 30, 31, 32, 33, 64
Longley ... 73
Lott ... 77
Lutwidge ... 2, 4, 7, 9, 19
MacDonald ... 6, 8, 24, 74, 75, 76, 78
Marsh ... 87
Millais ... 6, 9, 77, 78
Monier-Williams ... 49
Morrell ... 52
Murdoch ... 35
Oreilly ... 51
Owen ... 79, 80, 81, 82
Parkes ... 36
Parnell ... 82
Pollock ... 61
Price ... 34, 56
Raikes ... 36
Rankin ... 53, 75
Rejlander ... 13, 34, 94
Richardson ... 90
Rogers ... 83
Rossetti ... 6, 8, 9
Ruskin ... 6, 25
Slatter ... 39
Smith ... 84, 85, 86
Strong ... 8, 93
Tate ... 73
Taylor ... 55, 62, 63, 64, 69, 71, 73
Tennyson ... 9, 33, 87
Terry ... 9, 87, 88, 89, 90
Tidy ... 62
Todd ... 6, 92
Twyford School ... 90, 91
Wakeling ... 12
Webster ... 92
Weld ... 33, 34
Westmacott ... 35
White ... 76
Wilson-Todd ... 92
Wood ... 17, 73, 84

Front Cover: photograph of Georgina "Gina" Mary Balfour taken on July 5, 1864 by Carroll

Back Cover: photograph of Carroll with camera lens taken March 28, 1863 by O. G. Rejlander

www.ingramcontent.com/pod-product-compliance
Lightning Source LLC
Chambersburg PA
CBHW080939170526
45158CB00008B/2315